MICHEL PASTOUREAU

TRANSLATED BY JODY GLADDING

PRINCETON UNIVERSITY PRESS

PRINCETON AND OXFORD

First published in the French language by Éditions du Seuil, Paris, under the title *Blanc: Histoire d'une Couleur* by Michel Pastoureau
Copyright © 2022 Éditions du Seuil, Paris

Requests for permission to reproduce material from this work should be sent to permissions@press.princeton.edu
Published by Princeton University Press, 41 William Street, Princeton, New Jersey 08540
In the United Kingdom: Princeton University Press, 99 Banbury Road, Oxford OX2 6JX

press.princeton.edu

Jacket image: James McNeill Whistler, *Symphony in White, No. 1: The White Girl* (detail), 1861–1863, 1872, oil on canvas, National Gallery of Art, Washington, Harris Whittemore Collection, 1943.6.2

ISBN 978-0-691-24349-8

Library of Congress Control Number: 2022937786

British Library Cataloguing-in-Publication Data is available

This book has been composed in Tiempes and Neue Plak

Printed on acid-free paper. ∞

Printed in Portugal

1 3 5 7 9 10 8 6 4 2

FOREWORD

ROLAND BETANCOURT

Since the publication of *Blue* over twenty years ago, Michel Pastoureau's the History of a Color series has explored the material, sensory, and symbolic dimensions of colors across the western world. Moving away from those who might wish to find a universal symbolism or archetypal truth in a color, Pastoureau's series has sought to understand color as first and foremost a social phenomenon, one with historically grounded realities and effects.

The famed medieval art historian Michael Camille wrote that in Pastoureau's work, "the history of one color becomes the history of culture itself." As a scholar whose work was dedicated to understanding the labor of medieval artists and uncovering the voices of oppressed figures in the margins of medieval art, Camille's words showcase the power of Pastoureau's series to unsettle and disturb our familiar understanding of colors, what they represent, and how they have been mobilized over millennia for different aims and goals. In tracing the enduring life of a given color, Pastoureau has seamlessly woven ancient theories of vision with the nuances of medieval spirituality and the transformations of the early modern period during the rise of colonialism and capitalism.

In his research methods and approach, Pastoureau's series reflects two animating concerns in the study of art history and culture, namely, an interest in materiality and visuality. Over the past two decades, scholars have been attentive to how the materials and making of art contribute to their social meaning and function, while similarly seeking to understand how vision and perception affect our experiences of art. While we might take our modern understanding of optics for granted, throughout the ancient and medieval worlds philosophers, theologians, and authors contemplated and debated how sight operates and how we perceive colors, understanding this as a physical, sensory, and perceptual phenomenon. Naturally, a series that looks at the history of color contributes directly to our knowledge of how matter and vision intersect. Pastoureau's work acknowledges not only how pigments and colors were sourced, traded, made, and applied, but also how people through the ages have made meaningful distinctions between individual colors and applied purpose and meaning to them. As our research has continued to expand into the multisensory effects of the work of art, art historians have begun to look at how color, light, and optics combine with other sensory experiences, including hearing, touch, smell, taste, and other elements like the experience of weight and movement.

It is fitting that the History of a Color series would end with a volume dedicated to white. Not only did the ancient Greeks believe that all colors emerged as the intermediaries between black and white, but white also has come to be understood in the modern world as the outright absence of color. Yet nothing could be further from the truth. In this volume, Pastoureau vividly demonstrates how white was never understood as being "colorless" in the ancient tradition, coming only to be associated with this state of absence in the late Middle Ages and at the beginnings of modernity. The power of Pastoureau's *White* is that it confronts the reader with the artificiality and construction of white, tracing out the tensions it

created regarding how other colors were conceptualized and understood across several millennia. As the author states, this is hardly a comprehensive work, but one that urges scholarship to think further about the history of white and how it is that it came to be understood as such an enigmatic and fraught category.

On this occasion of the publication of this sixth and last volume in the series, we can appreciate the contributions that the series has made to our understanding of color and vision, but also reflect on its utility for ongoing and future areas of study.

As a scholar whose work has not only traced theories of vision and multisensory perception in the early Christian and medieval worlds but also processes of race-making and racialization in the premodern past, I am intimately aware of how the study of color becomes as pertinent today as it was two decades ago when the series was in its infancy. Pastoureau's color studies allow the novice and expert reader alike to survey the long trajectories that colors have had across the premodern and modern world. This permits us to better understand the vicissitudes of how colors can be variously used to stage piety or penance in the medieval world, or to articulate ethnic differences and racialized groupings across ancient peoples. While it has long been assumed that color-based ideas of race did not exist in the premodern past, ongoing scholarship has begun to demonstrate the rich and compelling evidence present across ancient Greek, Roman, and medieval sources to understand how premodern people thought about racialized differences and how color could also be deployed to delineate other differences, like gender identity or even sexuality.[1]

The material history of color itself also alerts us to the vibrant and dynamic interconnectedness of our world. While it is popularly believed that ancient or medieval people had limited interactions with the broader world, the study of trade routes, like the Silk Road or trans-Saharan trade, is expanding our horizons of contact and exchange.[2] Color, in these instances, can reflect not only how people came to visualize and represent each other, but it also speaks to how our distinctions between discrete colors evolved with contact with other civilizations, how trade and transport created new color possibilities, and how the privileging of certain colors promoted colonialism and other extractive approaches to land, people, and natural resources. With the rising interest in the Global Middle Ages, studies of color can now look beyond the European Middle Ages to think comparatively and to acknowledge how colors took on radically different meanings and operations across the world during a single period.[3]

As any volume of Pastoureau's series demonstrates, color is never an innocent or passive entity in our world, but an important actor in its own right. Color shapes how people have represented their own stories across time and also reminds us of how it has motivated human action around its sourcing, manufacturing, and meaning. Michel Pastoureau's the History of a Color series can serve as a starting point to further interrogate the varied and complex histories and complicities of color in our world, past, present, and future.

1. The study of race in antiquity and the Middle Ages is a current and thriving area of research with much work appearing constantly. Therefore, this is a very partial bibliography, but it is intended to give the reader a road map to pursue, highlighting key figures, books, and additional resources for following this area of research. For an introduction to the study of race in the ancient and medieval worlds, see Cord Whitaker, *Black Metaphors: How Modern Racism Emerged from Medieval Race-Thinking* (Philadelphia, 2019); Geraldine Heng, *The Invention of Race in the European Middle Ages* (Cambridge, 2018); Roland Betancourt, *Byzantine Intersectionality: Sexuality, Gender, and Race in the Middle Ages* (Princeton, 2020); Denise Kimber Buell, *Why This New Race: Ethnic Reasoning in Early Christianity* (New York, 2008); Denise Eileen McCoskey, *Race: Antiquity and Its Legacy* (Oxford,

2012); Francisco Bethencourt, *Racisms: From the Crusades to the Twentieth Century* (Princeton, 2014). For an introductory bibliography (up to 2017), see Jonathan Hsy and Julie Orlemanski, "Race and Medieval Studies: A Partial Bibliography," *Postmedieval: A Journal of Medieval Cultural Studies* 8 (2017): 500–531. For further, ongoing work, see Dorothy Kim, ed., "Critical Race and the Middle Ages," special issue, *Literature Compass* 16, no. 9–10 (2019); Urvashi Chakravarty and Ayanna Thompson, eds., "Race and Periodization," special issue, *New Literary History* 52, no. 3/4 (2021).

2. For an introduction to these topics, see Peter Frankopan, *Silk Roads: A New History of the World* (New York, 2016); Kathleen Bickford Berzock, ed., *Caravans of Gold, Fragments in Time: Art, Culture, and Exchange across Medieval Saharan Africa* (Princeton, 2019).

3. For an introduction, see Geraldine Heng, *The Global Middle Ages: An Introduction* (Cambridge, 2021). For an art historical approach, see Bryan Keene, ed., *Toward a Global Middle Ages: Encountering the World through Illuminated Manuscripts* (Los Angeles, 2019).

The color white is first among the colors (. . .).
It is with white that our pleasure in contemplating colors
and our knowledge of heraldic colors begin (. . .).
It resembles the moon, stars, snow, and other natural things.
In clothing, it is suitable for people of good disposition,
that is to say, joyful and resolute (. . .).
And when combined in livery with blue, it signifies courtesy and wisdom;
with yellow, the pleasure of love; with red, boldness in honest things;
with green, beautiful and virtuous youth.

Le blason des couleurs en armes, livrées et devises
(Anonymous author, c. 1480–1485)

Many decades ago, at the beginning of the twentieth century or even in the 1950s, the title of this book might have surprised some readers, unaccustomed to considering white to be a true color. Clearly that is no longer the case today, even if a few people may still dispute it. White has obviously regained the status it possessed for centuries, even millennia: that of a color in its own right, and even an important end point in most chromatic systems. Like its counterpart black, white had gradually lost its status as a true color between the late Middle Ages and the seventeenth century. The arrival of printing and engraving—with black ink on white paper—had given these two colors a special place, which first the Protestant Reformation and then scientific progress eventually shifted to the margins of the universe of colors. Finally, when Isaac Newton discovered the spectrum in 1666, he proposed to the scientific world a new chromatic order, within which there was no longer a place for either white or black. This marked a true revolution, not limited to science but expanding progressively to ordinary fields of knowledge and then to the material culture.

That change would last for nearly three centuries, during which time white and black were considered and experienced as "noncolors," and then as forming an autonomous "black and white" universe. In Europe, such a conception was familiar to a dozen generations, and even if it is no longer so prevalent today, it does not really strike us as odd: black and white on one side, colors on the other.

Nevertheless, our sensibilities have changed. Beginning in the years 1900–1910, artists were the first to gradually restore to white and black the status they had held prior to the late Middle Ages: that of colors in their own right. Scientists eventually followed suit, although some physicists long remained reluctant to recognize white's actual chromatic properties. The general public finally fell into line as well, so that today, in our daily lives, social codes, dreams, and imaginations, little reason remains for opposing the world of color to the world of black and white. Here and there we find a few vestiges (photography, cinema, journalism, publishing) of that old distinction. But for how much longer?

Thus the title of this book is not some sort of mistake or provocation. White is very much a color, even a color of "the highest order," as are red, blue, black, green, and yellow, whereas purple, orange, pink, gray, and brown

belong to a second group with a shorter history and less symbolism.

*

Before attempting to trace the long history of white in European societies, I must make several important remarks, which will be developed over the course of these chapters and the periods studied. Let me preface them by saying that this book discusses vocabulary, pigments, colorants, clothing, chalk, milk, snow, flour, the dove, the fleur-de-lis, and so on, not the colors of the human skin.

The first expands directly on what was just said about white, a color in its own right. For centuries in Europe, in no matter what language, the words for "white" and for "colorless" were never synonymous. In both Greek and Latin as well as vernacular languages, there were many figurative meanings for the adjective "white" (pure, clean, virgin, innocent, empty, intact, bright, luminous, favorable, and so on), but never did it mean "without color." This synonymity would not appear before the modern period. Until then, the notion of colorlessness—difficult in many respects to conceive, define, and represent—related only to matter or light, not to coloration. For authors who made color into a material, that is to say, a kind of film that enveloped bodies, colorlessness was the absence or very small quantity of coloring matter. Thus its synonyms were to be found among words like "desaturated," "washed-out," "diaphanous," "transparent." On the other hand, for authors like Aristotle who saw color as a weakening of light in contact with physical bodies, colorlessness found its root and its possible synonym in black. In neither case was it a question of white.

A kind of equivalence between "white" and "colorless" did not appear until the end of the Middle Ages and the beginning of the modern period. The role of paper seems to have been the determining factor. As the medium for the printed book and the engraved image, paper, being whiter than parchment, came to constitute a sort of degree zero for color. Indeed for any image, the color range depended on a background, and it was that background—or medium, whatever it happened to be—that represented "colorlessness": parchment for illuminated manuscripts; walls for murals; wood or canvas for panel paintings; paper for printing and engraving. In the fifteenth and sixteenth centuries, the increased use of paper as a medium for books and images alike helped to establish a kind of synonymy between the color of paper—white—and colorlessness.

My second remark concerns our perception of different shades of white: over the course of time, it has diminished, at least in the West. In comparison to our ancestors' perception, our modern eye seems decidedly less sensitive to the multiple varieties of white, not only those offered by nature but also those we have produced ourselves through dyes and paints. We are also less perceptive than non-Western populations, like those of the Far North, for example, used to discerning in the snow and ice a wide array of whites with subtle differences often visible (and nameable) only to natives. European languages reflect this impoverished state. Today they each possess only one commonly used term for naming the color white, whereas in the past there were many terms, frequently two per language, and sometimes more.

The third remark is related to the preceding one: at present, it is difficult not to oppose white to black. The two colors form an almost indissociable couple, more so perhaps than any other two colors, including blue and red. That was not always the case. In medieval texts, the passages in which white and black appear together are rare, and it is even less common in images and on objects for the two colors to be joined to form a meaningful dichromatic pair. Only the coats of certain animals (dogs, cattle) and plumage of certain birds (magpies) combine them, in images as in nature. In fact, until the appearance of printing and engraving—an absolutely decisive turning point in the history of colors—the true medieval opposite for white was not so much black as red. There is much proof of this in the world of symbols, emblems, clothing fashions, and later in sporting events and social games, with their teams, their sides, or simply their game pieces opposing two different colors: for a long time, white and black were not opposites, but rather white and red.

My last remark relates to the symbolism of colors. Colors are always ambivalent, each possessing its positive and negative aspects. There is a good red (energy, joy, celebration, love, beauty, justice) and a bad red (anger, violence, danger, sin, punishment). There is a good black (temperance, dignity, authority, luxury) and a bad black (grief, mourning, death, hell, sorcery). In the case of white, however, its symbolism is less dualistic. Most of the ideas associated with white are virtues or good qualities: purity, virginity, innocence, wisdom, peace, goodness, cleanliness. We could add social power and elegance; for centuries, white was the color of European monarchies and aristocracies, especially in dress and appearance. Our "white collars," our white shirts and dresses are more or less an extension of this. For a long time as well, white was the color of hygiene: all fabric that touched the body (undergarments, sheets, bath towels, and so on) had to be white, for both hygienic and moral reasons. Today that is no longer the case. We sleep between brightly colored sheets and our underwear comes in all colors. But white remains the color of cleanliness and hygiene, in the image of bathrooms, hospital rooms, and even refrigerators. White is clean, pure, cold, and silent.

For a long time, white was the color of the sacred and its rituals. In the liturgical color code, for example, medieval Christianity and modern Catholicism associated white with the holidays of Christ and the Virgin, that is to say, their most important religious celebrations. This link between the color white and the sacred is found in many religions, sometimes dating very far back. Animals with white coats or feathers were presented as divine offerings in many ancient religions, and their officiating priests or vestal virgins dressed in this color.

Nevertheless, white is not always positive. In much of Asia and Africa, it is the color of death, not death as opposed to life, but death as opposed to birth. Where death is considered a new birth, death and birth are both symbolized by the same color. In the West, white is sometimes associated with mourning, the dead, ghosts, and even with fairies and otherworldly creatures. More often still, it signifies the void, cold, fear, and anguish. A truly white white is all the more mysterious and disturbing because for centuries neither painters nor dyers were able to attain the absolute whiteness of the lily, milk, or snow. For a long time—at least until the eighteenth century—the whites produced in Europe were only "near whites": drab, ecru, beige, grayish, yellowed. Today the technical difficulties have been overcome, but something about white remains secret and inaccessible, both alluring and distressing, fascinating and paralyzing, as if this color, unlike others, was still not free of all its supernatural dimensions. Should we be delighted or troubled by that?

*

The present book is the sixth and last in a series begun more than twenty years ago. Five books have preceded it: *Blue: The History of a Color* (2001); *Black: The History of a Color* (2009); *Green: The History of a Color* (2014); *Red: The History of a Color* (2017); *Yellow: The History of a Color* (2019), all published by Seuil and Princeton University Press. As with the preceding books, the plan for this one is chronological; it is very much a history of the color white, not an encyclopedia of white, and even less a study of white in the contemporary world alone. I have tried to study this color over the long term and in all its aspects, from lexicon to symbols, and by way of everyday life, social practices, scientific knowledge, technical applications, religious values, artistic creations, the world of emblems, and representations. Too often works that claim to discuss the history of colors are limited to the most recent periods and sometimes even to pictorial matters alone, which is very reductive. The history of painting is one thing, the history of colors another, much more vast, and there is absolutely no reason to limit it to the contemporary era.

That said, as with the five preceding works, this one only appears to be a monograph. A color never occurs alone; it only derives its meaning, it only fully "functions" from the social, lexical, artistic, or symbolic perspective insofar as it is combined or contrasted with one or many other colors. Hence, it is impossible to consider it in isolation.

To speak of white necessarily leads to speaking of black, red, blue, and even green and yellow.

These six works form an edifice I have been working to build for more than half a century: the history of colors in European societies, from Roman antiquity to the eighteenth century. Although, as readers will find in the pages that follow and in my other works, I range considerably beyond and before those periods, it is within that—already quite ample—slice of time that the essence of my research lies. Similarly, I have deliberately limited my research to European societies because for me the issues of color are first of all social issues. As a historian, I am not competent to speak about the whole planet and not interested in compiling, second- or thirdhand, works by other researchers on non-European cultures. In order to avoid making foolish claims, plagiarizing, or recopying the books of others, I have limited myself to what I know and what was the subject of my seminars at the École Practique des Hautes Études and the École des Hautes Études en Sciences Sociales for four decades, beginning in 1983. A warm thanks to all my students, doctoral students, assistants, and auditors for the fruitful exchanges we had then, and which I hope will continue. Color concerns everyone and touches on all the issues of life in society.

White versus Red

In antiquity and the Middle Ages, white had two opposites: red and black. But until the appearance of the printed book and engraved image, it was more frequently opposed to the former than the latter. Dating very far back, that opposition is still present in twentieth-century art and everyday life. Mark Rothko, *Untitled*, 1969. Private collection.

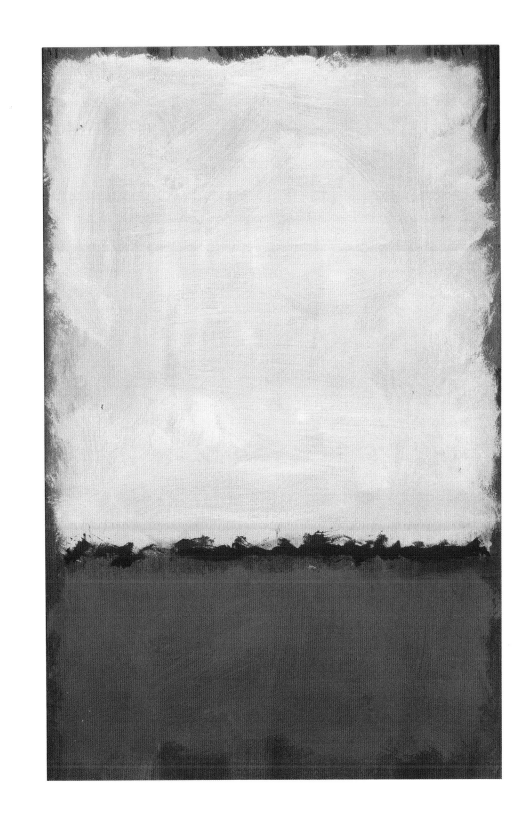

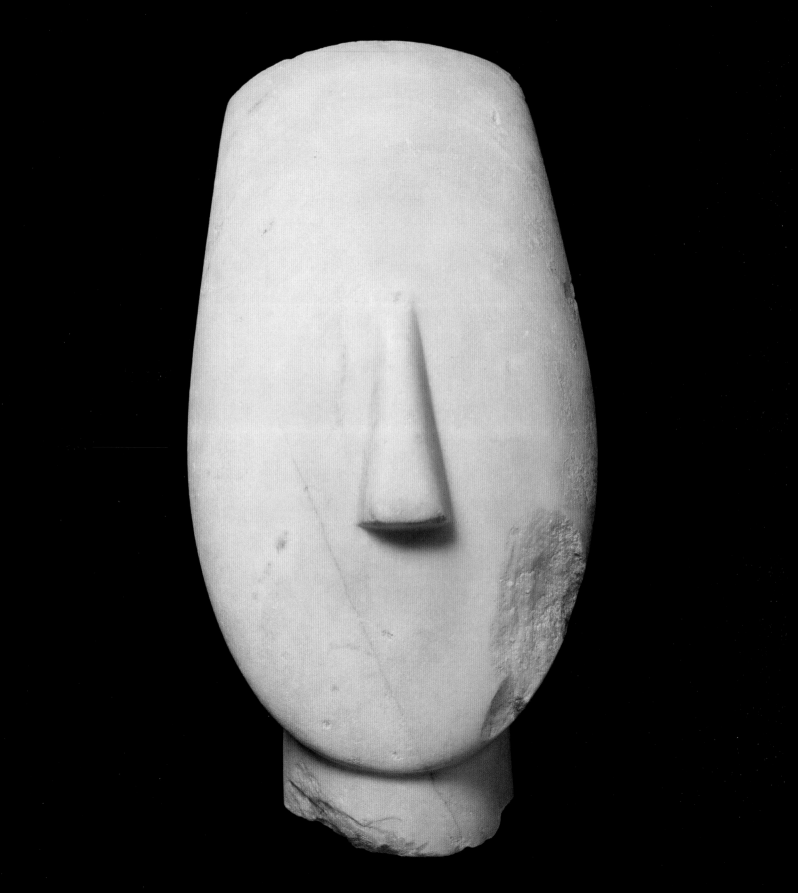

THE COLOR OF THE GODS

FROM EARLIEST TIMES TO THE BEGINNING OF CHRISTIANITY

PREVIOUS PAGE SPREAD

Keros Head (3rd millennium BCE)

This head from a marble statue found on the island of Keros, in the small Cyclades archipelago, belongs to an idol or female divinity whose identity and function remain mysterious. Its U form, refined style, and smooth grain permit us to date it to the Early Bronze Age, c. 2700–2400 BCE. The statue measured almost five feet high and represented a nude woman, standing with her arms crossed over her chest, legs together, and feet extended. The remaining head measures about ten inches high. Polychrome probably would have accentuated, or even covered, the whiteness of the marble. Paris, Musée du Louvre, Département des Antiquités Grecques, Étrusques et Romaines.

Defining what constitutes color is not an easy task. Not only have definitions varied widely over the centuries, but even just within the present age, color is not perceived the same way across the five continents. Every culture conceives of it according to its own environment, climate, history, and traditions. In this domain, Western knowledge is by no means the final authority, much less the "truth," but only one approach among many. Moreover, it is not a unified approach. I participate regularly in interdisciplinary conferences on color that bring together researchers with diverse backgrounds: sociologists, physicists, linguists, ethnologists, painters, chemists, historians, anthropologists, musicians. We are all very happy to meet with one another to discuss a subject that is dear to us, but after a few minutes we come to understand that we are not discussing the same thing. Each specialty has its own definitions for color, its own classifications, certainties, and sensibilities. This diversity and the impossibility of agreeing on a single definition is found in most dictionaries. The authors of dictionaries have not managed to provide a clear, pertinent, intelligible definition within a reasonable number of lines. Often the text tries to say everything and thus is long and involved, even as it remains incomplete. Sometimes it is inaccurate or incomprehensible to most readers, in French as in related languages. With regard to the word

color, it is rare that a dictionary adequately fulfills the role rightfully expected of it.

If defining color is not an easy exercise, defining white is even harder. To say that it is the color of milk, lilies, snow—as one generally reads in dictionaries—is not false but does not constitute a definition.[1] As for asserting that white is the color of solar light whose spectral dispersion gives rise to different monochromatic rays, that is a proposition that would only satisfy a physicist. What can the human sciences do with a definition like that? Nothing, absolutely nothing. The colors of the physicist, chemist, or neurologist are not those of the historian, sociologist, or anthropologist. For these latter disciplines—and more generally for all the human sciences—color is defined and studied first as a social phenomenon. More than nature, the eye, or the brain, it is society that "makes" color, that gives it its definitions and meanings, that articulates its codes and values, that controls its uses and determines its stakes. The issues it raises are always cultural.

That is why to speak of color is first of all to speak of the history of words and language events, pigments and colorants, painting and dyeing techniques. It is also to speak of the place of color in everyday life, the values and systems that accompany it, the laws and civic decrees that regulate it. And finally it is to speak of the morals and symbols of the church, the speculations of scientists, the creations and sensibilities of artists. The fields of inquiry and thought are manifold, and they present the historian with multifaceted questions. In essence color constitutes an interdisciplinary and interdocumentary field of research.

Certain domains, however, prove more fruitful than others. Those are the ones that make color into a tool of classification: the lexicon, clothing, the world of signs, codes, and emblems. To associate, oppose, distinguish, hierarchize: the first function of color is to classify. That is, to classify beings and things, animals and plants, individuals and groups, places and moments. In order to do this, contrary to what is generally assumed, most societies have relied on a limited palette. For a long time in Europe, three colors seemed to matter more than all the others, at least on the social and symbolic levels: white, black, and red, which is to say, from the historical perspective, white and its two opposites.

From Nature to Culture

Seeking to learn what relationships prehistoric men and women had with the color white is an impossible task. At most we can imagine that white tones were relatively abundant in their natural environment, more abundant than reds and blues, for example: plants and minerals of all kinds, of course, as well as the coats and plumage of certain animals; teeth, bones, tusks, and horns used to make weapons, tools, and eventually everyday objects; shells from seashores and riverbanks; white earth or rocks and limestone cliffs; moon and stars in the sky; clouds, lightning, and meteorological phenomena; snow and ice linked to climate and latitude, and so on. Nevertheless, we are the ones who arrange these white and off-white tones in a single chromatic category. Did humans do that as early as the Paleolithic period? Did they have the idea of a common denominator—color, and color alone—for these natural elements that were different in all other respects? That is far from certain. Likewise, although they may well have associated daytime early on with notions of brightness and light, there is no proof that they extended those notions to white or off-white animals, plants, or minerals. In fact, what link could exist between sunlight, limestone, lilies, and lamb's wool? At first glance,

none, at least not until the color white appeared and was called into service.

Identifying the period when that happened is not easy. Was it as early as the Upper Paleolithic, as materials found in tombs and the first traces of color in cave paintings and on stones lead us to believe? Red dominates but white is not absent. Or must we wait for the Neolithic period, when humans became sedentary and first practiced weaving and dyeing, for true color strategies and classifications to appear? Painting or dyeing? The gap between dates is considerable, many tens of thousands of years. Humans painted well before they practiced dyeing. But does painting imply that they thought about and classified colors,

Polished Stone Axes

In the Neolithic period, activities linked to settling and agriculture contributed to the improvement of tools. The stone heads of axes became thinner, sharper, and more resistant. But the work of polishing stone is long and exacting, especially when it involves the entire surface of the tool. That is why it is likely that some of these axes had a symbolic rather than a utilitarian purpose, related to displays of power and accompanying rituals. Ax heads found in Ploermeur, in Morbihan, Brittany, c. 4500–4000 BCE. Carnac, Musée de la Préhistoire.

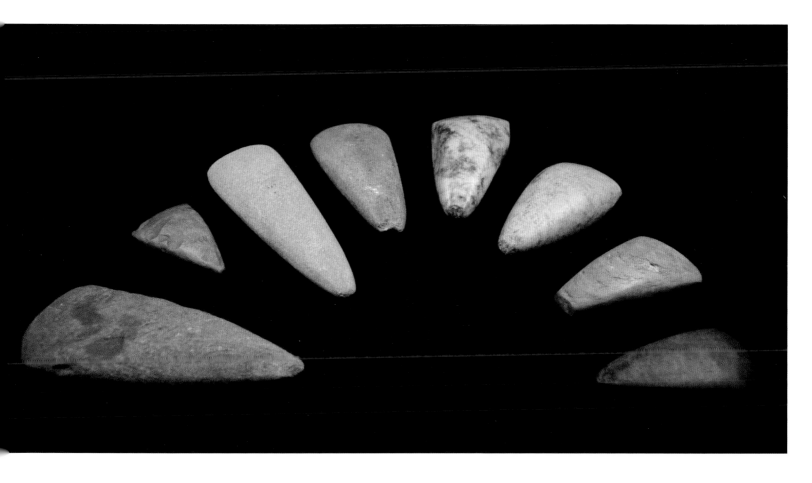

Negative and Positive Hands

Drawn as stencils or as silhouettes, hands are relatively plentiful in prehistoric rock and cave art. They are different colors, with white (from talc, chalk, and kaolin) being the most common. Three-quarters of them are left hands, but it is difficult to know the significance of this. Garfish Shelter, in the area of Laura, Australia.

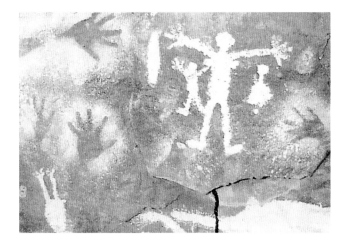

had ideas of red, white, black, and yellow? That is likely but remains difficult to prove.

It is patently obvious, however, that white numbers among the first colors humans made for painting, initially on their own bodies, then on stones and various objects, finally on the walls of caves. Of those first white body paints we know nothing. At most we can venture the hypothesis that they were chalk or kaolin (white clay) based and that they served as protection against the sun, diseases, insects, and even forces of evil. But no doubt, in combination with or contrast to other colors, white had a taxonomic function as well: perhaps to distinguish groups or clans, establish hierarchies, mark points in time or rituals, and possibly differentiate gender and age groups.[2] This is conjecture nonetheless.

Studying the rare traces of white present on personal objects that served as tools or receptacles is less theoretical. Some material evidence that is chalk, calcite,[3] or kaolin[4] based has been preserved for us, although there are many more ocher-based examples (yellows, reds, browns). The same is true for cave paintings. That is where the palette of prehistoric painters is most complete and best studied. In truth, that palette is limited, even in great works like those found in the most famous caves: Chauvet, Cosquer, Lascaux, Altamira, and a few others, dating from 33,000 to 13,000 BCE. The number of shades represented there is minimal, at least in relation to later practices. We find especially reds and blacks, sometimes yellows, oranges, and browns. Whites are the most rare and perhaps the most recent. Here again, they have chalk-like or calcined kaolin bases, more rarely gypsum or calcite bases. As for greens and blues, they are completely absent from the Paleolithic palette.

Thanks to laboratory analysis, we also know that some white pigments, like red and yellow ones, were enriched with products now considered to be charges, meant to alter their covering power and their relationship to light, or even to facilitate their application on walls: talc, feldspar, mica, quartz, and various fats. Surely chemistry is very much present here. Burning wood to make charcoal to use for drawing or painting in black is a relatively simple technique. But extracting blocks of kaolin from the earth, washing, diluting, filtering, burning, and then crushing the resulting material with a pestle to obtain a fine white powder, and finally mixing this powder with chalk, vegetable oils, or animal fats to give it different shades or make it adhere better to a rock surface is another, much more complicated process. It was already known and practiced by cave painters some fifteen, twenty, even thirty thousand years before our era.[5] We have thus moved from nature to culture.

Nature, in fact, does not offer us colors but only colorations, hundreds, even thousands of different colorations that human beings—like animals, but perhaps much later—gradually learned to observe, recognize, and distinguish for utilitarian ends: to spot edible fruit, dangerous animals, favorable soils, beneficial waters, and so on. These colorations were not yet colors strictly speaking, at least not for the historian. For the historian, as for the anthropologist, ethnologist, or linguist, colors

only truly appeared when societies began to group colorations observable in nature into several large sets, limited in number but coherent, and when they gradually isolated some from others, to which they eventually gave names. In this way, the origin of colors really does seem to be a cultural construction and not a natural phenomenon, whether physical or physiological. That construction took place at different times and following different rhythms according to society, latitude, climate, utilitarian needs, aesthetic concerns, and symbolic aspirations.[6]

And according to each color as well: they did not all emerge at the same time. In Europe, in this slow, complex process, three large sets seem to have taken shape before the others: red, white, and black. That does not mean that colorations like yellows, greens, blues, browns, grays, purples, and so on did not exist, of course; they were found abundantly in nature. But these colorations did not become "colors"—that is, categories established by society and conceived in an almost abstract way—until later, sometimes very much later (blue, for example). Moreover, that is why the red-white-black triad long retained superior lexical and symbolic power in many areas, as compared to other colors.[7] And that is perhaps more true for red than for white or black. Indeed red was the first color to be made and then mastered in Europe, first in painting, as early as the Paleolithic period, later in dyeing, in the Neolithic period. It was also the first color to be linked to stable, recurrent ideas that played an essential role in social life: strength, power, violence, love, beauty. Red's preeminence also explains why the same word signifies "red" and "color" in some languages, "red" and "beautiful" in others.[8] Gradually, white and black were added to red to form an initial triad around which the oldest color systems were constructed. Ancient mythology, the Bible, tales and legends, toponymy, anthroponymy, and especially the lexicon provide much evidence of this.[9] Green and yellow only joined this triad in a second phase, the dates varying according to the culture, but probably not before the Roman period. As for blue, it does not seem to have become a color in its own right, definitively ranked with the other five, until well into the Christian Middle Ages.[10] That does not mean it did not exist before then, obviously, but its various colorations had not yet been grouped into a single, coherent set, abstracted from their physical occurrences.

As for white, it seems to have been conceived and constituted as a category very early, well before the appearance of writing, and probably even before the profound changes of the Neolithic period. The production of pigments and the organized distribution of colors on the walls of certain caves lead us to think that by the end of the Paleolithic period, white, like red and black, already represented a color category, that is to say, a concept and no longer simply a set of white shades and colorations offered by nature. Given the present state of our knowledge, it is difficult to say more than that, but that is saying quite a lot already.

NEXT PAGE SPREAD

The Great Bulls of Lascaux
The Hall of the Bulls in the Lascaux cave owes its name to five huge aurochs painted there among a bestiary composed of horses, stags, a "unicorn," and perhaps a bear. As with all Paleolithic paintings, the palette is limited: reds, blacks, and brown and yellow tones in a variety of shades, to which is sometimes added a bit of chalk- or kaolin-based white. The Hall of the Bulls (detail), Lascaux cave (Dordogne), c. 17,000–16,000 BCE.

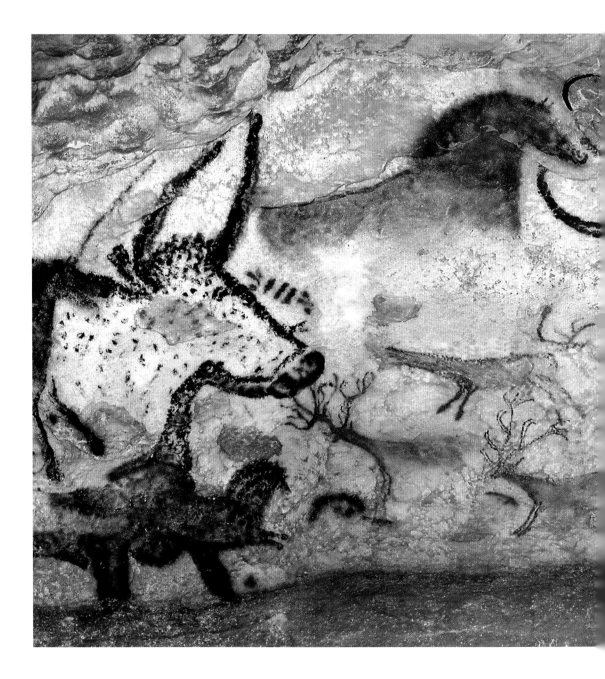

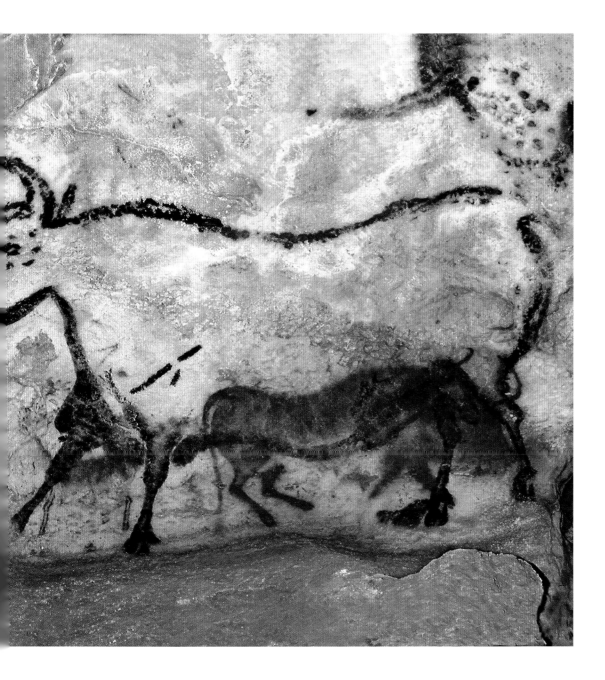

The Moon and the Sacred

The moon is undoubtedly the earliest divinity that humans worshipped, even before the sun, wind, thunder, ocean, and all the forces of nature. They observed its different phases, its changing forms, its white light illuminating the darkness, its growth and diminishment, then its disappearance and renewal. Hence they made it into a higher being, inhabiting the heavens and gifted with magical powers over all that lived on earth. They worshipped it in order to win its favor and prevent it from harming them.[11] It was only later that the moon came to be paired with the sun, and later still that humans recognized it possessed no light of its own but only reflected the sun's light. From then on, it was more or less subordinate to the sun, becoming its wife, sister, or daughter, even while retaining its remarkable characteristics. Moreover, although it became a female principle in many cultures, in others it remained a male divinity. Even today, the lexicon attests to these differences. In German, for example, the word designating the moon (*der Mond*) is masculine in gender while the one designating the sun (*die Sonne*) is feminine. Among the ancient peoples of the north, Germans and Scandinavians, the moon was often presented as a masculine god (Mani) whose luminous whiteness guided sailors and travelers at night. During the twilight of the gods (Ragnarök), the moon is devoured by the wolf Hati, a formidable monster with black fur who destroys all things white.[12]

Of the earliest lunar religions we know nothing. It is not until the Neolithic period when life became settled that we find traces of rituals and computation practices that show how the first calendars were lunar and not solar. It is true that lunar cycles are easier to observe than solar cycles. Following the appearance of writing, there are mythological accounts and numerous legends that speak of the moon, which help us identify its extremely rich symbolism as well as its ties to the rhythms of time, the nocturnal world, primordial waters, fecundity and fertility, and especially the color white.[13] The moon is the white star par excellence, the one that allows us to see in the dark and that, like the color itself, is a source of life, knowledge, health, and peace. On the contrary, black, like night, is a source of fear, ignorance, evil, and death.[14] The ancients observed the moon in detail; not only did they measure its cycles and transformations, but they also calculated the intensity of its light, the saturation of its color, and the periodicity of its eclipses.[15] Some thought that the moon was inhabited and interpreted its spots as a sort

Diana the Huntress

Artemis (Diana for the Romans) is the twin sister of Apollo. Just as Apollo is the god of solar light, Artemis is, among other things, the goddess of lunar light. Thus she maintains close ties with two colors: white and yellow. In Greece, priestesses wore yellow at many of the places of worship devoted to her. In Rome, priestesses officiating in her temples wore white. A fiercely shy virgin, the goddess, like her brother, possesses many attributes, among them the silver bow and arrow seen here. Mural painting found in the Villa Ariane on the Varano hillside near Stabiae, 1st century BCE (?). Naples, Museo Archeologico Nazionale.

of bestiary.[16] Many strange beings encountered on earth were even thought to have fallen from the moon, like the monstrous Nemean lion slayed by Hercules as the first of his twelve labors. It was supposedly the son of the moon itself, and its invulnerable coat was said to be the same color: white. Unable to kill it with either his arrows or club, Hercules strangled it with his bare hands.

In Greece, the moon was represented by two goddesses: Selene on the one hand, who was the lunar star and worshipped from very early on;[17] Artemis on the other hand, whose functions and attributes, like those of her brother Apollo, were numerous, and in this case represented lunar light more than the celestial body itself. But over the course of decades and centuries, Artemis expanded her empire everywhere, and in the Hellenistic period the two goddesses tended to merge.[18] Afterward, lunar worship became less conspicuous and tended to make way for solar religions. In Rome, Diana and Luna, more or less comparable to Artemis and Selene, had far less prestige. On the other hand, the sun (Sol) enjoyed greater religious prominence than it had among the Greeks, especially during the Roman Empire when older Roman religions came under the influence of Eastern religions. That was the case with Mithraism, which worships the sun god Mithra and not the bull, an all too common misconception.

The Bible protests lunar religions (Deuteronomy 4:19 and 17:3; 2 Kings 23:5) and emphasizes how this celestial body is not a divinity at all, but God's creation and subject. The moon is only a means of illuminating the night and counting the days, seasons, and years (Genesis 1:14–16; Jeremiah 31:35; Psalms 136:9); its darkening is a sign of divine wrath (Ezekiel 32:7). Isaiah (Isaiah 3:18) rails against women who wear jewelry in the form of lunar crescents, while Job insists that unlike others, he has never blown kisses to the moon as a sign of worship.[19]

Later, Christianity waged war on solar and lunar religions, as these two celestial bodies were no longer divinities but only lights surrounding the cross on which Christ died. The moon especially incited mistrust and reprobation, probably because in less Christianized rural areas it was still the object of many enduring superstitions. Christian

Hercules and the Hydra of Lerna

Confronting and killing the hydra of the Lerna swamps, a many-headed monster that terrorized the region of Lake Lerna, was the second labor imposed on Hercules by Eurystheus, king of Argolid. The design on this lekythos (a small vase with a narrow neck containing perfumed oil for applying to the body) shows Hercules, aided by his nephew Iolaus, attacking the hydra's heads that, once cut off, grew back. Attic white-ground lekythos, c. 524 BCE. Malibu, J. Paul Getty Museum.

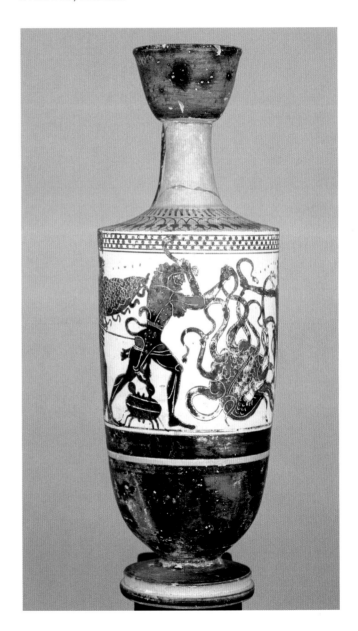

The Abduction of Europa

Europa was a Phoenician princess of great beauty. To approach without frightening her, Zeus took on the appearance of a calm and splendid white bull. The imprudent girl drew near to the animal and climbed on his back. Zeus immediately escaped with her to Crete where he seduced her. Three sons were born of their union, among them Minos, future king of Crete. Chalice krater decorated by the painter Asteas (detail), c. 350–320 BCE. Paestum, Italy, Museo Archeologico Nazionale.

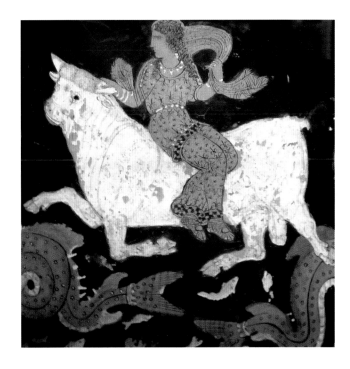

symbolism often presented it in a bad light and claimed it had harmful influences on men and women, making them fickle, agitated, and "lunatic," if not completely insane, as changeable and capricious as the celestial body itself. But far from destroying superstitions, the negative attention of Christian authors created new ones. Until well into the nineteenth century, superstitions in rural Europe warned against looking at the moon for too long, pointing one's finger at it, and sleeping in moonlight in a white chemise. Monday—the day bearing its name—was considered to be more or less unlucky.[20]

Let us return to the ancients. Early on, white became for them the color of the gods and religions; that was the case in Egypt, Anatolia, Mesopotamia, and Persia, among most biblical peoples, and even among the Celts where druids gathered mistletoe and dressed in white. Was this a distant chromatic inheritance from the first lunar religions? Or much more simply the idea that white, like the lily, linen, and milk, was the symbol of purity? It is impossible to know. But we can note that in Greece as in the Near and Middle East, all celestial divinities, in the image of Zeus himself, wore white clothing, while the powerful subterranean gods (Hades, Hephaestus) are most often dressed in dark colors.[21] Their attributes and substitutes were often the same color. When Zeus abducted Europa on a Phoenician beach, he transformed himself into a splendid white bull with a gentle, calm manner in order not to frighten the young girl. Similarly, to seduce Leda, the wife of Tyndareus, king of Sparta, Zeus took the form of a swan "with feathers whiter than snow" (Ovid). Thus the young queen conceived Helen and Pollux.

Like Zeus and most of the Olympian gods, the priests and priestesses who served in their temples were dressed in white, as were the singers of sacred hymns, the servants in charge of libations and sacrifices, the initiates, and even the simple followers. Statues themselves were sometimes draped in this color. The gods and goddesses were offered immaculate linen cloth, white flowers, and animals with white coats. When those coats were not impeccably white, they were rubbed with chalk if necessary before the animals were sacrificed. It was only in the Hellenistic period and only in certain temples that, under the influence of rites coming from Asia and Egypt, yellow sometimes replaced white for worshipping Artemis and black for worshipping Isis. But such practices were limited. Most often priestesses and priests were dressed entirely in white, as later were the vestals of Rome, young virgin women devoted to the worship of Vesta, goddess of the hearth.

In poetry, especially, the goddesses are described as having very white faces and arms, two criteria for beauty that we find again in the paintings that have survived. They also applied to women of high society; their facial complexion and arms had to be as white as possible in order to distinguish them from the peasants who lived and worked outdoors and had more or less reddish skin. If necessary, a layer of makeup with a plaster or ceruse base could hide natural imperfections or ill effects of the sun. White, smooth, uniform—these traits were worthy of admiration and contrasted with everything dark, rough, reddish, or bright and colorful.

In many of his dialogues, Plato explains why white is the purest, most beautiful color and thus the one best suited to the worship of the gods. He shows himself to be the enemy of dyeing, luxury, makeup, and all colorful artifice that alters nature and constitutes indecent or immoral practice. In this way he seems to establish synonymy between "white" and "undyed."

> Beauty is simple, pure, unmixed, far removed from the perversions of color and all human vanities. . . . Seeking to beautify oneself through clothing is an evil, hypocritical, base, servile thing; grooming deceives not only through forms but also through fabrics, colors, cosmetics, and artifices of all kinds.[22]

White is the color most proper for the gods, in particular for woven cloth offered to them and worn by priests attached to their temples. . . . Dyed cloth is not to be used except for military adornment.[23]

Incidentally, painters were considered no better than dyers; according to Plato, they exploited the weakness of human perception by creating colorful illusions that abused the eye and disturbed the mind. For Plato, color was always deceptive because it concealed what it covered and made appear something other than the reality and simplicity of being and things. It was a perverse counterfeit that had to be rejected.[24]

Leda and the Swan

The myth of Zeus taking on the appearance of a great white swan in order to seduce and mate with Leda, wife of the Spartan king Tyndareus, has tempted many artists. The scene is usually treated in a sensual, even erotic manner. Gustave Moreau, however, made it into a symbolist allegory, evoking the Annunciation or the coronation of the Virgin: the swan replaces the dove, and Leda, despite her nudity, appears virginal or Marian. Gustave Moreau, *Leda*, 1865–75. Paris, Musée Gustave Moreau.

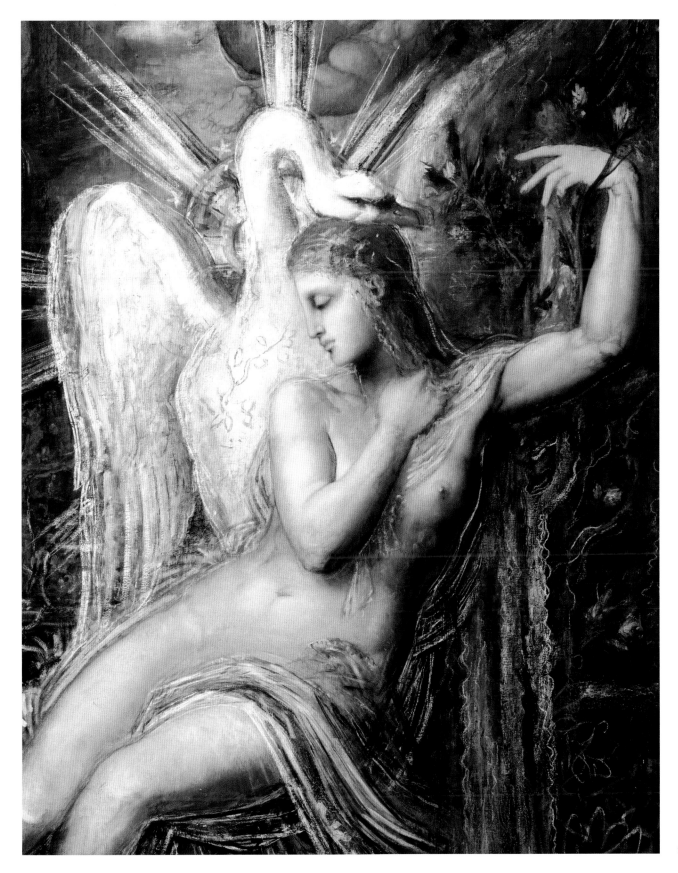

A False Image: White Greece

arly on, such ideas were readopted, commented on, and emphasized by historians and archeologists of classical antiquity. They believed, or pretended to believe, that Plato's position represented the general opinion. In doing so, they helped to create a myth beginning in the eighteenth century, the myth of a "white Greece"—I am borrowing that expression from the title of a fine book by Philippe Jockey[25]—a myth that has, until recently, misled certain specialists and the general public. No, ancient Greece was not white, or monochrome, but covered in bright and contrasting colors. Whether in the archaic periods, the time of Pericles, or the Hellenistic age, the Greeks loved colors and covered their walls, columns, temples, and statues with them. The image of a white Greece is a false image, as is that of an austere, colorless Rome.

Archaeological excavations and research conducted in recent years, which relies on increasingly sophisticated technological means, confirms what a few young archaeologists had already proposed in the early nineteenth century: the architecture of the temples, sculpted friezes, and all statuary had been painted and/or gilded. Having made the voyage to Greece, they discovered numerous traces of polychromy everywhere and accordingly sent reports to renowned scholars who had remained at their institutions in Paris, London, Berlin, and elsewhere. But those scholars did not believe them because their findings, although recorded in situ, did not correspond to the image they held of ancient Greece.[26] Specialists thus continued to promote the image of a white, sober, immaculate Greek, impervious to the barbaric tastes and brightly colored patterns of Eastern fashions. It was this false image that lasted for decades and that we still see today on postcards, tourist brochures, and even in museums. The ruins are white, the Parthenon—emblematic monument if there ever was one—is white, the statues have been cleaned, and the marbles have all lost their colors: a spotless white,

Ancient Ruins

During his first visits to Rome, Charles Percier (1764–1838), the future official architect for Napoleon I, made many watercolor drawings representing the ruins of palaces, villas, and monuments, not only in the city itself but also and especially in the surrounding countryside. Many were of ancient ruins. Color made them less austere than pure line drawings and allowed Percier to suggest various effects of volume. Charles Percier, *View of a Roman House*, watercolor drawing, 1797. Paris, Musée du Louvre, Cabinet des dessins, Inv. XII, B 928.

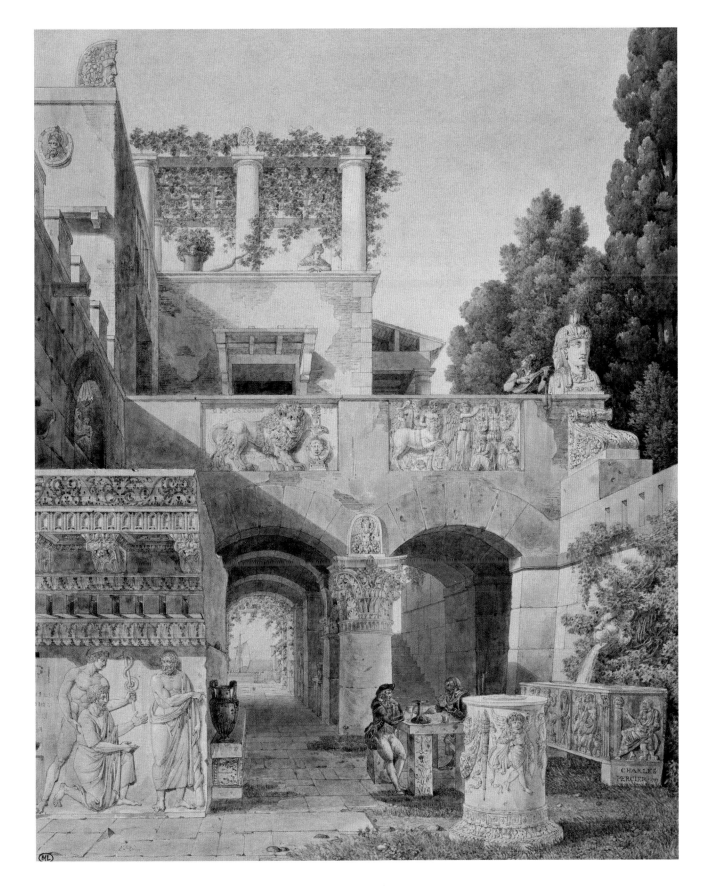

The Erechtheion Caryatids

The Erechtheion is a temple in Athens built toward the end of the fifth century on the Acropolis, north of the Parthenon. It includes many sanctuaries, one of which is dedicated to Erechtheus, legendary Athenian king. On the southern side is found the famous Caryatid porch, displaying six statues of young women serving as columns. Today, all six are modern replicas lacking polychrome. Five of the original statues are found at the Acropolis Museum, the sixth at the British Museum. Athens, Erechtheion temple, Caryatid porch.

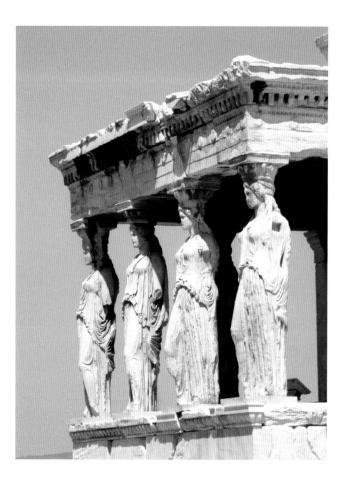

they are resplendent in the light of a Greek summer that seems eternal. This same false image has survived as well in the theater, cinema, literature, and graphic novels. Having come so far and been glorified for so long, it seems indelible.

The reality now brought to light by the work of historians and archaeologists is something altogether different.[27] Not only have they shown us that temples and public buildings were all painted, the architecture as well as the sculpture, but moreover we know that painters in general were better paid than sculptors and sometimes even architects. On reliefs, friezes, pediments, and statues, they provided the finishing touches and brought to life the gods, heroes, and all figures represented there. Similarly, on architectural elements, the colors they carefully applied helped to highlight the axes and planes, to create the effects of rhythm and movement, and compartmentalize the whole through the play of color combinations and contrasts, echo and chiasmus. To the color was added gold, especially on statues of the divinities. The most lavish of these were made of solid gold or else gold and ivory (chryselephantine), sometimes silver. Others were gold leaf or, more modestly, gilded bronze. The world of the gods was a universe of brilliant, shining, sumptuous light. Nothing was too beautiful for their temples, and enormous sums of money were constantly spent on maintaining the paintings and repair of the colors and precious metals. These sums constituted an offering, sometimes a tax, and were managed by specialized magistrates in charge of the sacred.[28] White stone left unpainted, faded, or dirty was a sign of incompletion, negligence, disorder, even ugliness. On the other hand, polychromy was not only considered admirable but also represented the norm, order, a well-governed city. It was the opposite of incomplete or unfinished white at one extreme and the gaudy mix of colors and other excesses of barbaric neighbors at the other extreme, those of the Persians, Medes, Thracians, and Galatians (Celtic people of Asia Minor), not to mention more distant populations living in exotic Asia and wearing strange, discordant colors. For the Greek sensibility, polychromy and a mix of bright colors were two

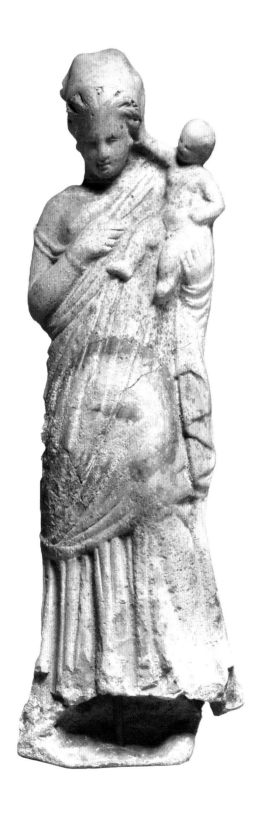

very different things. The first was regulated, harmonious, and musical. The second was irregular, tumultuous, and unpleasant to eye and mind.[29]

Similarly, for the Greeks, there was white and then there was white, and Plato was not entirely wrong to prefer fabrics in the natural shade of linen over the artifices of various dyes. There were, in fact, two whites: one, pure, uniform, luminous (*leukos*); the other, dull, dirty, grayish (*polios*, *péras*, *tholeros*). The first was good and worthy; the second evoked dirt, disease, or death. Nevertheless, that mattered only for fabric and clothing, not for the stone of walls, pediments, columns, and statues. Good taste and good order required them to be gilded or painted in many vibrant colors.

The spectacular recent discoveries made in Macedonia and Thessaloniki (sanctuaries, temples, palaces) are a definitive challenge to the idea of a Greek palette limited to a few colors. Bedrooms, beds, stelae, thrones, royal furniture, as well as walls and facades decorated with long historiated friezes: they were all painted, the stone as well as the marble or metal. In the last two or three decades, such discoveries have profoundly changed our understanding of Greek painting.[30] They have taught us that not only was the palette not limited to four colors (white, red, black, yellow) as Pliny and all the historians following him claimed, but that it extended to as many as eleven different hues, which were themselves broken down into shade after shade after shade, thanks to the mixing

Polychrome Terra-Cotta Statuette
Excavations have unearthed a great number of terra-cotta statuettes from the Hellenistic period that represent female figures. Some are religious, others memorial or funerary, and still others simply playful or decorative. All were painted, and most of them still bear polychrome traces. *Woman Holding a Child*, terra-cotta from Asia Minor (Myrina), 2nd century BCE. New York, Metropolitan Museum of Art.

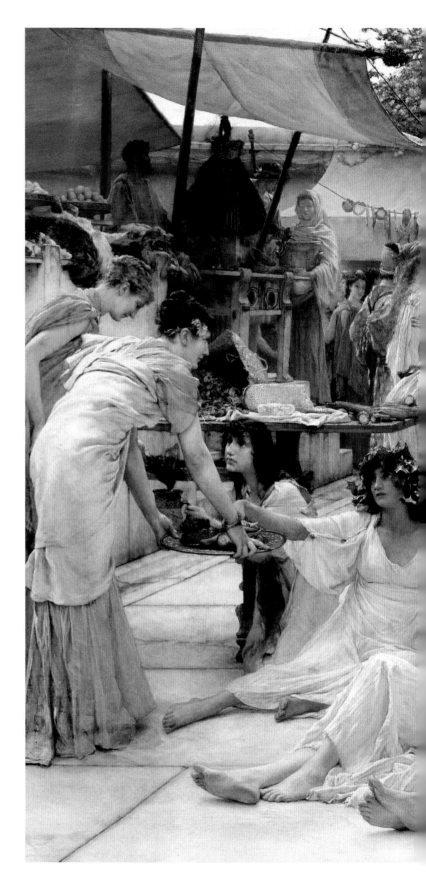

The Thyiades Awakening

The Thyiades (or Bacchantes among the Romans) were women comprising the usual retinue of Dionysus, god of wine, excess, and immoderation. They entered states of ecstasy and trance through dancing and shrieking. The painter captures them here as they awaken after a night of debauchery, in their white garments and lascivious postures. They contrast with the honest women arriving at their marketplace not far from Delphi. Sir Lawrence Alma-Tadema, *The Women of Amphissa*, 1887. Williamstown, Clark Art Institute.

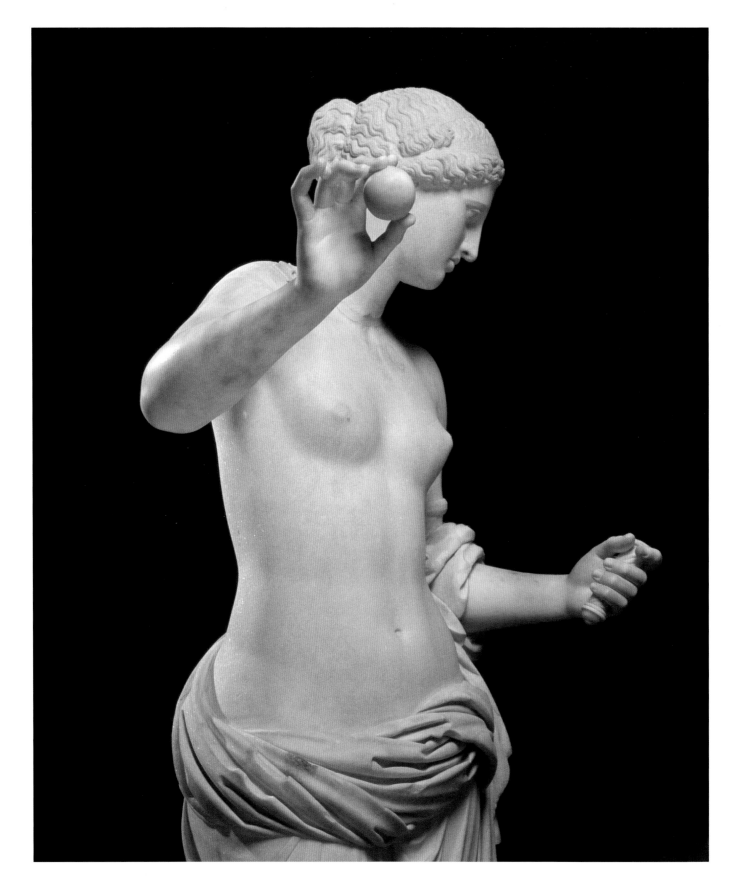

of pigments and the superimposition of multiple layers forming a kind of glaze. White was not at all dominant, only one color among many.

That said, the idea of a Greek white appeared very early and was first spread by the Romans whose taste for Greek arts and culture continually grew, beginning in the first century BCE. They liked Greek statues in particular and had numerous copies made, usually in white marble, but they neglected to have the polychromy of the originals reproduced.[31] Now it is these Roman copies that have come down to us and not the Greek sculptures themselves, whether in stone, bronze, or ivory. Beginning in the fifteenth century, the Roman copies were collected in Italy and then copied in turn. Throughout the modern period, both the earlier and later copies led to the belief that Greek sculpture had no color, the white marble having been polished and left bare. The works of famous sculptors like Polykleitos, Kresilas, Praxiteles, Scopas, and Lysippos are known only through these copies, and for a long time no one suspected that the originals could have been made in materials other than stone, nor that the sculptors who carved marble always worked with painters and left to them the final responsibility of adding colors to their work, absurdly admired by posterity for its supposed immaculate whiteness.

Let us cite for examples of these historic misinterpretations: Polykleitos's *Doryphoros*, which came from Pompeii; the *Discobolus Lancellotti*, a copy in marble of a bronze statue by Myron; and especially the *Aphrodite of Knidos* by Praxiteles, which Pliny considered to be the most beautiful sculpture in the world.[32] The very same Pliny reports that once when Praxiteles was asked which of his own sculptures he liked best, he answered, "the one upon which the painter Nicias has added the genius of his hand." A great sculptor like Praxiteles considered his contemporary, the Athenian painter Nicias, to be superior to him. In his view, the colors of the brush prevailed over the white of the stone.[33]

Nevertheless it was white that the Romans admired, and a famous legend seems to support them in this and validate the wonderful whiteness of Greek statuary: the legend of Pygmalion. The best known version is the one that Ovid presents in his *Metamorphosis*, one of the seminal texts of Western culture.[34] It has inspired many literary, artistic, musical, dramatic, and even cinematographic works. A sculptor of great talent, Pygmalion falls in love with a statue that his chisel has just carved from ivory "white as snow." It represents a young woman "of such great beauty that nature could produce nothing more beautiful." Smitten with his work, and as though bewitched, Pygmalion asks Aphrodite, the goddess of love, to bring his statue to life. His wish is granted. He then marries his strange beloved, who comes to be called Galatea. Two daughters are born of their union, Paphos and Matharme.

The Venus of Arles

Discovered in Arles in the mid-eighteenth century, this marble statue is a Roman copy of a Greek statue, now lost, attributed to Praxiteles. Restored and completed by François Girardon in 1684 (right arm, left forearm, base of neck), the statue has lost its colors and gilding and displays an immaculate whiteness unrelated to its original state: both the Greek statue and the Roman copy were painted. There were long-standing debates over whether the deity represented was Diana (Artemis) or Venus (Aphrodite). Since the eighteenth century, scholars have leaned toward Venus, but this identification remains tenuous. Likewise, only stylistic comparisons allow us to see Praxiteles's hand in the Greek original. Paris, Musée du Louvre, Département des Antiquités Grecques, Étrusques et Romaines.

Pygmalion and Galatea

In his *Metamorphosis*, Ovid tells how the sculptor
Pygmalion fell in love with the statue he had just
completed "in ivory white as snow." He then asked
Aphrodite, goddess of love, to bring his statue to life. His
wish was granted. The statue became a beautiful young
woman the artist married and who was given the name
Galatea. Jean Baptiste Regnault, *Pygmalion in Love with
His Statue*, c. 1785–86. Versailles, Château de Versailles.

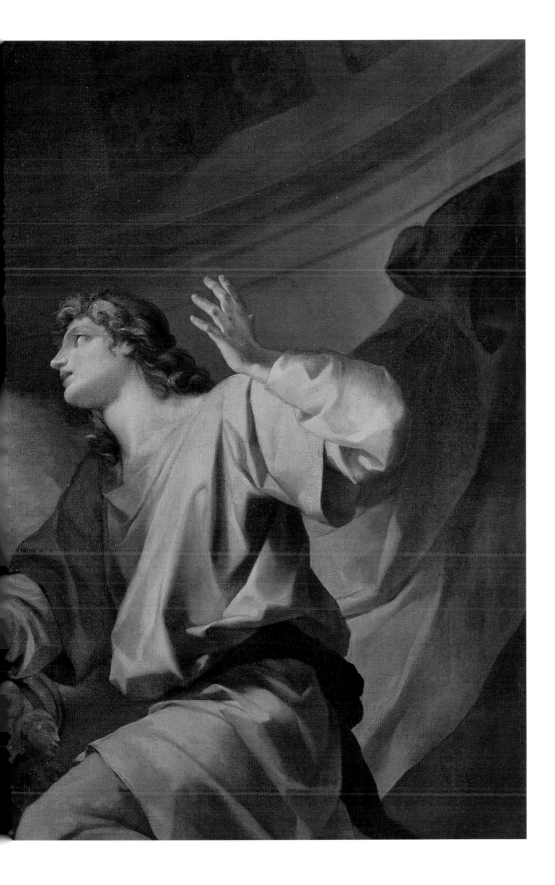

Wool and Linen: Dressing in White

et us leave painting and sculpture and turn now to dyeing. In this case, there is no need to look back to the very distant past. Human beings painted long before they began using dyes. Although it is difficult to date with precision the first dyeing practices, they did not appear prior to the time when humans became sedentary, and probably not before they began weaving. The oldest surviving pieces of dyed cloth date to the late fourth or early third millennium BCE, at least in the West; dyeing developed much earlier in China. The earliest colors all fall into the range of red tones. Yellows are more recent, while greens, purples, blacks, and browns are newer still. As for whites, they were either bleached or seem not to have existed before the first millennium. Dyeing in white was long a difficult exercise, and many populations preferred leaving textiles in their natural state rather than trying to dye them white, as white colorants would often not penetrate the fibers or not be resistant to the effects of water, sunlight, washing, or even simply the passing of time.[35]

As it happens, there were not many dyestuffs for producing the color white, and they never provided truly white whites, but only off-white, beige, ecru, gray, and yellowish tones. For wool, one often had to be content with shades naturally bleached in the fields by morning dew and sunlight. But that was a long, slow process that required much space and was hardly possible in winter. Moreover, the white thus obtained was not stable and turned dirty and drab over time. That was why it was rare in ancient societies to be dressed in pure, bright white, as is too often depicted in historic paintings, the cinema, and graphic novels. Here again, the image is false, all the more so because the use of certain plants for dyestuffs (saponins, for example), or washes with ash, clay, stone, or minerals (magnesium, chalk, ceruse) produced whites with bluish, greenish, or grayish highlights, thus diminishing their brightness. That was why wool and linen were often left undyed, with only their natural colors.[36]

Fuller's Workshop in Pompeii

There was a flourishing wool industry in Pompeii. Many workshops have been partially preserved. Veranio Ipseo's displays frescoes representing a few of the various processes that took place there. First, the fullers prepared the virgin wool so it could be spun and then woven. Once the cloth was produced, they beat it, cut it, and pressed it. They also seem to have been responsible for cleaning and mending clothes. *Fullonica* of Veranio Ipseo, mural painting, Pompeii, 1st century CE. Naples, Museo Archeologico Nazionale.

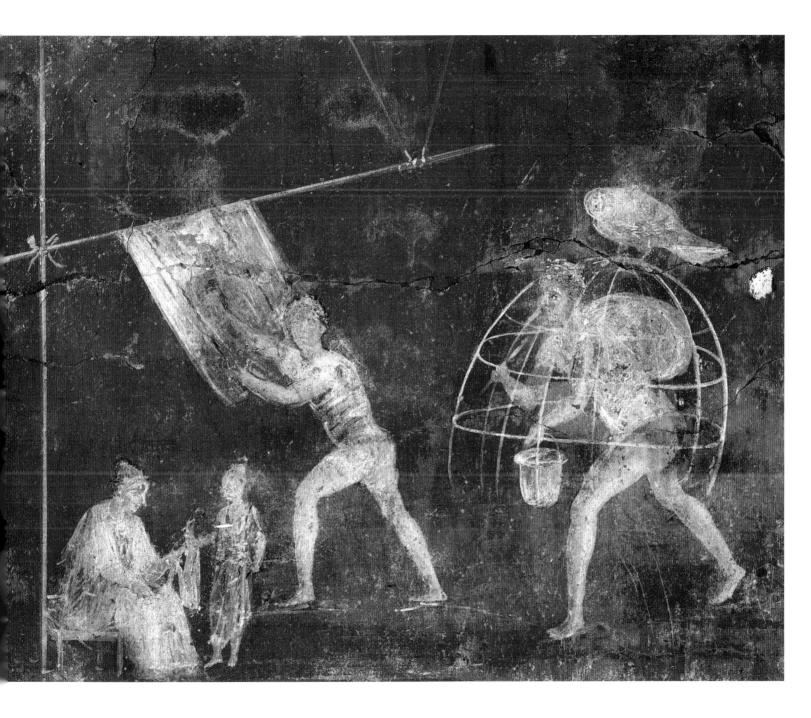

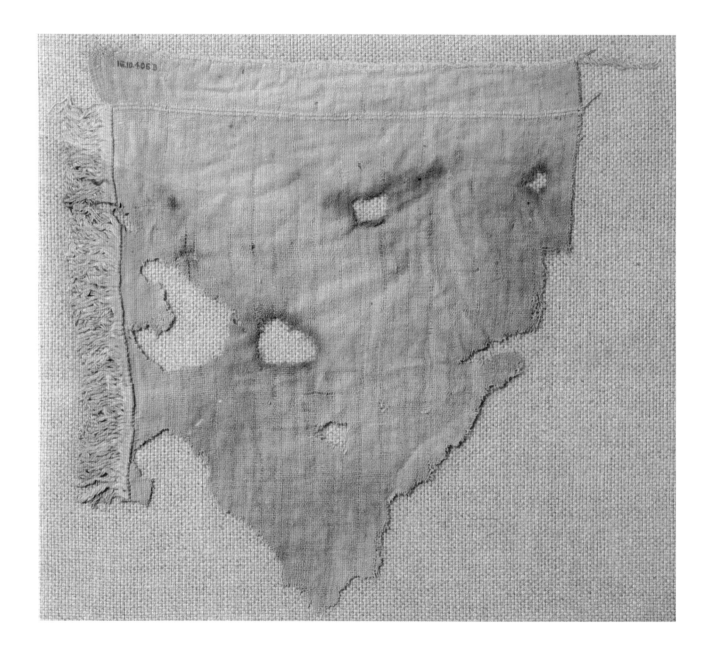

Fragment of Woven Linen

For a long time, dyeing in white was a delicate exercise. That was why textiles in antiquity were often left undyed, their natural shades playing the role of white. That was true of linen cloth, the oldest known textile. It was rarely dyed, sometimes whitened with chalk, and usually simply left to bleach in the morning dew. Egypt, c. 1600–1500 BCE. New York, Metropolitan Museum of Art.

Flax was one of the earliest plants to be cultivated, both for its textile fibers and its oleaginous seeds. In the Middle East, in the plains of the Euphrates, Tigris, and Jordan Rivers, it was already being cultivated in the first agricultural villages of the Neolithic period. From there, its cultivation expanded into Egypt and then Europe.[37] But it is possible that wild flax had been gathered and used even earlier, before populations settled, as bits of fibers discovered in the clay soils of a Georgian cave and dating back some thirty -five thousand years seem to prove.[38] At the beginning of first millennium CE, the weaving of linen was common in much of the Roman Empire, at least according to Pliny who notes how fine, supple, white fabric thus produced was admired and in great demand for women's veils and liturgical garments. Unfortunately, he does not tell us how their whiteness was obtained or how the flax was cultivated and processed. But he does specify that the price of linen was generally higher than that of wool.[39]

Many agronomists (Columella, Palladius) provide additional information. When mature, the flax was harvested and its stems placed in water or on a moist surface. The woody part of the plant was then removed and the fibers, extracted from their husk, were gathered together, combed, and finally spun. Once woven, linen provided strong, delicate, soft cloth that dried quickly. It was usually left as its natural color, going from off-white to brown or light gray, and including the whole range of beige and ecru tones. If they wanted to whiten it, the Romans soaked it in milk, or bleached it with the oxygenated water of the morning dew or oxalic acid from sorrel or algae and certain marine plants. To obtain very white whites remained difficult nevertheless. Like wool, linen was sometimes simply whitened with chalk mixed with water. Such a whitener hardly worked as a dye, and the procedure had to be repeated for each occasion that called for truly white garments (religious services, public ceremonies, holidays).[40]

Despite the prestige of Roman purple and its important role in dyeing, the Greeks and Romans were not great dyers. In this area, their expertise was essentially inherited from the Egyptians and Phoenicians, but it served them in the range of reds alone, the only truly reliable tones for cloth.[41]

For other colors—especially blues and greens—they proved even less skillful than the Celtic or Germanic peoples, who wore much more motley clothing, in many more hues that were often paired in striped or checked patterns.[42] In Greece, monochrome was the rule, at least for masculine clothing. However, we must note that the everyday clothing worn by free men has not been studied enough to be well understood. We know a bit more about women's clothing thanks to the moralists who continually railed against too garish colors, ever changing fashions, and lavish expenses for grooming. To makeup, jewelry, and other accessories, they preferred sober, monochrome attire: white, yellow, brown, and especially the natural shades of linen and wool.

In Rome, color was not regarded in such a negative way, although many authors, like Varro, "the most learned of the Romans," to quote Cicero, related the word *color* etymologically to the verb *celare*, which means "to hide," "to cover," or "to conceal."[43] Color was that which hid beings and things, and thus an artifice best avoided. Moreover, dyers belonged to a guild that was disdained (dyers were dirty, worked with their hands, and their workshops stank) and strictly supervised (dyers were violent, restive, and quarrelsome). Nevertheless they were essential to the social order. Through its styles, materials, and colors, clothing not only indicated one's gender, age, and status or social class, but it also revealed one's level of wealth, office, rank, and profession. Sometimes it indicated a holiday or formal occasion that called for wearing certain clothes rather than others. Its function was social before being practical or aesthetic.

As a general rule, Roman clothing is better known to us than Greek clothing, thanks especially to sculpture.[44] It was not cut or sewn, but folded, so as to drape and flow. It was not the styling but the figure that gave it form, the alterations varying according to social class, climate, era, and circumstance. For a long time, dress changed little, remained sober, and resisted novelty. But at the end of the republic, things changed; appearance began to play a larger role both in how one carried oneself and in what one wore. Subsequently, at the beginning of the empire, different fashions (Greek, Eastern, "barbarian") made

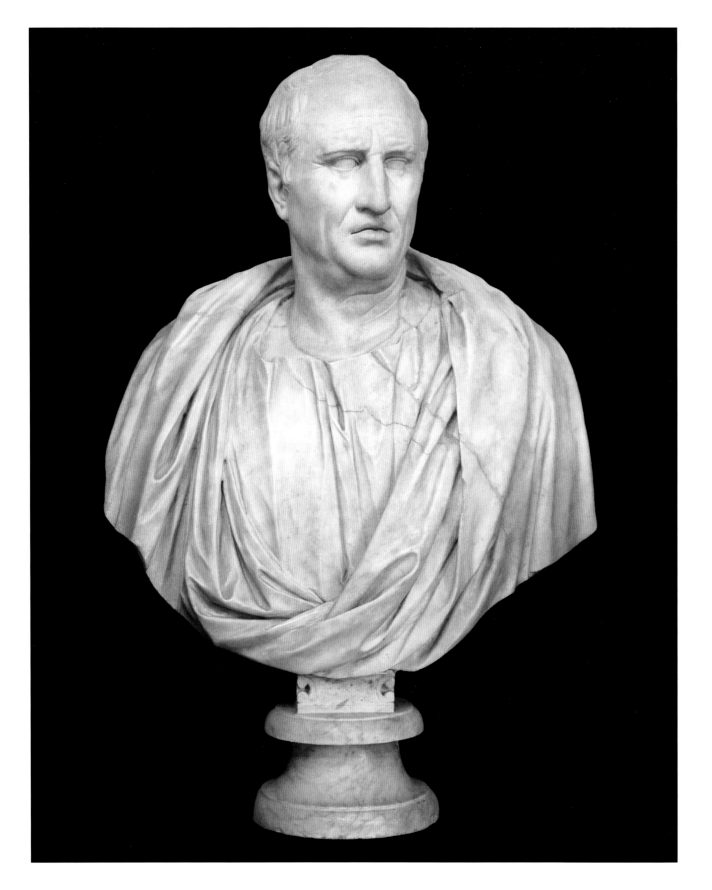

their debut, increasingly diverse and changing over the course of time, especially with regard to women's clothing. Nevertheless, whatever the period, cloth and clothing were precious goods that were kept in a chest (*arca*) or a wardrobe (*armarium*) and were sometimes passed down from generation to generation. Even the clothes of slaves (generally short, dark-colored tunics) were saved.

Because sculpture lost its polychromy and painting usually represented gods rather than mortals, we must rely on texts to learn what colors were worn in ancient Rome. Historical texts and narratives are more long-winded on the exceptional or scandalous cases than on the everyday, and poetic texts greatly embellish reality. Nevertheless we know that for men's clothing, the dominant colors were white, red, and brown; yellow was generally reserved for women while other shades were considered eccentric or "barbarian" (blue in particular). At least that was true until the end of the republic, because during the empire, Roman matrons introduced into their wardrobes an increasingly varied palette of colors.

Free men, that is to say Roman citizens, wore togas, and they had to be as white as possible.[45] They were made of wool, large, heavy, impractical, and easily soiled; circular in form, moreover, they were draped according to complicated patterns. They were not dyed but rather lightened and bleached with the help of potash or plants in the saponin family. Through successive washings and whitenings, the wool was damaged and, prior to any civic ceremony, it had to be thoroughly dusted with chalk to hide the imperfections. In fact, togas were generally worn only in public. At home or in the country, the patrician wore over his tunic (which was also white or ecru) a kind of large shawl or light cloak, or even a second tunic (*pallium*, *lacerna*). As part of private life, these clothes could be different colors, but the toga could only be white. Not until the third century did yellow, red, and brown togas appear, in addition to togas with two- or three-color patterns, and only then were such togas no longer considered gaudy and eccentric. As it happened, during the empire many Roman men tried to avoid wearing togas whenever possible, following the women in adopting lighter and more practical clothes. White was just one color among many.

Cicero (106–43 BCE)

In his discourses, Cicero hardly mentions colors. As with all Roman orators, the shades of rhetoric are enough for him and help to multiply the effects of his style. Nevertheless, we know from various sources that he took pride in his public attire and always appeared in an immaculate white toga. White marble bust, 1st century BCE. Florence, Uffizi Gallery.

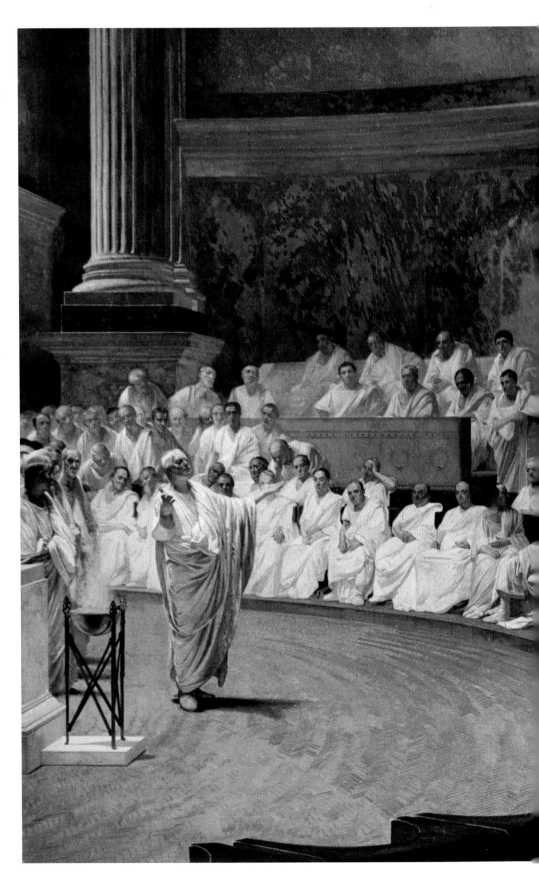

The Toga of the Senators

In Rome at the end of the republic, all Roman citizens wore togas. But there were togas and then there were togas. Those of the senators, heavy and cumbersome, were of thick, natural wool, artificially whitened. They required the help of slaves to be draped and adjusted correctly, the left arm covered, the right arm free, the folds carefully arranged in a prescribed fashion. Wearing them inhibited sweeping or sudden movements and imposed a slow, majestic gait. Cesare Maccari, *Cicero Denounces Catiline*, mural painting, 1882–88. Rome, Palazzo Madama.

The Lessons of the Lexicon

Ancient societies seem to have had a more developed and more nuanced awareness of the color white than contemporary societies do. There was not one white but rather many whites. The white of linen that priests wore was not the same as the white of wool from which the Roman toga was made. Likewise, the white of ivory was not the white of chalk, milk, or flour, much less snow. In most ancient languages, the vocabulary for white reflects these distinctions and strives to convey the various shades, those found in nature as well as those of textiles and crafts. Nonetheless the vocabulary often seems more related to the nature of the material or effects of light than to coloration strictly speaking. The emphasis is first on the brightness, luminosity, intensity, or density of the color, only afterward on its tonality. Moreover, the same term can sometimes be used to name many colors; that is the case with *canus* in Latin, which applies to hair or a beard and sometimes means gray, sometimes white, and sometimes simply old, wise, or respectable. Hence the difficult problems of translation and interpretation, especially in biblical Hebrew and classical Greek.[46]

The Latin lexicon for colors is a bit closer to our modern conceptions.[47] But through subtle use of prefixes and suffixes, it continues to give priority to the play of light (light/dark, matte/glossy), material (saturated/faded), and surface (plain/composite, smooth/rough, clean/dirty) over the shade itself. It distinguishes between two major kinds of white: on the one hand, a physical, neutral, objective white (*albus*); on the other, a symbolic, favorable, pure, brilliant white (*candidus*). Herein lies an essential characteristic of the color white in Latin: whereas red (*ruber*) and green (*viridis*) are expressed through a single basic term, and yellow and blue have no basic term and are conveyed through a great number of terms, white and black each enjoy two stable and widely used terms, for which the semantic field is sufficiently rich to cover a wide chromatic and symbolic palette.

Albus, of Indo-European origin, possesses a generic sense and was therefore more frequently used than *candidus*. It signifies natural white. That explains its use in toponymy (*Alba*: Albe; *Alpi*: the Alps), botany, zoology, and mineralogy as well as whenever the white in question is neutral, dull, or closer to off-white or gray (bones, horns, the coat of a donkey, for example). Its figurative meanings are rare, but sometimes the chromatic idea of whiteness gives way to the idea of paleness. *Candidus*, on the other hand, designates a beautiful, luminous, brilliant white,

White Highlights on Red-Figure Vases

On Greek vases, highlights in white paint could be applied before or after firing. They draw attention to certain figures, as here, to this kneeling woman, adorning herself between a fleeing satyr holding an animal hide and the god Eros extending a mirror. Chalice krater, Athens, c. 340–320 BCE. Paris, Musée du Louvre, Département des Antiquités Grecques, Étrusques et Romaines, Inv. CA 1262.

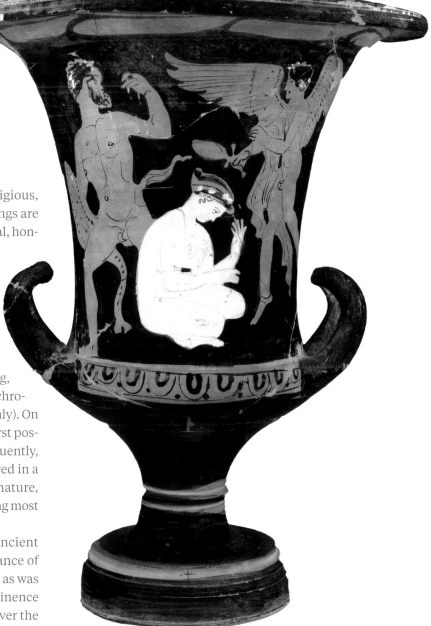

as well as all the whites highly valued on the religious, social, and symbolic planes. Its figurative meanings are numerous: pure, clean, beautiful, happy, beneficial, honest, sincere, innocent, and so on.

Latin also possesses two basic terms for naming black: *ater* and *niger*.[48] The first, perhaps of Etruscan origin, long remained the most frequently used term. Relatively neutral at first, it became progressively specialized as the matte or dull shade of black and then took on a negative connotation. It became the bad black: sad, disturbing, horrid, even "atrocious" (this adjective has lost its chromatic meaning, retaining the affective meaning only). On the other hand, *niger*, its etymology obscure, at first possessed only the meaning of "glossy black." Subsequently, it was used to characterize all the blacks considered in a positive light, especially the beautiful blacks in nature, before supplanting *ater* as the basic term for naming most of the black tones.[49]

A similar duality is found in the lexicon of ancient Germanic languages. It emphasizes the importance of white and black for the "barbarian" peoples, and, as was true for the Romans, seems to affirm their preeminence over all other colors, with the exception of red. Over the

Poppaea

Poppaea (c. 30–65) was the second wife of Nero. Roman historians treat her harshly, calling her ambitious, scheming, immoral, and cruel. On the other hand, they all emphasize her great beauty. Writing in the early third century, Cassius Dio, with much imagination, tells how Poppaea had five hundred postpartum donkeys milked each day so that she could bathe in their milk. Donkey milk was reputed to beautify the skin and slow its aging. Marble bust of a princess often identified as Poppaea because of its beauty, Rome, c. 55–60. Paris, Musée du Louvre.

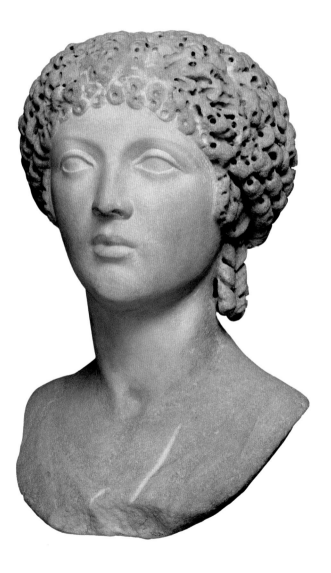

course of the centuries, however, the vocabulary was reduced and one of the two words disappeared. Today, German, English, Dutch, and all the languages in the Germanic family possess only one standard term for "white" and for "black" each: *weiss* and *schwarz* in German, *white* and *black* in English, for example. But that was not the case in Proto-Germanic, or later in Frankish, Saxon, Old English, or Middle High German. Until well into the Middle Ages, sometimes later, the Germanic languages used two standard terms to name white and black, as Latin did. Let us stay with the examples of German and English. Old High German distinguished *wiz* (matte white) from *blank* (glossy white); and *swarz* (dull black) from *blach* ("luminous" black). Likewise, Middle English opposed *wit* (matte white) to *blank* (glossy white), and *swart* (dull black) to *blaek* ("luminous" black).[50] Over the course of the centuries, the lexicon was reduced to a single word for each of the two colors: *weiss* and *schwarz* in German, *white* and *black* in English. This occurred slowly, according to different rhythms. Luther, for example, knew only a single common word for white (*weiss*), whereas a few decades later Shakespeare still used two words to name that color: *wit* and *blank*. In the eighteenth century, this last adjective, although an old term, was still being used in certain counties in the north and west of England, and it survives today in a few proverbs and archaic expressions.[51]

The lexicon of ancient Germanic languages teaches us not only that two terms existed for naming "white" and two terms for naming "black," but also that two of the four words used, *blank* and *blaek*, have a shared etymology, found in a verb belonging to Proto-Germanic: **blik-an* (to gleam, to shine). Thus these two words express in particular the luminous aspect of the color, whether it is white or black. They thereby confirm what other ancient languages (Hebrew, Greek, and even Latin) have taught us: to name a color, the light and materiality are more important than the tonality. The lexicon attempts first to say if a color is matte or glossy, light or dark, dense or diluted, and only afterward to determine if it belongs to the range of whites, blacks, reds, yellows, or other tones. That is a phenomenon of language and sensibility of considerable importance,

which the historian must constantly keep in mind when studying not only texts but also images and works of art left to us by antiquity. In the domain of colors, the rendering of brilliance and materiality take precedence over everything else.[52]

Let us return to Latin. The poetic texts employ words other than *albus* and *candidus* to name the color white. These are often terms derived from concrete realities, used in affective or metaphoric ways. For example, from the word *nix*, designating snow, comes the adjective *niveus* that poets use and abuse to describe any brilliant white whatever. It is synonymous with *candidus*, but in a superlative form: "gleaming white." Similarly, *lacteus*, literally "white as milk," is frequently used in poetry to describe a soft, silky white, the white of a goddess's arms, for example, or a mortal's breasts. In poetry, the white of the female body may also be compared to that of ivory (*eburneus*), so pleasant to the touch, or that of marble (*marmoreus*), firm, smooth, polished.[53] A Roman woman of good society was expected to have the whitest skin possible so as not to be taken for a peasant. Some of them, like Julia, the daughter of Augustus, or Poppaea, the second wife of Nero, devoted part of each day to bathing in donkey's milk, which was supposed to make skin "whiter than snow and softer than gosling down."[54] Many other women coated face, neck, throat, and arms with a thick layer of ceruse (white lead) to hide their skin's imperfections or redness. They knew it was highly toxic but were willing to risk their lives to be beautiful.[55]

In contrast to poetic works, encyclopedic, technical, and didactic texts were expected to be precise. Not only did they avoid imagery and comparatives, but with the help of numerous prefixes and suffixes, they sought to pinpoint exactly the shade of the color in question. Exemplary in this regard is Pliny's *Natural History*, which provides the historian with considerable lexicographic material—considerable and especially precise as Pliny often used color to distinguish, classify, and hierarchize the animals, plants, minerals, and everything else he discussed. When he was not satisfied with the existing chromatic vocabulary, Pliny sometimes created a new word in order to

be as exact as possible with regard to the color shade he wanted to describe for his reader. Hence, with regard to a rock less white than chalk but whiter than sand, we find the adjective *subalbulus*, a pure Plinian invention based on two diminutives: "slightly off-white."[56]

In reading Pliny, the encyclopedists, agronomists, and authors of specialized treatises (on medicine, botany, zoology, geology, cosmography, hippiatry, viticulture, architecture, painting, and so on), the historian will note the numerous occasions for naming white. Roman art and architecture were certainly not white, but white played a major role in everyday life nonetheless. To its usual referents that come down through the centuries—snow, chalk, milk, flour, lilies, ivory—we must add many minerals and related products (marble, gypsum, talc, ceruse, plaster, lime, seashells, tartar, and various salts), the coats and plumage of domestic and wild animals (sheep, goats, cattle, horses, dogs, wolves, swans, geese, roosters, hens), trees (poplars, birches), flowers, fruits, and various plants, not to mention fabrics and clothing as well as all the food products made or transformed by the offerings of agriculture. Beginning with bread: the whiter it was (*panis cadidissimus*), the more it was prized, costing more and reserved for the wealthiest classes.[57] That would be true throughout the Middle Ages and the ancien régime.

Egyptian Funerary Portraits

Found in tombs where they covered the faces of mummies of the deceased, Egyptian funerary portraits from the Roman period could be very stereotypical or more or less realistic and individualized, as is the case here. They were usually encaustic paintings on wooden boards, often sycamore, occasionally oak, cypress, or cedar. For women, special attention was given to makeup and jewelry, for men, to beard and hair. Two Fayum portraits, 2nd century CE. RMN-Grand Palais (Musée du Louvre)/Hervé Lewandowski.

White versus Black

For a long time, historians and philologists of antiquity emphasized the preeminence of the white-black-red triad over other colors in many areas of social life, religion, and symbolism. Georges Dumézil was the first to show how, in some societies of Indo-European origin, these three colors allowed for distinguishing three functions linked to human activities: white for religion, red for war, black for production.[58] Other researchers after him demonstrated how, for a long time, the dominance of this triad could be found in tales and legends, toponymy and anthroponymy, and literary texts and artistic creations. That was true in ancient Greece and Rome as well as in the Christian Middle Ages.[59] Ancient lexicons, however, as we have just seen with regard to Latin and Germanic languages, emphasize another chromatic system as well, no longer ternary but binary, based on the opposition of white and black. Not only do these two colors take on a larger role than others in the texts, but they also often form a pair of opposites. In truth, such a duality goes beyond the language and lexicon; it shows up in the social and religious life of a great number of cultures and probably dates very far back in the history of humanity. The simple alternation of day and night, light and darkness, probably sufficed for establishing the first opposition between these two colors.[60] Culture did the rest and transformed the two shades into archetypes of light and dark. Nowhere, in fact, does there exist a light black or a dark white, whereas reds, greens, grays, blues, and even yellows can all be more or less light or dark.

In classical antiquity, there are numerous accounts in which white appears as the opposite of black. Let us cite here two famous examples drawn from Greek mythology. The first involves the plumage of the crow and is linked to the story of the unfortunate Coronis. The second appears in the legend of Theseus, after his victory over the Minotaur.

An Ancient White Sail
During one of his journeys, Dionysus, god of wine, fell victim to pirates who wanted to sell him into slavery. The god made vines grow over their ship. Frightened, the pirates dived into the water and were transformed into dolphins. That is what this scene depicts, with its circular composition perfectly adapted to the form of the drinking cup. Attic black-figure kylix, c. 540–530 BCE. Munich, Staatliche Antiquensammlungen.

Coronis—whose name is related to that of the crow, *korone* in Greek—was a very beautiful Thessalian princess, beloved by Apollo and pregnant with his child. The jealous god had her watched by a white crow in whom he had complete confidence. But the crow relaxed its vigilance and Coronis, harboring no illusions about the god's fidelity, decided to marry a mortal, the seductive Ischys. The crow eventually discovered them and reported what it had witnessed to the god. Unfortunately for the crow: Apollo was furious and punished the informer by changing the color of its feathers from white to black. The bird would have done better to keep quiet because henceforth, according to the will of the god, all crows were given black plumage. As for Coronis and Ischys, they were led to the stake and put to death on Apollo's orders, but not before the god drew from the young woman's belly the child she was carrying: Asclepius (Aesculapius for the Romans), whose life was saved and who became Apollo's favorite son. Asclepius demonstrated a gift for healing at a very young age and later became the god of medicine.[61]

Let us leave the world of the gods and turn to the Minotaur, the most famous monster in Greek mythology. Half man, half bull, he was the fruit of the unnatural love of Pasiphaë, queen of Crete, for a powerful white bull. His story was related by many authors and gave rise to differing versions. Once again, let us follow the classic version as reported by Ovid in his *Metamorphosis*. Wishing to punish Minos, king of Crete, for his lack of respect, the god Poseidon inspired in Minos's wife Pasiphaë a mad passion for a bull. Victim of this irrefutable desire, the queen mated with the beast by

enclosing herself inside a wooden cow. After many months she gave birth to a monstrous being with a human body and the head of a bull: the Minotaur, a horrifying creature that fed on human flesh. To hide the shame brought on his family and to conceal the spectacle of such a creature from his subjects, Minos had the ingenious architect Daedalus construct a palace so elaborate that once one entered it was impossible to leave again: the Labyrinth. The Minotaur was shut away at the center of the palace surrounded by a maze of halls and tortuous corridors; henceforth, no one could see him.

During the war between Minos and Aegeus, king of Athens, Aegeus was defeated, and Minos exacted a particularly cruel tribute: every seven years, Athens had to deliver seven young men and seven young women who were to serve as the Minotaur's meals. The third time that Athens had to send a contingent of victims, Theseus, the son of Aegeus, asked to be among the sacrificed young men sailing for Crete. Emboldened by his previous exploits, he hoped to do away with the monster and thus free the Athenians from their subjugation. Upon leaving Athens and boarding a ship with sinister black sails, Theseus promised his father Aegeus that if he was successful, he would return on a ship displaying white sails as a sign of victory and rediscovered joy. In Crete, Theseus received unexpected help from Ariadne, the daughter of Minos and Pasiphaë, who had fallen in love with him. The young woman described the famous Labyrinth to the Greek hero and gave him a huge ball of thread to unwind beginning immediately on entry, thread that would allow him to find the exit again once the monster was defeated. In exchange for this complicity,

Theseus promised to take Ariadne with him to Greece and to marry her.

Everything went according to plan. Theseus unwound the thread, fought the somewhat languid Minotaur victoriously, and thanks to Ariadne's ruse, was able to find his way out of the Labyrinth. He reembarked on the ship that had brought him but, stopping on the island of Naxos, in the Cyclades, he betrayed Ariadne and left her there, never having had the least intention of taking her for his wife. Moved by the young girl's grief, the god Dionysus consoled her, married her, and took her with him to Olympus. During this time, Theseus sailed toward Athens, but, in all his delight and glory, he forgot to change the ship's sails. Thus the fateful black sails were the ones that Aegeus saw from the shore. Believing his son to be dead, mad with grief, he threw himself into the sea that has since borne his name. No one ever saw him again, and Theseus succeeded him to the Athenian throne.[62]

Mythological accounts and literary texts are not the only places we find white to be the opposite of black. Many examples of this opposition can be discovered in material culture and daily life. In the world of games, for example, especially those played on a board with two sides confronting each other, one side is white, the other is black. Ancient Rome did not play chess (which appeared in northern India in the sixth century CE) but they had many other games, with or without dice, in which pieces or tokens of two different colors were used: the game of gladiator (*ludus latronculi*), the game of twelve lines (*ludus duodecim scriptorum*), the game of seven stones (*ludus septum calculorum*), and so on.[63] Archaeology has uncovered everywhere a great number of such pieces, tokens, tesserae, pebbles, and bone or ivory discs that served not only as playing pieces but also for keeping score or as tokens or vouchers for attending assemblies, celebrations, banquets, or even for engaging in divinatory practices. They were also used for taking part in a vote. In the world of the magistracy and public life, when a decision was submitted for the approval of those present, a white piece or token (*tessera*) meant "yes," and a black one "no." The same was true in the courts: each juror had two pebbles (*caluli*), one white, the other black. If he found the accused to be guilty, the juror placed before him the black pebble; if innocent, the white pebble.[64]

Our modern expression, "to mark with a white stone" finds one of its earliest examples therein. For Western culture, white is a beneficial, favorable, peaceful, and blessed color.

OPPOSITE PAGE

From White to Black: Apollo's Crow

Apollo is the god most often represented in Greek art and the one possessing the greatest number of attributes. Chief among them are the bow, lyre, flute, laurel crown, and, among the animals, wolf and crow. The crow we see on this libations cup, found in a tomb at Delphi itself, has lost its white plumage and is already represented as a black bird, punished by the god for not keeping closer watch over the very beautiful Coronis. Attic white-ground kylix, c. 480–470 BCE. Delphi, Delphi Archeological Museum.

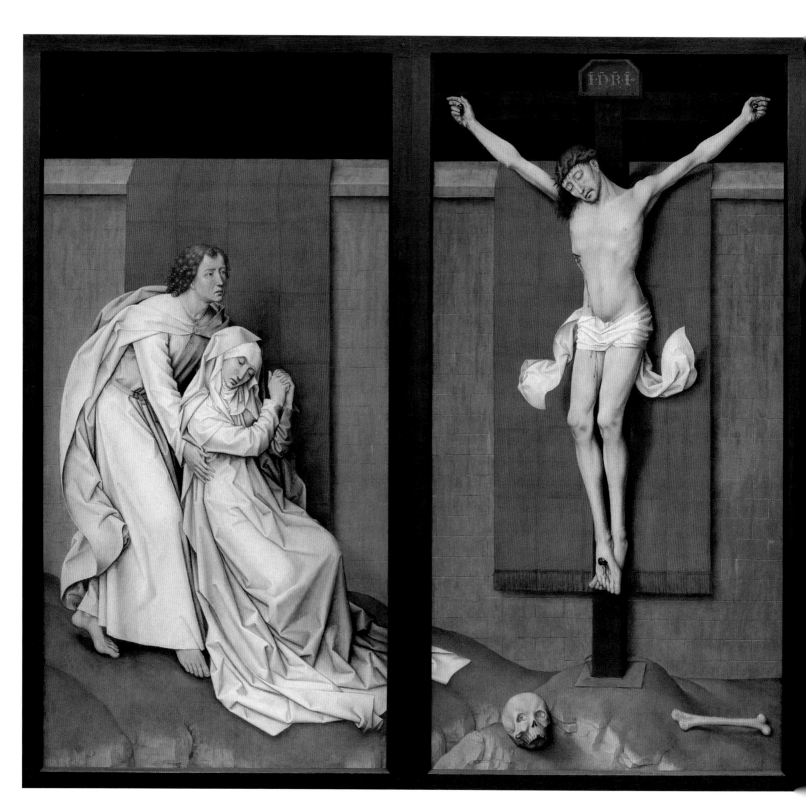

THE COLOR OF CHRIST

FOURTH TO FOURTEENTH CENTURIES

Crucifixion

Beginning in the eighth century, Jesus is not represented naked on the Cross, but dressed in a sort of loincloth, called a "perizoma" in Greek. The historical existence of such a garment is doubtful. Its presence seems due to the apocryphal Gospel of Nicodemus (fourth century) in which it is written: "Leaving the hall, Jesus was stripped of his clothes; he was girded in a linen cloth and on his head was placed a crown of thorns." Tradition has made this linen cloth white, although it takes various shapes and sizes. Here, Christ's white cloth echoes the robe worn by John, while the Virgin's robe is slightly blue, a Marian color. Rogier van der Weyden, *Crucifixion Diptych*, 1463–64. Side panels of an altarpiece of which the central panel is lost. Philadelphia, Philadelphia Museum of Art.

The opposition between white and black is a natural opposition, or at least finds its origin in a physical phenomenon: the alternation of day and night, light and darkness. Societies paired white and black as opposites as they developed their knowledge, techniques, and codes. On the other hand, the opposition between white and red owes nothing to nature; it is very much cultural and appeared relatively recently. Contrary to what one might think, the first manifestations of it are not in painting—no opposition of white and red appears on cave walls of the Paleolithic period, rocks, or pebbles—but in dyeing, that is, four or five thousand years before our era, when humans had become sedentary, had invented weaving, and had begun to use clothing for taxonomic purposes: to classify individuals within groups and those groups within the whole of society. In addition to the long-standing white/black pair, a white/red pair was thus established that gradually ceased to be limited to the world of textiles and expanded into other areas of material culture and then into intellectual life. In the first millennium BCE, the two systems of opposition coexisted. Sometimes they even merged to form the white-red-black triad discussed earlier.[65]

In ancient Greece and Rome, however, the white/black pair was called on more often than the white/red pair to contrast two groups, entities, or ideas. That is not entirely the case in the Bible, which sometimes gives preference to red as the principal contrast to white, notably with regard to fabric and clothing. But it was with Christianity that the opposition between white and red grew in scope, first among the Church Fathers and then especially among theologians and liturgists who wrote commentaries on them. Beginning in the Carolingian period, the Christian Church increasingly highlighted red and made it, like black—and sometimes more so than black—the color that opposed white.

That remained true until the fifteenth century, that is, until the appearance of the printed book and the circulation of engraved images. At which time—and for long after—ink and paper ushered Western culture into a world where black and white dominated. Before the Middle Ages there were few occasions for seeing those two colors combined. One encountered them in the plumage of some birds (magpies, for example), the coats of many quadrupeds (horses, cows, dogs), the habits of Dominican monks (white robes and black copes),[66] and various coats of arms and banners: very few occasions, in fact. On the other hand, the opportunities for combining or opposing white and red, beginning in the year 1000, were many and diverse, whether it was a matter of Christian rituals, secular activities, social codes, or artistic and literary creations.

Biblical White

The Bible is not a text in which color notations abound, far from it. There are whole books lacking a single color term (Deuteronomy, for example); others limit their use to the area of textiles; throughout, light (light, dark, bright, brilliant, dim) and material (gold, silver, ivory, ebony, precious stones, flax, murex, kermes) take precedence over color strictly speaking. Moreover, in biblical Hebrew, there is no generic term that designates color, while in Aramaic the word *tseva'* refers more to dye than to color. When color does come into play, it is never in an abstract way but to describe an element belonging to material culture or everyday life: fabric, clothing, the body, livestock, foods. Despite these limits, one lexical and chromatic observation becomes clear: most of the occurrences involve red and white. Black is rarer; yellow and green even rarer still; as for blue, it is totally absent from the biblical text. The word *tekelet*, which some modern Bibles translate incorrectly as blue, designates either purple or a dye with a murex base.[67]

Let us cite the linguist François Jacquesson who has done a thorough study of the oldest versions in Hebrew and Aramaic of the books of the Old Testament. Lengthy reading for a modest yield:

Colors are not common in biblical texts, and their appearance is very localized. Sometimes they describe livestock (in the same way as qualifiers like "spotted" or "striped"), sometimes diseased skin (here white dominates), sometimes the brilliance of fabrics used for sacred ceremonies (red and crimson tones dominate), more rarely royal pomp. In a few passages, they help to create symbolic systems still in their infancy.[68]

Regarding white (*laban*), many passages prove particularly instructive. That is true for the verses in Leviticus that discuss skin and leprosy. Beautiful skin, like beautiful cloth or the coat of an animal that is to be sacrificed, must be pure, without spots or imperfections. Dull, dirty, or soiled

The White Clothing of the Apostles
In Paleochristian art, the apostles are generally dressed in long tunics or robes with cloaks over them. They appear barefoot but bear various insignias or attributes. In mural paintings and mosaics, their clothes are white, symbolic of purity. Arian Baptistery ceiling mosaic showing the baptism of Christ surrounded by the apostles, late 5th century, Ravenna, Italy.

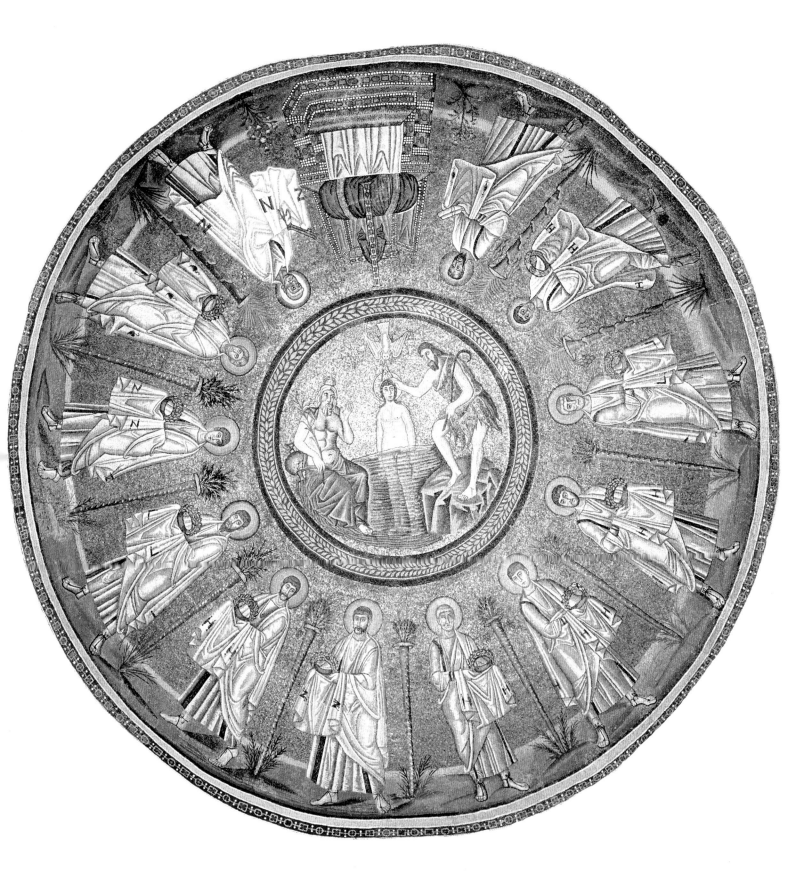

white is a sign of disease or sin. It must be rejected. When it is seen positively, which is most frequently the case, white is opposed to black, sometimes to colors in general (Proverbs, Numbers, the book of Wisdom). In contrast, in the book of Esther, rich in descriptions, white does not appear. It is much too sober and virtuous to describe the sumptuous, depraved court of the king of the Persians. That is left to gold and crimson, the vivid, showy colors of the East. But the book of Esther constitutes an exception. Generally, there are few color terms to be found in the Old Testament (the Talmud is much more colorful), and their exact shades are hard to identify. Often only comparative expressions allow us to determine the color in question: "the color of flax," "like the feathers of a crow," "similar to blood."

The Greek translation of the Septuagint, begun in Alexandria about 270 BCE, is hardly more colorful than the Hebrew Bible. With Latin, on the other hand, all that changed. The first Latin translators tended to introduce a certain number of chromatic adjectives where they had not previously appeared, either in the Hebrew or the Greek text. Saint Jerome himself, following their lead at the turn of the fourth to fifth centuries, added a few more when he revised the Latin text of the New Testament and then retranslated the Old Testament directly from the Hebrew and Greek. The fluid biblical text thus tends to become more colorful over the course of centuries and translations, especially in the modern period with vernacular languages accentuating this phenomenon. Adjectives that in Hebrew or Greek mean simply "pure," "clean," and "bright" are translated into Latin as *candidus*, and then into French as *blanc comme neige*, "white as snow." Similarly, what the Hebrew calls "a magnificent cloth," Latin translates as *pannus purpureus*, and modern French as *un tissue écarlate* or *une couverture cramoisie*, "a scarlet cloth" or "a crimson cloak."[69]

In Latin versions, the New Testament is richer than the Old Testament in color notations. White is the color most often named. Always esteemed, it is the color of purity, holiness, and dignity, and thus the color of God and the glorified Christ. Exemplary in this regard is the scene of the Transfiguration over the course of which, for a few moments, Jesus changes in corporal appearance and reveals his divine nature to three of his disciples (Mark 9:2–3):

> He took with him Peter, James, and John, and led them up a high mountain apart by themselves. There, he was transfigured before them: his face shone like the sun, and his clothes became white as the light, a whiteness such as did not exist on earth.

Santa Francesca Romana

Patron Saint of Rome, Saint Frances (1384–1440) was the founder of the Oblates of Mary, an association of women connected to the Benedictine monks of Mount Olivet (Olivetans). Like them, they wore white habits. According to legend, this habit, a symbol of purity and the renunciation of worldly life, was presented to Frances by the Virgin herself. Antonio del Massaro da Viterbo, *Santa Francesca Romana Clothed by the Virgin*, c. 1480. New York, Metropolitan Museum of Art.

Angels Dressed in White Linen

Created for Louis I, the duke of Anjou and brother of King Charles V, the immense tapestry of the Apocalypse (probably 6 m × 140 m in its original state) follows the biblical text quite faithfully. Here, the last panel of the fourth section shows the angels "dressed in robes of white linen" announcing the Last Judgment following the opening of the seventh seal (Revelation 15:1–4): above, they bear the final plagues manifesting God's wrath; below, accompanying themselves on harps, they sing the songs of Moses and the Lamb of God. *Apocalypse Tapestry*, c. 1373–82. Angers, Château d'Angers, Musée de la Tapisserie.

Likewise in the book of Revelation, where the color white, the color of victory and justice, occupies a dominant place, Christ rides a white horse and the celestial armies that follow him ride white horses as well (Revelation 19:11–16). This resplendent white is also the color of the angels who appear to Mary Magdalene after the Resurrection (Matthew 28:3), to the holy women (Mark 16:5), and to the apostles (Acts 1:10). It is the color of the lamb and the garments of the twenty-four elders mentioned in Revelation (Revelation 4:4). In the Old Testament, there are just a few passages where Yahweh appears dressed in white. Let us cite the book of Daniel in which the Almighty ("ancient of days") appears to the prophet: "His raiment was white as snow and the hair of his head like pure wool" (Daniel 7:9). On the other hand, there are more numerous verses that emphasize how men who have revolted against God can purify themselves with white and witness their gravest sins change color: "Though your sins are red like crimson, they will become white like wool" (Isaiah 1:18).

Throughout the Bible, snow, wool, and milk are the most frequently cited referents for presenting the color white. The first was especially admired because it is so rare in Palestine. It is the symbol of purity, brilliance, and beauty, and was thought to fertilize the earth. The purest wool is lamb's wool; it combines whiteness and softness and was used as an offering in the sanctuary. As for milk, it is the first food that human beings receive when they are born; it is also a symbol of softness and purity. Adding to this the idea of health and prosperity, goat's and sheep's milk constituted a basic food for biblical peoples.[70] When abundant, it was a sign of well-being, wealth, and a certain messianic happiness. For the Hebrews, the promised land was "the land of milk and honey."[71]

Crucifixion

In medieval illumination, white is never comparable to colorlessness. To convey colorlessness, painters left the parchment bare so that its shade played the role of degree zero for color. As for white, it was a color in its own right, frequently used to paint faces and parts of the body not covered by clothing. Huguccio Pisanus, *Liber derivationum*, c. 1270. Chantilly, Musée Condé, Bibliothèque, ms. 428, folio 126.

A Christian Color

The Church Fathers had more to say about colors than the Scriptures on which they were commenting. Beginning in the fourth century and until the late twelfth century, both they and the theologians who followed them gradually constructed an ambitious chromatic symbolism that exerted deep and lasting influence in many domains: religious life first (especially the liturgy), then social practices (clothing, coats of arms, games, ceremonies), and finally literature and iconography.[72] For the moment, let us stay with religion, because that is where major additions take place throughout most of the Middle Ages that involve our color white.

A census done beginning with patristic texts from before the mid-ninth century is particularly instructive in this regard. Compiling all the color terms present in the first 120 volumes of the *Patrologia Latina* (a collection of all the Christian authors writing prior to the thirteenth century, published between 1844 and 1855 by the priest Jacques-Paul Migne and his collaborators), François Jacquesson noted the following figures. The words signifying white represent 32 percent of the total; red 28 percent; black 14 percent; gold (and yellow) 10 percent; purple 6 percent; green 5 percent; blue less than 1 percent. Of course the texts

in question are essentially a matter of exegeses, theology, hagiography, or morality. But for this particular period, would more technical or encyclopedic treatises, or more narrative works, change these results? Not necessarily. Throughout, white and red dominate.

Thus, identifying the role and significance of these two colors for the Church Fathers is relatively easy. To white they attributed most of the virtues that the Romans already associated with this color (purity, beauty, goodness, power), suppressing what could be negative (disease, sloth, cowardice), adding what could be drawn from the Bible (essentially from the New Testament: glory, victory, jubilation, holiness), passing everything through the filter of Christian values, and constructing a solid

A Mass for the Dead

In the early fifteenth century, the Cistercians were not the only monks who wore white. The Carthusians and Olivetans did as well, not to mention many smaller, more recently established orders. But in this wonderful miniature, it is very much a matter of Cistercian choir monks assisting at a mass in honor of the great figures in their order, now deceased. *Psalter of King Henry VI of England*, Paris, c. 1405–10. London, The British Library, MS Coton, Domitien A. XVII., folio 150 verso.

Saint Bernard Writing

Founded in 1098, the order of Cîteaux soon adopted white robes to distinguish itself from the Benedictines with their black robes. Moreover, most of the new orders established in the eleventh century did the same. But this white remained theoretical. First, it included only the choir monks; second, it was not truly white but off-white or grayish. Dyeing in white was a difficult exercise in the Middle Ages and would remain so until the eighteenth century. Saint Bernard of Clairvaux, 1090–1153, French abbot and leading reformer of the Cistercian order. Miniature, twelfth century.

symbolism of white that their successors, especially the liturgists, would take up. Before the arrival of heraldry and the great chromatic changes of the twelfth and thirteenth centuries, it is very much the liturgical treatises and manuals—they were numerous between the ninth and thirteenth centuries—that historians look to for the most abundant and relevant information regarding the symbolism of colors. Here, for the first time, colors were considered as concepts, that is, as abstract entities whose materiality and shade did not matter. Liturgical colors were viewed independently from any fabrication or representation, as heraldic colors would be subsequently: they were symbols or emblems. It is worth lingering here for a moment.[73]

The matter of the appearance and expansion of the liturgical color system has not been given much attention by scholars, unfortunately. There are many liturgical histories, but they hardly mention colors.[74] Nevertheless let us continue to trace the course of their evolution through to the thirteenth century. In the earliest Christian times, priests wore no particular garb; to celebrate the mass, they wore their ordinary clothing. Subsequently, a specific vestiary made its appearance (amice, alb, stole, chasuble, maniple), but the fabrics and articles of clothing were not dyed, as color was considered impure. Nonetheless, undyed fabric gradually evolved to white, reserved for Easter and most important feast days, after which black appeared for the times of affliction and penitence. The patristic texts agree in making white the most dignified color and black the color of sin and death. Later, in the Carolingian period, when luxury made its entry into the churches, gold and certain bright colors began to find a place in liturgical cloths and vestments. But customs varied according to dioceses. After the year 1000 however, a certain unity began to take shape, at least for the high holidays: white was chosen for Christmas and Easter; black for Good Friday and days of mourning; red for Pentecost

and the feasts of the Cross. As for the rest, notably for the saints' days and ordinary times, local customs persisted and varied.[75]

Everything was clarified with Pope Innocent III (1198–1216)—the greatest pope of the Middle Ages—who succeeded in imposing the idea that the practices of the diocese of Rome had to be adopted by all of Roman Christendom. He described these practices himself in an early work, compiled about 1195, when he was still only Cardinal Lothar of Segni and far removed from the affairs of the Roman Curia. This work, *De sacro sancti altaris mysterio*, was a treatise on the mass in which, as was the practice at that time, the author did much quoting and compiling. Nonetheless, for us this text has the merits of discussing at length the symbolism of colors, at much greater length than earlier texts, and of commenting on their liturgical role in the Roman diocese at the end of the twelfth century.

Regarding white, red, and black, Cardinal Lothar broke little new ground compared to the liturgists who preceded him (Honorius, Rupert of Deutz, Jean Beleth), but he extended the list of holidays in question. White, the symbol of purity, joy, and glory, was used for all the holidays for Christ as well as the feasts of the angels, virgins, and confessors. Red, which evokes both the fire of the Holy Spirit and the blood spilled by and for Christ, was used for Pentecost as well as the feasts of the apostles and martyrs, and for those of the Cross. Black, associated with mourning and penitence, served for Good Friday as well as for funeral masses and throughout Advent and Lent. But it was with regard to green that our author proved himself to be most original. He made it the color of hope in eternal life—that was a new thing—and assigned it a place midway between the other three: "Green must be chosen for the holidays and days when neither white nor red nor black are suitable, because green is a middle color between white, red, and black."[76]

In this system, which would gradually be adopted by all the dioceses and that remains in place even today in Catholic worship, there is no role for yellow or blue. These are not liturgical colors. White, on the other hand, occupies a central place, especially since the feasts of the Virgin, which Cardinal Lothar does not discuss, were soon added to those of Christ and the angels. White is the most holy and most glorious color. It must be respected and not used thoughtlessly, even outside any liturgical context. A good example of this involves the quarrel between the monks of Cluny and Cîteaux in the first half of the twelfth century. Let us consider it briefly.

At the beginning of Western monasticism, a concern for simplicity and modesty ruled; monks adopted the same clothing as peasants, and they neither prepared nor dyed the wool. Gradually, however, clothing acquired greater and greater importance for the monks; it became the symbol of their condition. Thus the gap between monastic and secular dress grew as well as the tendency toward a certain uniformity to ensure and proclaim the unity of the *ordo monasticus*. Beginning in the ninth century, black, the color of humility and penitence, became the monastic color par excellence. But after the year 1000, movements with hermetic leanings began to react against increasing monastic luxury, especially noticeable within the Cluniac order. Through clothing, these movements sought a return to the original monastic poverty and simplicity. This translated into a quest for coarse fabric, left its natural color or simply bleached in the fields.

The Cistercian order grew out of the chromophobic trend at the turn of the eleventh to twelfth centuries. It was also a reaction against Clunian black and aimed at returning to the origins. It wanted to reestablish the essential principles of the Rule of Saint Benedict: to use only common, inexpensive cloth made from undyed wool, spun and woven by the monks themselves in the monastery. Undyed wool meant a color tending toward gray. In fact,

the first Cistercian monks were described as "gray monks" (*monachi grisei*) in many texts in the early twelfth century. But quickly, for reasons that remain unclear, they moved from gray to white, at least for the choir monks if not for the lay monks. This new white robe caused shock. White was not a monastic color. In 1124, Peter the Venerable, abbot of Cluny, was the first to publicly question Bernard, abbot of Clairvaux, in a famous letter addressed to him, reproaching him for the excessive pride that this choice of color represented. White was the color of holidays, the glory and resurrection of Christ, and holiness. What pride to want to dress in it! Black on the other hand, worn by all the Clunian monks, was the color of humility and temperance. Bernard responded violently to him, retorting that black was the color of the devil and hell, whereas white was the color of the purity and virtue required of monastic life. The controversy grew bitter, flared up repeatedly, and turned into a veritable dogmatic and chromatic confrontation between the black monks (Cluny) and the white monks (Cîteaux). Despite many attempts at appeasement, it lasted

until 1145. Thus it not only constituted an important time in medieval monastic history but also provided a very rich source regarding the symbolism of white and black at the heart of the Middle Ages.[77]

In fact, it is the theoretical aspect of the quarrel that proves most instructive for historians of color. In material reality, the monks of Cluny and of Cîteaux were not truly dressed in white or black but only in shades approaching them: ecru, gray, bluish, more or less dark brown. Dyeing in true white or black was a difficult exercise and would remain so until the eighteenth century. For monks, white and black were not colors actually worn but emblematic and symbolic colors, like those read about in texts or seen in images. The same was true, incidentally, in iconography. Many figures, for reasons of theology or exegesis, had to be dressed in white: angels, virgins, confessors, the elders in Revelation, the elect ascending to heaven at the Last Judgment. Here, however, there was no problem painting their clothing a very white white, whether in illuminations or murals.

The White Robes of the Olivetans

Despite their white robes, the monks of Our Lady of Mount Olivet are very much Benedictines. Their order was founded in 1313 in Asciano, near Siena, by Bernardo Tolomei. Because their first hermitage happened to be on a hill called Monte Oliveto, "the mount of olive trees," they were named Olivetans. That hermitage soon became a monastery and then the principal establishment for the new congregation recognized by Pope Clement VI in 1344. Il Sodoma, *Saint Benedict Lets a Spring Appear*, c. 1530–35. Mural painting in the cloister of Monte Oliveto Maggiore Abbey (south wall), Tuscany, Italy.

White versus Red

n the secular world during the feudal period, various codes and practices existed that combined or opposed white and red rather than white and black. Let us cite two examples: the game of chess and a famous tale, *Le Conte du Graal* by Chrétien de Troyes.

Originating in northern India in the early sixth century CE, the game of chess spread in two directions: toward Persia and toward China. It was in Persia that it definitively acquired the characteristics it still has today. In taking over Iran in the seventh century, the Arabs discovered the game, enjoyed it, and exported it to the West. It entered Europe in about the year 1000, both from the Mediterranean (Spain, Sicily) and from Scandinavia: Viking merchants trading in the North Sea introduced it early to northern Europe. But to spread throughout Christendom, the game had to undergo a certain number of transformations. The first concerned colors. In the original Indian game, and then in the Arabic-Muslim version, black pieces and red pieces opposed each other on the chessboard—as is still the case today in the East—two colors that have constituted a pair of opposites in Asia since very early times. But in Christian Europe, that opposition of black and red, so striking in India and Islamic lands, had almost no significance. It played no role in the symbolism of colors. Thus over the course of the eleventh century, the color of one of the sides was changed to provide an opposition conforming more to Western values. White pieces faced red pieces on the chessboard. In fact, for the secular world in the feudal period, the opposition of white and red represented a more powerful contrast than white and black. For over three centuries, white and red pieces thus confronted each other on European chessboards; the squares themselves were often painted in these two colors. Then another change took place beginning in the late fourteenth century; first for the chessboard and then for the pieces, the white/red opposition was slowly replaced by a white/

A Game of Chess

For a long time, the Western game of chess pitted a white side against a red side. At the end of the Middle Ages, the red side began to be replaced gradually by a black side. The scene represented in this splendid *cassone* panel (an Italian wedding chest meant to adorn a wedding chamber) corresponds to a period of transition: the chessboard squares are still white and red, but black pieces have already made their appearance. Painted *cassone* attributed to Liberale da Verona, c. 1470–75. New York, Metropolitan Museum of Art.

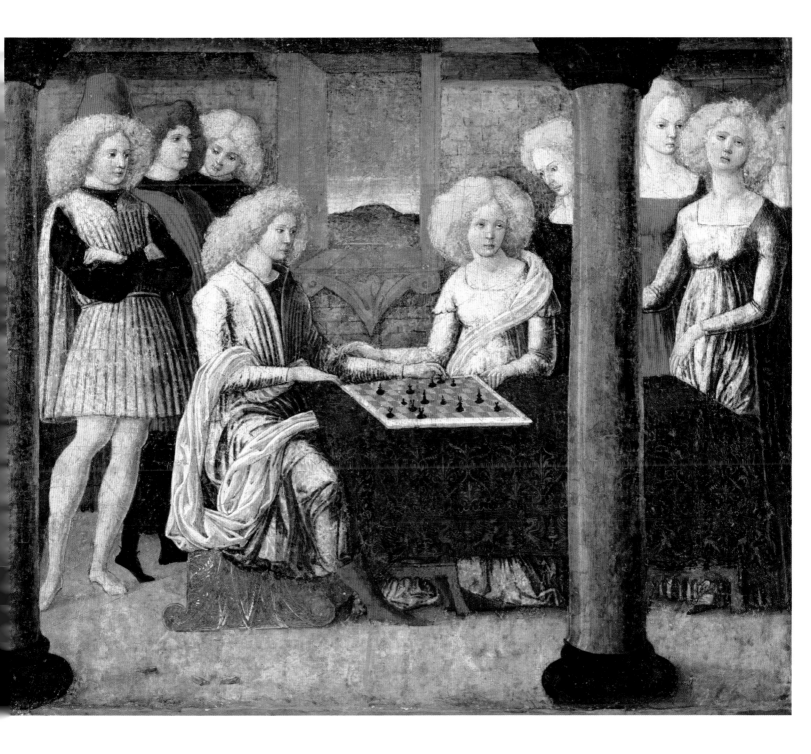

black opposition that was definitively established in the sixteenth century and has lasted in Europe to the present day. In that time, printing had appeared, which had definitively made black and white the strongest pair of opposites visible in all domains. The game of chess was no exception to this phenomenon of society and sensibility that still has considerable impact on us today.[78]

Just as emblematic of the pair formed by white and red in the feudal period is a chivalric romance, one of the most famous in medieval literature in the French language: *Le Conte du Graal* by Chrétien de Troyes. It was probably composed between 1181 and 1190 at the request of Philip of Alsace, count of Flanders. Philip of Alsace, who died in the Holy Land in 1191, frequented the court of Champagne because, for political reasons, he hoped to remarry the Countess Marie, widowed as he was. That was where he may have encountered Chrétien, for whom Marie, a friend of the arts and letters, served as patroness. The prologue of the romance explains to us that the author was supposedly inspired by a manuscript recounting the history of a strange object, the Grail. The manuscript was entrusted to him by the count of Flanders. Despite many hypotheses, this manuscript remains a mystery. Perhaps it is a matter of a simple literary hoax? In its present state,

the text includes about 9,070 lines, the number varying a bit according to the copy in question. The romance is unfinished, but it is difficult to say to what extent. The story stops abruptly, mid-sentence, at the moment when we have left Perceval to follow Gawain on the road to adventure. It may be that the author's work was interrupted by his death, but that is not certain.[79]

The text's incompleteness adds many difficulties to the interpretation of this strange work, one of the most studied in medieval literature and probably the one exerting the greatest influence on European arts and letters until recent times (let us think for example of Richard Wagner's opera *Parsifal*, 1882; or the film by Éric Rohmer, *Perceval le Gallois*, 1978). Chrétien de Troyes's text inspired especially four long "continuations" (about sixty thousand lines), compiled between roughly 1195 and 1225 and presenting different variants, omissions, and interpolations, depending on the manuscript. It was also adapted or translated into many vernacular languages early on. In French, beginning in the late twelfth century and the first half of the thirteenth century, it gave rise to rewritings, prose versions, and especially a whole body of literature constructed around the Grail, its origins, history, quest, and meanings.

The Grail is an enigmatic object that Chrétien de Troyes was the first author to mention. He presents it as a sort of marvelous vessel that provides miraculous sustenance, like the ancient cornucopias or the cauldrons of immortality in Celtic mythology. The first time that young Perceval sees it is at the castle of the Fisher King, a king wounded in the legs who cannot move by himself. A strange procession advances through the great hall where Perceval is seated at a table with his infirm host. Leading this procession is a young man dressed all in white and bearing a bleeding lance; a drop of gleaming red blood forms on its blade. Behind him follow two valets bearing candelabra, and following them, a young lady holding a *graal* decorated with rubies and dazzling with such light that the candelabra seem extinguished. At the end comes another young lady bearing a silver platter. The procession, which violently combines white and red, passes by the table again and again, each time replenishing it with abundant, delicious dishes.

Perceval should have asked about the significance of the procession, the bleeding lance, the *graal* itself, and for whom this precious vessel and its contents were meant, but he remains silent. The valiant knight Gornemant of Gorre, who has recently dubbed him, in fact taught

OPPOSITE PAGE

The White of Ivory

Carved from morse ivory, the chess pieces discovered on the west coast of the Isle of Lewis, in Scotland, number among the most famous objects left to us from the Middle Ages. Compared to elephant ivory, morse ivory is not quite as white, lighter in weight, and less uniform in texture. It is easier to work but not as solid. Chess pieces from Trondheim, Norway, c. 1150–80. Edinburgh, National Museum of Scotland.

ABOVE

White Side versus Red Side

Whether carved from bone or ivory, many medieval chess pieces still show traces of red paint. In fact, until at least the fourteenth century, it was most often white pieces and red pieces that confronted each other on the chessboard. Chess piece from the "Charlemagne" chess set, Salerno, Italy, late 11th century. Paris, Bibliothèque Nationale de France, Cabinet des médailles.

him that a young knight should not talk too much and that it was courteous and wise not to ask questions. Thus Perceval keeps quiet. Night falls, he goes to bed, and the next morning on waking, he finds the castle absolutely empty. Later, crossing through a forest, he encounters a young lady who turns out to be his cousin. She informs him that his mother has died of grief following his departure for King Arthur's court. She also reveals to him her name, which, until then, Perceval did not know (identity and kinship play essential roles in Arthurian romances). But above all, she reproaches him for remaining silent at the castle of the Grail. That was a grave error: by keeping quiet, the young man failed to put an end to the suffering of the Fisher King, the latest guardian of the Grail, and to the desolation of his lands that seem to forever share the infirmity of their king.

Chrétien says little more, and his silence, like that of Perceval, deprives the reader of an explanation, never offered throughout the rest of the romance. The story continues to follow Perceval's progress, but then abandons him to follow the amorous, tumultuous adventures of Gawain. The text breaks off suddenly at the moment when Gawain is preparing to confront a vain and brutal knight named Guiromelant.

At the Fisher King's castle, Perceval had a rendezvous with fate, but as he did not ask the questions he was supposed to ask, it failed. The lack of an explanation for the procession, its lights and colors, and the powers of the *graal* left Chrétien's successors and imitators with the possibility of advancing different hypotheses. The one that met with the most success and greatly contributed to Christianizing the legend was proposed at the very end of the twelfth century by Robert de Boron, an author about whom we know almost nothing. In his romance in verse, *L'Estoire dou Graal*, the mysterious vessel is identified as the Holy Chalice, that is, the cup with which Christ celebrated the Last Supper on the eve of his death. According to Robert de Boron, that was the same cup in which Joseph of Arimathea supposedly collected the blood of Christ the next day when he hung dying on the Cross. The bleeding lance supposedly belonged to the centurion Longinus who

The Grail and Its Procession

This miniature is a good example of the way in which colors participate in the construction and function of images. In the left part, the rhythmic succession of clothing colors (orange, mauve, blue, orange, mauve, blue) creates a dynamic effect that sets the procession in motion from left to right. In contrast, in the right part, the nonrhythmic colors (mauve, orange, blue, red) render static the figures seated at the table. Moreover, a kind of chiasmus exists between the two parts: to the left,

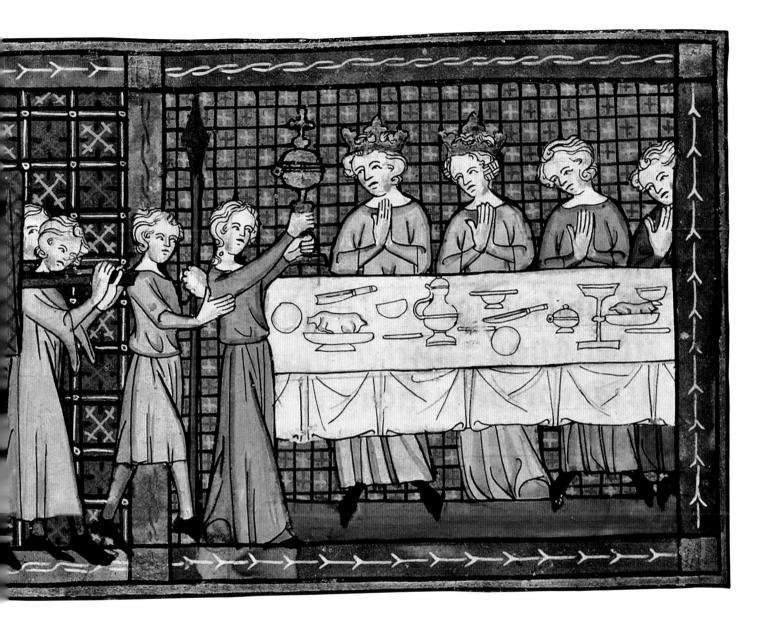

a dominant blue background and red border; to the right,
the opposite. But below the woman leading the procession,
a little bit of the left's red border becomes part of the right's
blue border, thus participating in the procession's movement
from left to right. Miniature from a manuscript of *Le Conte du
Graal* and its *Continuations*, Paris, c. 1330. Paris, Bibliothèque
Nationale de France, ms. français 12577, folio 74 verso.

had pierced Christ's right side. This hypothesis was immediately adopted by many authors, and the Christianization of the legend was completed a few years later with the *Queste del saint Graal*, an anonymous prose romance written about 1220, perhaps by a Cistercian monk, who dematerializes the Grail and likens it to divine grace opening the way to eternal life.

Le Conte du Graal spawned a vast bibliography.[80] Most of the exegetes agree in seeing in the tale a spiritual quest, that of Perceval, and a critique of chivalry becoming, in the image of Gawain, more worldly and violent, less virtuous. On the other hand, they are divided over what exactly the *graal* and its procession represent, and more generally over the role of themes and motifs inherited from Welsh tales and Celtic mythology. Was *Le Conte du Graal* already entirely Christianized or still very pagan? Did Chrétien de Troyes himself understand all the mysteries and stakes in his account? Criticism has multiplied the efforts to try to answer these questions. It has sometimes gone astray in anachronistic or sensationalist interpretations, wrongly calling on esotericism, Catharism, alchemy, or psychoanalysis. These are certainly not directions worth pursuing. It is better to begin with the text itself, observing how it is constructed, and considering what elements recur, are combined, opposed, or interwoven.

Let us take colors, for example. Two of them play essential roles: red and white. Two passages are particularly significant in this regard. The first involves only red, the second, red and white, which form a pair. At the beginning of the romance, Chrétien tells how the young and naive Perceval, simply dressed in a robe of rough, undyed wool, confronts and vanquishes a "vermilion knight," that is, a knight whose shield, banner, and horse's quarter sheet are red. Having defeated him, he takes his horse, armor, equipment, and arms, and outfitted thus he proceeds to King Arthur's court to be dubbed. Henceforth he in turn becomes a "vermilion knight." What is remarkable in this highly symbolic episode is the complete reversal of the usual codes of Arthurian literature. In most chivalric romances involving Arthur and his companions, the red knights are bad knights who rise up in the paths of he-roes to challenge them and do them harm. They are the opposite of white knights, always presented favorably, in the image of young Lancelot and later, Galahad his son. Sometimes the red knight is a figure from the otherworld who mingles with the living to sow disorder, spread evil, or avenge a wrong that was done to him. The color red of his weapons and equipment evokes the flames of hell and opposes the white of faith, justice, and glory. The red knight vanquished by Perceval belongs to this category. That Perceval—the hero of the romance—becomes a red knight in turn seems strange at first. But for a poet of genius like Chrétien de Troyes, this is a way of reversing the literary topos, transgressing a symbolic code, and giving his hero an extremely strong dimension, stronger than if he were dressed all in white.

The second passage, one of the most annotated in all medieval poetry, pairs and provides evidence for red and white as complementary colors. Sad and alone, Perceval is crossing a snowy plain and pauses to contemplate three drops of blood on the ground, shed by a goose whose neck had been pierced by a hawk. The sight of this red blood against the white of the snow reminds him of the bright face and vermilion cheeks of his beloved Blanchefleur, whom he left behind to seek adventure. That memory plunges him into a state of such deep melancholy that no companion of the Round Table can help him escape it. This melancholy seems to pervade Chrétien de Troyes's whole tale, and much of Arthurian literature and its readership after him.[81]

The White Stag, Christological Symbol
White stags occupy an important place in Celtic mythology; they are messengers from the otherworld. When Arthur and his knights (Perceval and Galahad here) hunt the White Stag, it is less a matter of venery than of a spiritual quest. Like the Grail, this animal can only be approached by knights who are pure of heart. Miniature from a manuscript of the *Queste del Sainct Graal*, northern France, 1315–16. London, The British Library, MS. Add. 10294, folio 45 verso.

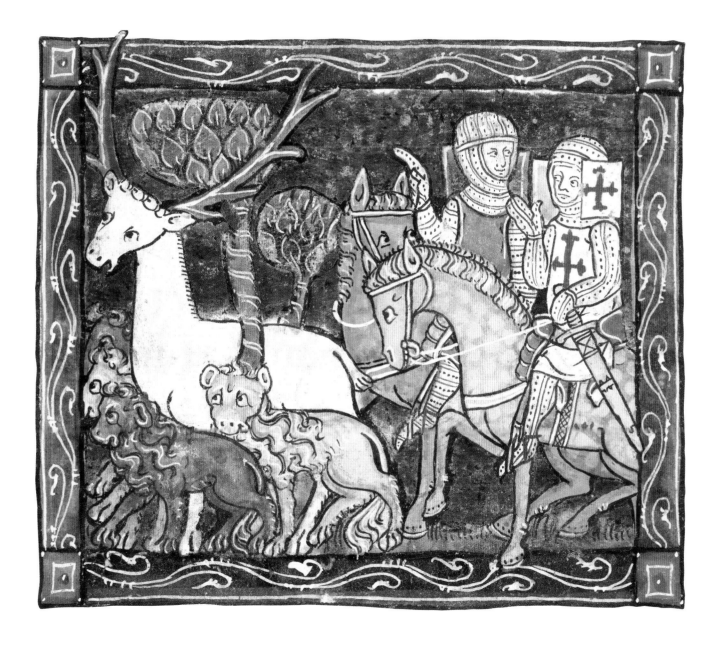

Regarding the Lily: A White Floriary

For the authors of the Middle Ages, the color white had three referents: snow, milk, and lily. These are the same as in the Bible, minus the biblical wool. The lily is the white flower par excellence, the one opposed to or associated with the rose, the archetypal red flower, even though roses and lilies of different colors exist in nature. It was already the case in Roman antiquity that these two flowers dominated over all others. Moreover, in the twenty-first chapter of Pliny's *Natural History*, he begins his discussion of flowers with them.[82] Among the ancients, admiration for the lily dates back very far. In various forms—true flower, simple floret, stylized plant motif—it can be seen represented on Mesopotamian cylinder seals, Egyptian bas-reliefs, Mycenaean pottery, Gallic coins, and Eastern fabrics. Not only does it play a decorative role, but it also often adds a strong symbolic dimension. Sometimes it is a matter of a nurturing fertility figure, sometimes a sign of purity or virginity, sometimes an attribute of power and sovereignty. These three symbolic meanings seem to merge in the medieval lily, simultaneously fertile, virginal, and sovereign.

It is in the form of a floret (and not a true fleur-de-lis) that it became a monarchic attribute, first in Byzantium, then in the West. It is found on scepters, crowns, and mantles, all of which constitute insignias of power. Charles the Bald, king of the Franks (843–877) and then Western Emperor (875–877), used it widely throughout his reign. His entourage had read the Church Fathers who regarded the lily as a royal plant. His tutor Walafrid Strabo (808–849), author of the strange *Hortulus*, a sort of treatise on symbolic botany, even characterized the immaculate white lily as "queen of all the flowers."[83]

At the same time, even while retaining its value as a royal attribute, the lily was endowed with a religious, primarily Christological significance. The origin for this is found in a verse from the Song of Solomon, repeated and annotated many times by the Church Fathers and

The Angel and the Lily of the Annunciation
The Annunciation is the most important Christian holiday after Easter. It inspired many artists. Botticelli left us seven different versions of it, but all include the same elements: the angel, the lily, divine rays of light, the dove, Mary, the book, the chamber, the garden. As with all Italian Renaissance artists, painting the Annunciation scene allowed Botticelli to demonstrate his skill in rendering perspective, light, and the miracle of the Incarnation. Sandro Botticelli, *The Annunciation* (detail), 1489–90. New York, Metropolitan Museum of Art, Inv. 1975. 1. 74.

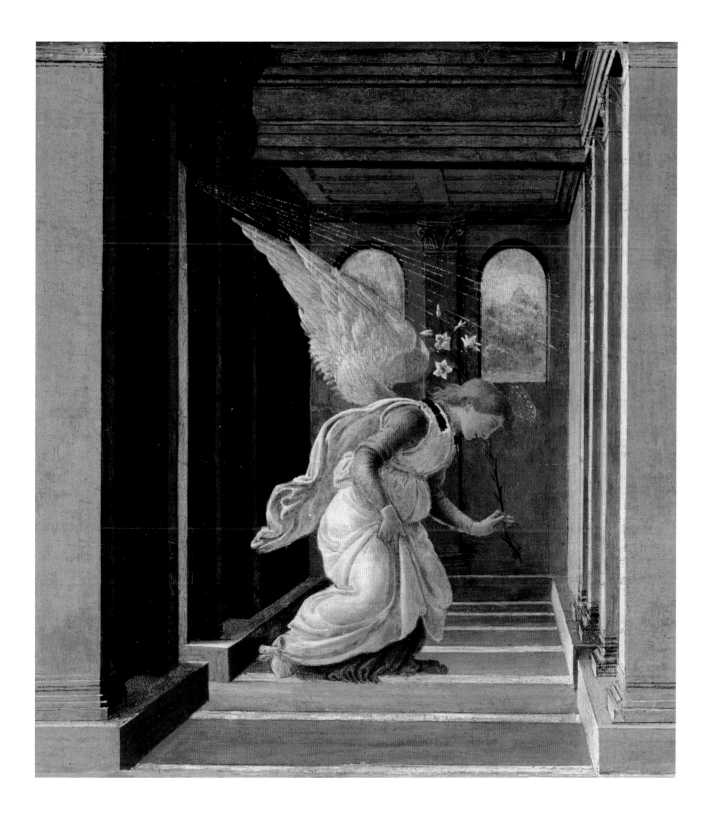

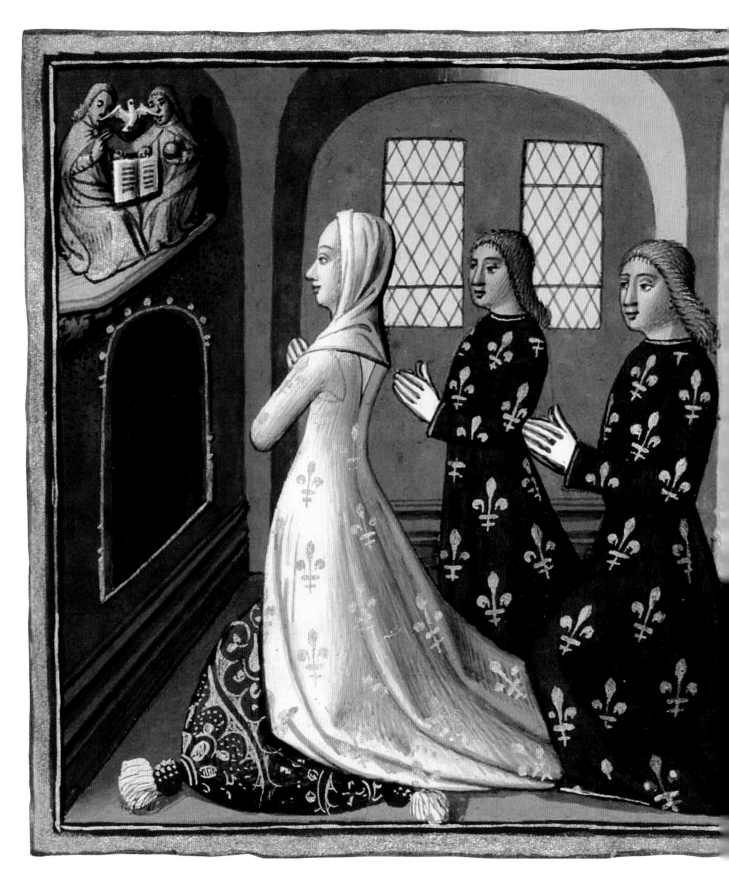

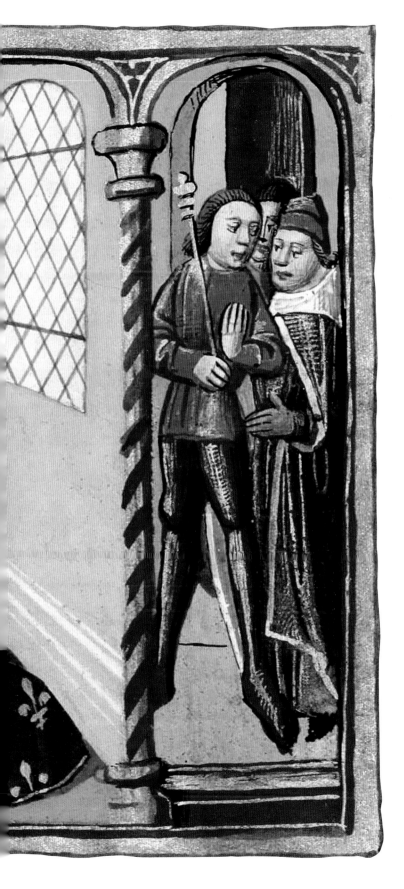

France at Prayer before the Trinity

At the end of the Middle Ages, the armorial bearings for the king of France were *d'azur à trois fleurs de lis d'or*. For evoking the dynasty and not the king himself, the *trois fleurs de lis* were often replaced by a *sémé de fleur de lis*. When it was a matter of France personified, as is the case here, the *champ d'azur* became a *champ d'argent*, that is to say, all white, but it remained *sémé de fleurs de lis d'or*. Miniature from a manuscript of *Vigiles de Charles VII* by Martial d'Auvergne, Paris, c. 1483–84. Paris, Bibliothèque Nationale de France, ms. français 5054, folio 35 verso.

their successors: *Ego flos campi et lilium convallium*, "I am the flower of the fields and the lily of the valleys" (Song of Solomon 2:1). From the Carolingian period until the twelfth century, it was not uncommon to see Christ represented in the midst of lilies or fleurs-de-lis. However, after the year 1000, Marian symbolism was gradually added to this Christological content, linked to the growing worship of the Virgin Mary, with whom the following verse from the Song of Solomon was identified: *Sicut lilium inter spinas, sic amica mea inter filias*, "As a lily among brambles, so is my love among maidens" (Song of Solomon 2:2). Henceforth, the Virgin was associated with many passages from the Scriptures and the Church Fathers in which the lily is presented as a symbol of virginity. Mary was thought by certain authors to have conceived without original sin; this was not yet the dogma of Immaculate Conception—that was not definitively established until 1854—but already there was a tradition that led to giving Mary attributes related to the theme of purity. White, a symbol of virginity, thus became her liturgical color, while the lily took precedence over all her other iconographic attributes. In this process, the Bible and the Church Fathers were not the only authorities consulted. Pliny was called on as well, who claimed the lily to be the whitest, most pure, and most fertile of all the flowers.[84] On this point, Christian and pagan authors were in full agreement.

Purity, fertility, sovereignty: around the year 1000, these were the three symbolic meanings of this flower whose whiteness had no equal. Henceforth there was a great increase in iconographic evidence (seals, coins, miniatures, murals) representing Mary holding or surrounded by lilies. It was echoed in prayers, poems, songs, and sermons (by Saint Bernard, notably) that compared the Virgin to a lily and that viewed this white flower as the primary symbol of her virginity. In images, the form of these lilies can vary dramatically without its meaning being altered. Sometimes they are simple florets, sometimes garden lilies represented more or less naturalistically, sometimes true stylized fleurs-de-lis, already more or less heraldic. In this last case, the flower appears on a scepter or a crown, or else it dots the large surface of a mantle. The shift from the Marian fleur-de-lis to the royal fleur-de-lis took place in the second half of the twelfth century by means of the various objects that the Queen of the Heavens and the King of France possessed in common. At the same time, the color of the flower changed: from white it became gilded, gold often representing a kind of "super white" in medieval iconography and symbolism. That is the case with the Capetian coat of arms, which originated in the second half of the twelfth century and was adopted by the French monarchy in the following century: *d'azur semé de fleur de lis d'or*.[85]

Contrary to what one might think, the bibliography devoted to the heraldic and monarchic fleur-de-lis is relatively poor, both in quantity and quality. Nevertheless, this symbol constitutes an authentic historical subject, simultaneously religious, dynastic, political, artistic, and symbolic. But it is not a neutral subject, far from it, and the ideological diversions and partisan appropriations that its study spawned in France following the birth of the French Republic has earned it distrust among historians. Even the heraldists, most likely to carry out such studies, have proved to be distrustful and have yet to deliver the ambitious—and necessarily collective—work, so rightfully expected, on this figure of heraldry and symbol of French monarchy.[86] Nevertheless there is no lack of documentation; from the twelfth to nineteenth centuries, the fleur-de-lis is present throughout, on countless objects, images, works of art, and monuments. Moreover, scholars of the ancien régime partially prepared the way and collected much evidence.[87] Their works, however dated and sometimes naive, are often superior to those of the prolific scholars of the nineteenth century and even those of the early twentieth century.[88] In the writings of the latter, the fleur-de-lis was often sacrificed to the excesses of positivism, esoteric ramblings, or political militancy.[89] Let us not pause to address this issue here. We will do so further on, in relation to white as a royal color.

Staying with the Middle Ages, let us simply note how the twelfth and thirteenth centuries seem to mark the height of the vogue of the lily as an attribute of the Virgin Mary. By the end of the Middle Ages, the lily appears less

frequently in painted and sculpted images and begins to be challenged by other flowers, notably the rose. The red flower of love then takes precedence over the white flower of purity, which is in itself important evidence of the new directions Marian worship was taking and the new sensibilities attached to it.[90]

On the whole, the white floriary of the Middle Ages seems relatively limited, at least on the symbolic level. The lily was joined by the daisy, lily of the valley, and hawthorn blossom in addition to a few white varieties of flowers that can feature different colors (honeysuckle, columbine). But only the daisy possessed a stable, recurrent symbolism: purity and innocence like the lily, as well as youth, gaiety, and love. On the other hand, despite its yellow center and its ray-like petals, despite being related to the sunflower, it was rarely associated with the sun, a celestial body for which the Christian Middle Ages had no particular admiration and which it distrusted. As for the lily of the valley, it symbolized nature reawakening and a certain joie de vivre. It entered late into the Marian flower realm, and a legend explains that it arose from the tears shed by the Virgin at the foot of the Cross, but that legend did not appear before the seventeenth century. Likewise, to plant a hawthorn, a Marian bush, near a house to protect it from lightning is a modern practice rather than a medieval one.

The Lamb, the Swan, and the Dove: A White Bestiary

n comparison to the floriary, the bestiary associated with the color white in the Middle Ages is richer and its symbolism more consistent and extensive, beginning with the animals possessing white fur or feathers, highly esteemed by Christianity.[91]

Thus the lamb is "the softest of all beasts on earth," claims the anonymous author of a Latin bestiary from the late twelfth century. The lamb, he writes, possesses no horns, cannot defend itself, and "when shorn of its wool whiter than snow, it keeps still without balking and obeys in all things. This is a symbol of purity and innocence."[92] Other authors claim that a lamb recognizes its mother in a herd with a single bleat from her, and that, among a flock of identical lambs, a ewe recognizes her own by its voice, although they seem to all bleat alike. She displays incomparable tenderness toward it, "in the same way as the Lord recognizes each of us and lavishes us with love, and we know that he is the one and only father."[93] Many authors explain that in the New Testament the Savior is called "Lamb of God" because he is the victim who bears our sins and because he offers himself to God in our place to atone for them. In the flesh of the lamb all authors see the flesh of the suffering Christ as well the ram sacrificed in the place of Isaac in Genesis 22:1–14. They have less to say about the lamb in Revelation (although it is cited twenty-eight times in the biblical text), a judging and avenging lamb who turns its wrath on the forces of evil.

After the lamb comes the dove. For medieval culture, its feathers are an immaculate white, rather than glistening with lively colors like those of ancient doves. In the biblical episode of the Flood, the dove returns obediently to the ark, carrying in its beak an olive branch: an announcement to Noah that the waters have receded and peace has been restored on earth. In doing so, the dove appears as a bird of peace and hope, a messenger from the heavens sent by God, in contrast to the crow who does not return to the ark, preferring to feast on the flesh of dead bodies floating in the water. In miniatures, this opposition between the white

The Lamb as Symbol of Christ

This great painting, appearing at the beginning of a manuscript of the *Commentary on the Apocalypse* by the monk Beatus de Liébana (c. 750–98), faithfully translates into an image the biblical text: "I am the Alpha and the Omega, the beginning and the end . . . the one who is, who was and who is to come, the Almighty" (Revelation 1:8). Beatus de Liébana, *Commentary on the Apocalypse*, Monastery of San Pedro de Cardeña, near Burgos, Spain, c. 1175–80. Madrid, Museo Arqueológico Nacional, Inv. 1962. 73. 2, folio 1 B.

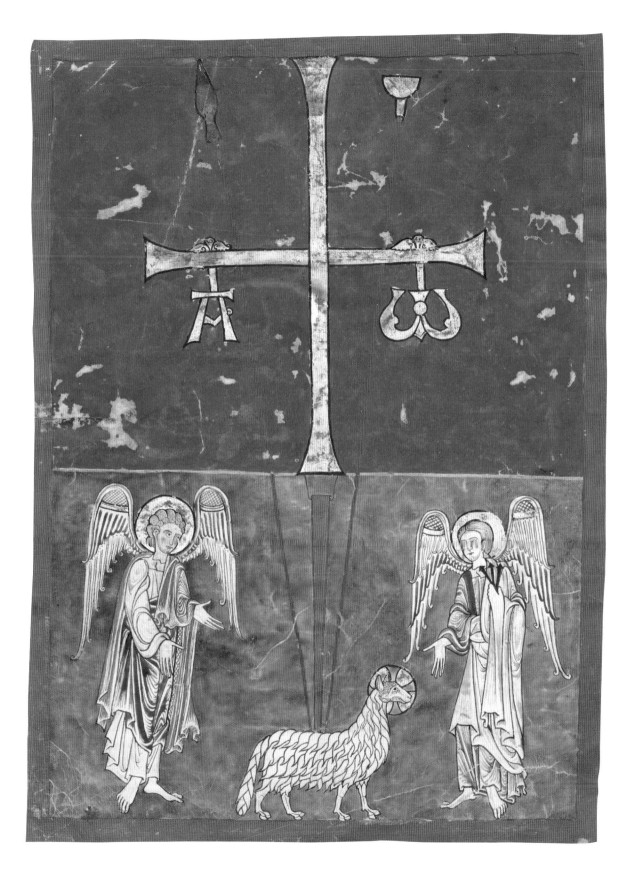

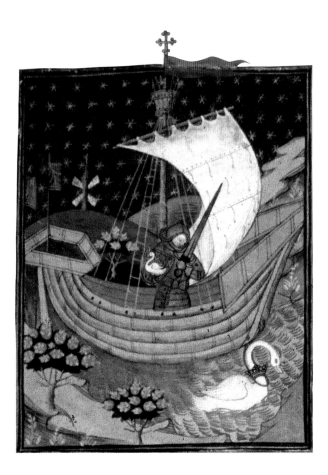

ABOVE

The Swan Knight

The legend of the swan knight comes down to us in many versions. The most familiar tells how an unknown knight appeared one day in Nijmegan, on the shores of the Rhine, in a boat drawn by a swan. Having proved himself valiant and courteous, the knight won the hand of a woman of high birth. He married, had children, and became a rich and powerful lord. But one day, the swan and the boat reappeared, and the knight left as he had come. No one ever saw him again. *The Talbot Shrewsbury Book*, Rouen, c. 1445. London, The British Library, MS Royal 15 E VI, folio 273.

OPPOSITE PAGE

The Dove from the Ark

After forty days and forty nights on the ark, Noah sent the crow to see if the floodwaters were beginning to subside. But the crow did not return to the ark, preferring to linger and eat dead bodies. Noah then released the dove, who was the one to report the good news. The black bird is impious and deathly; the white bird is virtuous and benevolent. Guyart des Moulins, *Bible historiale*, Saint-Omer, c. 1335–40. Paris, Bibliothèque Nationale de France, ms. français 152, folio 19 verso.

bird and the black bird is very pronounced; the first flies above the ark, the second feeds on carrion below it. The first is a pure, divine bird, the second a vile creature that evokes the depths of hell. Following the Church Fathers, the bestiaries cite as examples the three most famous doves mentioned in the Bible: the one of the ark, a symbol of peace; the one of David, a symbol of power; the one of the Holy Spirit, a symbol of hope. The authors also note how, after death, the souls of the just fly to heaven in the form of white doves, while the souls of the wicked take on a dark, hideous form, that of scorpions, toads, or demons.[94]

Despite Christianity's high esteem for the dove, it was not the white bird par excellence for medieval culture: that was the mysterious and ambiguous swan. It occupied an important place in Greco-Roman and northern European mythologies, embodying many symbolic themes appealing to the authors of the Middle Ages: beauty, metamorphosis, song, and death. To be changed into a swan was a motif dear to Germanic legends, the most famous being that of the swan knight, a singular figure whose brothers had been changed into birds by a formidable stepmother. Many illustrious princely houses claimed to descend from this mysterious knight who plied the Rhine and its tributaries in a vessel drawn by a white swan: the dukes of Brabant and Lorraine, the counts of Boulogne, Hainaut, Limbourg, and Holland, the houses of Berg, Clèves, Juliers, and others. In the countries of the Rhine and Meuse Rivers, the aristocracy worshiped the swan. But we can find this bird elsewhere as well, always as a sign of nobility. In the late Middle Ages, there were many princes and lords who "played" the swan knight for a joust or tournament, or who adopted an emblem or device of a swan, which was always white.[95]

Nevertheless, the swan is not a bird about which the Bible has much to say. It may be mentioned in a list of impure animals that appears in Leviticus (Leviticus 11:13–19), but that is not certain. It seems that the word *cycgnus* proposed by the Vulgate incorrectly translates the Hebrew and Greek terms that preceded it and that seem to designate the owl instead. Thus there are no swans in the Bible. Its absence left the Church Fathers

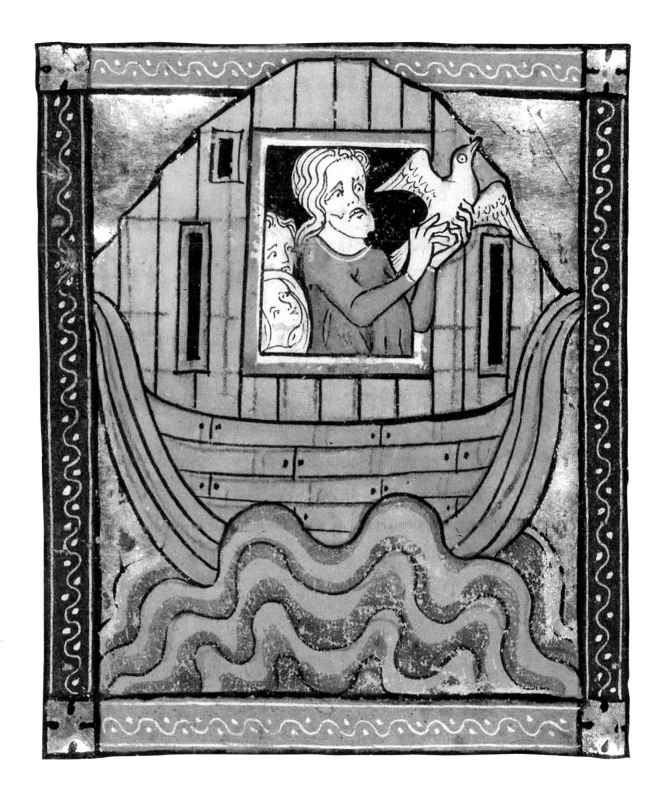

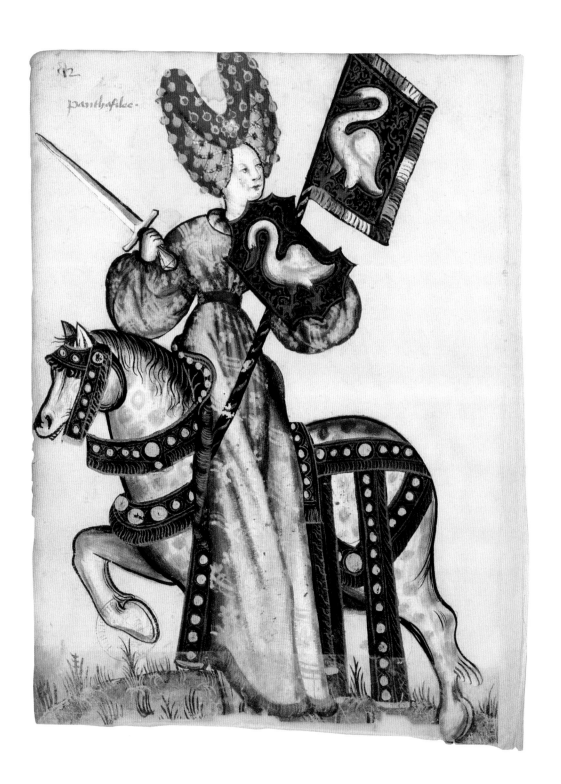

Penthesilia, Queen of the Amazons

In the Middle Ages, Penthesilia is rarely depicted alone. She most often appears as one of the "Nine Worthies," a series of famous women chosen from ancient mythologies. These "Lady Worthies" received coats of arms in the second half of the fourteenth century, but they long remained unstable. Only that of Penthesilia, decorated with a mysterious *cygne d'argent* (white), recurs from one document to the next. *Petit armorial équestre de la Toison d'or*, Lille, c. 1435–40. Paris, Bibliothèque Nationale de France, ms. Clairambault 1312, folio 248.

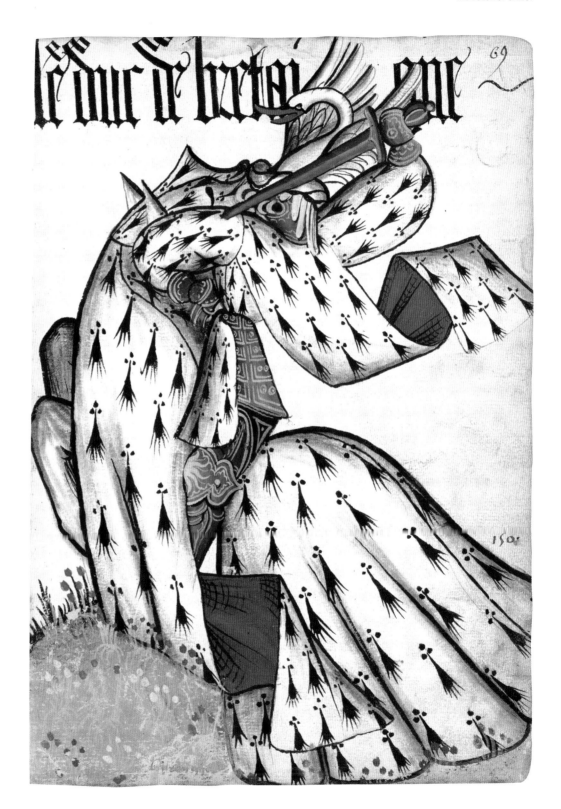

Equestrian Portrait of the Duke of Brittany

The image of the Duke of Brittany in the *Grand armorial équestre de la Toison d'or et de l'Europe* is the most spectacular in the whole collection and seems to defy the laws of perspective, even of spatial geometry. As for the ermines, represented here on the knight's attire and his mount's quarter sheet, there is absolutely nothing originally Breton about them. The ermine is a heraldic mark of cadency of a younger branch of the House of Dreux, from which came the dukes of Brittany who descended from Pierre Mauclerc, who died in 1250. *Grand armorial équestre de la Toison d'or et de l'Europe*, Lille, c. 1435–38. Paris, Bibliothèque de l'Arsenal, ms. 4790, folio 69.

and their commentators perplexed. What to say about a bird on which the Holy Scriptures are silent? Nothing, or hardly anything. In fact, the Church Fathers remain quiet on this strange creature. Medieval bestiaries thus had to find the *senefiance* of the swan elsewhere: among Greek and Roman authors, in Slavic and Scandinavian legends, and in oral traditions. There they discovered enough evidence and information to dwell at length on their subject. Its most remarkable feature involves its soft and melodious song. A pair of male and female swans can even sing harmoniously together because the female's voice, claim our authors, is pitched a semitone above the male's voice. This is the bird musician par excellence. Moreover, it was thought to be attracted to music; on hearing a lute or harp being played, it drew close.

The song of the swan is harmonious, but it is also melancholy, even sad or plaintive, especially when the swan senses its approaching death. Sick, weakened, resigned to its fate, it thus begins a song of mourning to accompany its own funeral. Its long plaintive dirge can last many months. It serves as an example for men and women:

> The swan knows that there is nothing sad or painful in death, it is a passage to a better life. . . . The courage of the swan is greater than that of a man: it sings until the last moment.[96]

Unlike with the crow, encountering a swan is generally a good omen: white is beneficial, black is not. The bestiaries tell us that sailors are often happy to sight a swan swimming in the waves because that means the shore is not far off and the dangers of the sea are behind them. Moreover, wordplay between *signe* (*signum*, "sign") and *cygne* (*cygnus*, "swan") is constant throughout the medieval texts. From swan to sign, from signs to swans, the connection is almost obligatory; more than any other bird, the swan is always more "significant" than it appears to be. Thus many authors, following Aristotle and Pliny, were intrigued by the immaculate whiteness of its plumage, rare among wild animals. What was hiding beneath this whiteness, purity, and light? Was the swan too beautiful? For some, it certainly was. Its white coat hid black flesh; it

was a dissembler, a hypocrite, a traitor. A beautiful exterior corresponded to an ugly interior, and positive symbolism gave way to a more nuanced, sometimes outright hostile, discourse. The swan became a haughty and arrogant bird; conscious of its beauty, it did not mix with other birds. Moreover, it did not like to be disturbed, proudly arched its neck, spent almost all its time in the water but never entirely dove under it. It was also a quick-tempered and quarrelsome bird; males fought with each other for possession of females, sometimes almost to death. And it was a lascivious bird; it frequently engaged in sex, practiced long embraces using its sinuous neck, and then coupled with such vigor that the male cruelly wounded the female. Finally, as one of the strangest creatures and resembling no other, the sight of it made one wonder each time if this was a prince or princess that a wicked fairy had changed into a swan.[97]

Just as ambivalent is the unicorn, which, for medieval scholars, was neither a monster nor an imaginary creature. It truly existed, and it was not until the sixteenth century that its existence began to come into doubt. Nevertheless, the descriptions that bestiaries offer of this marvelous animal vary widely. Albert the Great gives it the size and body of a horse, the head of a stag, the legs of an elephant, and a lion's tail. On the other hand, a few authors make it a small animal, similar to a kid goat. Others endow it with a goat's head, a doe's body, and a bull's tail; still others, the legs of a horse—a beast that runs so quickly cannot have an elephant's legs! All authors make it a hybrid animal, borrowing different body parts from other animals. They give it a white coat and a very long horn that grows from the middle of its forehead. The main virtue of this horn is to keep away demons and purify everything it touches. In contact with a venomous substance or poisonous water, it begins to bleed. It is a natural wonder much sought after.

However, capturing a unicorn was no easy task. The animal was fierce, proud, and brutal. The speed with which it ran made any pursuit futile. Thus hunters resorted to tricks to capture it. They knew the unicorn was attracted by the scent of virginity. Thus they had a young girl sit

in a clearing in the depths of the forest while they hid in the surrounding undergrowth. Attracted by the odor, the animal left its shelter, came to kneel before the virgin, rested its head on her knees or her breast, and fell asleep. The treacherous hunters seized the opportunity to kill the beast or lead it to an enclosure. But the unicorn was so proud that it refused any form of captivity and let itself die. If the young girl who served as lure was not absolutely virginal, if she had already known the pleasures of the flesh, the unicorn flew into a rage, eluded the trap, and killed the unfortunate decoy with its horn.[98]

Lamb, dove, swan, and unicorn: these are the four white animals over which the authors of the Middle Ages lingered. To these must be added the ermine, presented by the bestiaries as a relative of the weasel living in cold countries. Like the weasel, it ate rats, mice, and moles. Its belly was "white as snow and only the tip of its tail black; furriers prized its pelt and scattered small flecks of black through the white fur." Ermine sold for a very high price in the late Middle Ages, higher than vair coming from the gray squirrel, but not as high as sable, the magnificent black fur coming from the marten with the same name.[99]

Let us also list in this white bestiary those animals whose fur or feathers are ordinarily one color but who, among some individuals, assume an all white coat. Tamed or domesticated, they were particularly esteemed in princely circles: the horse, of course, to which we will return, but also the greyhound, leopard, falcon, and gyr-falcon. As wild animals, they were the glory of specific regions. Thus the white wolf, both rare and formidable, gave rise to an expression already attested in the late fifteenth century and still common in France today: "to be known like the white wolf." Also there was the white blackbird that Albert the Great claimed to be extremely rare but that, a few decades later, Konrad von Megenberg asserted was "most common" in Livonia (northern part of the present-day Baltic countries).[100] In literary texts, kings and princes sometimes hunt wild animals with white coats, in the image of the "white wild sow" or the "white stag" that Arthur and his huntsmen pursue in many Arthurian romances from the twelfth and thirteenth

centuries. These are messengers from the otherworld who will alter the course of the story. In the late Middle Ages, these animals were transformed into royal emblems or princely devices, like the winged stags of the French kings Charles VI and Charles VII.[101] Also, there is the collared white hart of King Richard II of England, and again, a few decades later, the white wild boar of King Richard III.[102]

Particular mention must be made of the polar bear, absent from ancient texts as from medieval bestiaries. Scandinavian sources long remained the only ones to note its existence.[103] It was later mentioned in the great encyclopedias of the thirteenth century (Thomas of Cantimpré, Bartholomew the Englishman) and made its very real appearance in royal menageries. These were bears captured on Spitsbergen or in Greenland and presented by Norwegian kings to the sovereigns of temperate Europe. The one that Haakon IV sent to King Henry III of England made an impression on contemporaries and left a few traces in documents. One chronicler related how it bathed each day in the River Thames in London, another how it was given the nickname *Piscator* (the Fisherman), while a bookkeeping note specifies the daily salary of its guardian and even the price of the muzzle and long chain that was made to keep it from swimming away.[104]

The Lady and the Unicorn Tapestry: Touch

Despite a vast bibliography, the series of six tapestries called "The Lady and the Unicorn" has still not revealed all its secrets. Once widely accepted, the iconographic theme of the five senses no longer seems so obvious today. The tapestry's sponsor has yet to be identified; it was probably one of two cousins, Jean or Aubert Le Viste, a wealthy Lyon family originally from Paris. The coats of arms themselves, prolifically represented on each of the tapestries, pose problems. Their armorial bearings are *de gueules à la bande d'azur chargée de trois croissants d'argent* and thus blatantly break the rules for the use of colors: the *gueules* and the *azur* touch. It cannot be a mistake made by the tapestry designer or weavers, much less a matter of the Le Viste family taking liberties because they were not nobles. Much to the contrary, patricians and those in the legal profession who aspired to nobility scrupulously respected the rules of heraldry. So how to explain such an infraction? Paris (tapestry design) and southern Netherlands (weaving), c. 1485–1500. Paris, Musée National du Moyen Âge, Cl. 10832.

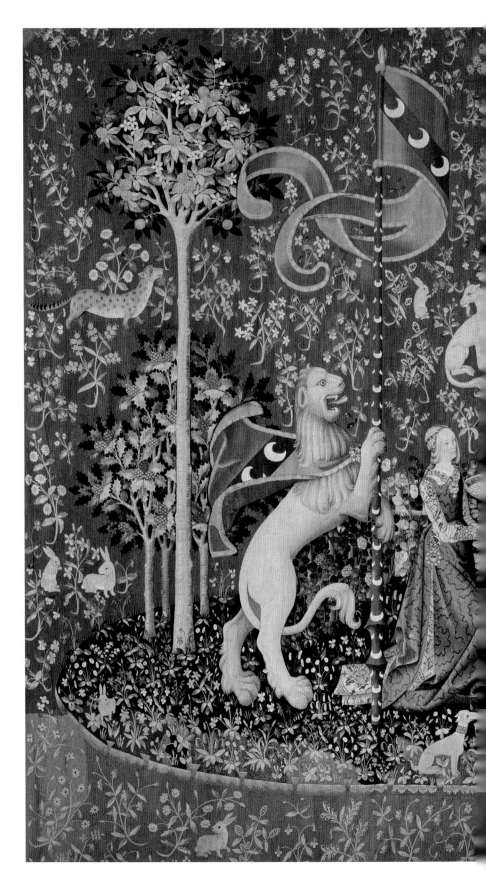

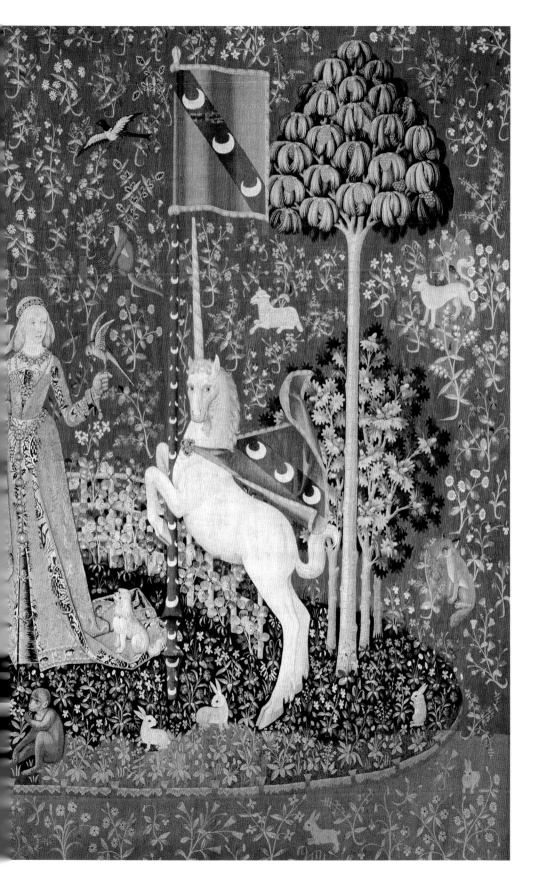

A Feminine Color

et us leave the huntsmen to their pursuits and Piscator the bear to bathe in the Thames. Let us rejoin the ladies who, in the Middle Ages, maintained close relationships with the color white, whether in terms of the body, clothing, names, or symbols. As the color of purity and beauty, innocence and chastity, peace and simplicity, white is much more feminine than masculine.

The chivalric romances of the twelfth and thirteenth centuries give us some idea of what defined feminine beauty in seignorial circles. A beautiful woman must have white skin, an oval face, blond hair, blue eyes, delicate, arching eyebrows, a small, high bust, slim waist, narrow hips, and a slender body. The physical ideal was that of the *pucelle* (a nubile young virgin) often described in Arthurian romances.[105] Of course these were clichés—which furthermore would change at the end of the Middle Ages—but they corresponded to a certain social reality. The female face especially retained the attention of poets and romancers. They insisted on the eye color: blue, of course, but not just any blue; the shade had to be specified: *azur, pers, vairet, inde, sorinde*.[106] They also insisted on the fairness and radiance of the complexion as well as the contrast between the face's white skin and red cheeks and lips. If necessary, that red could be intensified with various kinds of makeup, which we know ladies of high standing used, despite repeated condemnations by clerics and moralists. For the Catholic Church, makeup was a deception, an attack on the natural state desired by the Creator. Only a light rouge on the cheeks was sometimes tolerated because it could be a sign of modesty. Red lips, on the other hand, were an abomination that transformed women into witches and prostitutes.

Clothing also demonstrates how white was a feminine color. Aside from chemises, men rarely wore clothes of this color (that would be less true in the modern period), whereas it was abundantly present in the female wardrobe: chemises once again, but also cloth ribbons that served as bras, *chainses* (long white linen robes), *chausses* (leg coverings), *bliauds* (tunics), gowns, pelisses, blouses,

A Light Complexion
In the value systems of the feudal period, a pretty woman had to have the lightest complexion possible, through cheating if necessary with the help of a ceruse-based cosmetic. By the late Middle Ages, that was less obligatory, except for young girls whose delicate faces had to be "soft as milk and the color of snow." Petrus Christus, *Portrait of a Young Girl*, c. 1470. Berlin, Gemäldegalerie, Inv. 532.

gloves, veils, and assorted head coverings. Of course these various articles of clothing were not always white, but in the thirteenth and fourteenth centuries, that color dominated and was obligatory for all cloth that touched the naked body. Only belts escaped white, in favor of lively colors. As dyeing in white was a difficult feat, the cleaner and brighter the white, the higher the social rank it conveyed. That would be the case, for women as for men, until the nineteenth century.

But it was Christian names especially that proclaimed the femininity of white. There are very few masculine names constructed around this color (Aubin, Alban), whereas they abound in female anthroponymy. Let us cite for examples Blanche, Blandine, and all their derivatives, but also and especially Margaret, which evokes the daisy by that name, and more importantly the pearl (*margarita* in Latin), a symbol of purity and beauty. In the medieval hierarchy of precious materials, pearls were at the top, above gemstones, gold, ivory, sable, or silk. There was nothing more precious than pearls, and the name Margaret shared something of their prestige. However, if Margaret was the second most popular female Christian name throughout Europe from the twelfth through nineteenth centuries, following Mary, there was a whole other reason for that. Saint Margaret was the patron saint of pregnant women. If childbirth went well and if the child was a girl, she was given the name Margaret to thank the saint for her protection. Hence the huge popularity, lasting almost a millennium, of that name and its countless variants and derivations: Margot, Marjorie, Marguerite, Mette, Megan, Guite, Greta, Rita, Maggie, Peggy, and so on. And hence the existence of two or more sisters named Margaret in some families, for each time the parents wanted to show their gratitude to the saint. Saint Margaret was a young Christian woman martyred in Antioch in 305. Her legend tells how, before being decapitated, she was swallowed by a dragon and then succeeded in escaping by piercing its belly with the cross that she carried to proclaim her faith. She was worshipped widely throughout Roman Christendom.[107]

Although the name Margaret was encountered in all social classes, the name Blanche was more strictly aristocratic, at least in the late Middle Ages. Moreover, neither has a masculine equivalent. The vogue for Blanches seems to have come from Spain and spread beyond the Pyrenees thanks to royal marriages. In France, Blanche of Castille (1182–1252), mother of Saint Louis, was the first queen to bear that name. Following her, many queens, princesses, and women of the aristocracy were named Blanche, until the beginning of the modern period. The fourteenth century witnessed the height of this trend that, in written

OPPOSITE PAGE

Saint Margaret and the Dragon

White is the color of Saint Margaret and all women bearing that name because it evokes the pearl (*margarita* in Latin) as well as the daisy flower. But in this exceptional book of hours, all the figures represented on every page are dressed in white, with a few gold highlights or discreet grisaille. *The Hours of Henry IV of France*, Paris, c. 1500. Paris, Bibliothèque Nationale de France, ms. latin 1171, folio 87.

OPPOSITE

Coronation of the Virgin

In images and works of art, Mary is rarely dressed in white prior to the end of the Middle Ages. For a long time she was dressed in dark colors because she was in mourning for her son. Then in the Romanesque period, her colors lightened and her cloak often became red. But in the early Gothic period, blue took over, sometimes for her robe, sometimes for her cloak. It remained dominant throughout the modern period, although the Marian palette did diversify. Baroque art, especially, featured gilded virgins. Finally, after the dogma of the Immaculate Conception was adopted (1854), white became the iconographic color of the Virgin (whereas it had long been her liturgical color). Tomasso del Mazza, *Coronation of the Virgin*, c. 1380–90. Paris, Musée du Louvre, Département des peintures.

documents, created some confusion between queens named Blanche and widowed queens with other names required by mourning customs to wear white, not only in France in the Valois court but also in other European courts that followed French etiquette.[108] These were "white queens," that is to say, widows. The last French queen who wore white for mourning seems to have been the wife of Henry III of France, Louise of Lorraine, who was widowed in 1589 and died in 1601. But wearing black for mourning, inherited from the Burgundy and then the Hapsburg courts, had already started to emerge a few decades earlier. Catherine of Medici, for example, the widow of Henry II of France, wore black in mourning for almost thirty years (1559–1589). That was nothing compared to Blanche of Navarre, the most beautiful princess of her time. She married the king of France, Philip VI of Valois, in January 1350.[109] Widowed after six months, she never remarried and died forty-eight years later in October 1398. She wore white in mourning for almost half a century and doubly earned the moniker of "the white queen" since Blanche was her Christian name and the color imposed on her as widowed queen.[110]

Among the Celts, names constructed around the root Gwen-, Gwyn-, or Guin- evoke the feminine white. There are vast numbers of them, but the name of Queen Guinevere, wife of King Arthur, remains the most famous. Thanks to her name (of Welsh origin), Guinevere is also a "white queen," but a very ambiguous white queen. Because of her more or less magical birth (white is the color of fairies and supernatural beings), her power (whoever possesses Guinevere possesses the realm of Logres and the Round Table), and her adultery (she deceives Arthur with Lancelot), she is also something of a sorceress in certain thirteenth-century texts (she knows how to make potions and cast spells). But Guinevere was not the only female name constructed from the Celtic root *gwen-*, meaning "white." Many such names existed both in the British Isles and on the Continent, and those names still exist in modern forms like Gwenaelle, Gwendolyn, and Jennifer.[111]

Let us note that the Virgin, the heavenly queen, was not especially devoted to white. Until the twelfth century, she appears in images dressed in any color, although it is almost always a dark color: black, gray, brown, purple, blue, or dark green. This is to convey the idea of mourning because the Virgin is in mourning for her son, dead on the Cross. Subsequently, the palette was reduced and blue alone tended to fill this role as Mary's attribute for mourning. Moreover, it turned lighter and more appealing; from dark and drab as it had been for many centuries, it became more pure and luminous. Master glassworkers and illuminators endeavored to bring this Marian blue into accord with the new conception of light that architect-prelates, like Abbot Suger of Saint-Denis, borrowed from theologians. In the early twelfth century, these theologians definitively made the Christian god a god of light, while artists increasingly associated the color blue with the sky and, by extension, with "the queen of the heavens."[112]

This diversity in Marian colors can also be observed in the liturgy. For a very long time, the feasts of the Virgin—unlike those of Christ—were not associated with a specific color, and until the thirteenth century, customs could vary from one diocese to another. From then on, however, liturgists recommended the use of white for the four major feasts of the Virgin, in keeping with the practices of the diocese of Rome: Annunciation (March 25), Assumption (August 15), Nativity (September 8), and Purification (February 2).[113] Henceforth, and for centuries to come, there was a discrepancy between the Virgin's liturgical color (white) and her iconographic color (blue).

Young Woman Wearing a White Headdress

Although this portrait is among those most admired in the entire history of painting, the identity of the young woman wearing a sort of starched white hennin remains unknown. She is not a young girl (her hair is covered), or a nun (her clothes are elegant, she is wearing many rings). Perhaps she is a young widow, or quite simply the painter's wife, Elisabeth Goffaert. Rogier van der Weyden, *Portrait of a Young Woman*, c. 1435–40. Berlin, Gemäldegalerie, Inv. 545 D.

Liturgical Colors and Iconographic Colors

White is the liturgical color for the holy days of Christ and those of the Virgin; red for the feasts of the Holy Spirit, the Cross, and the martyrs. Sometimes iconography parts ways with liturgy. Here, in the left-hand folio, white is very much the liturgical color of the Ascension: liturgy and iconography are in accord. But in the right-hand folio, one would expect much more red, the color of Pentecost; whereas all the clothing is white in this image, as it is on every page of this magnificent book of hours. Iconography prevails over liturgy. Book of Hours, use of Rome: the Ascension and Pentecost, Rouen, c. 1500. Écouen, Musée National de la Renaissance, Inv. Cl. 1251, folios 47 verso and 48 recto.

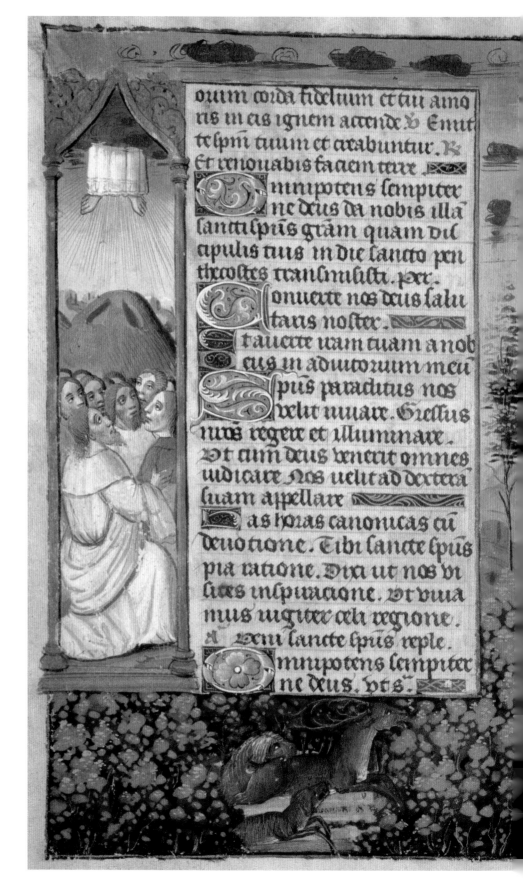

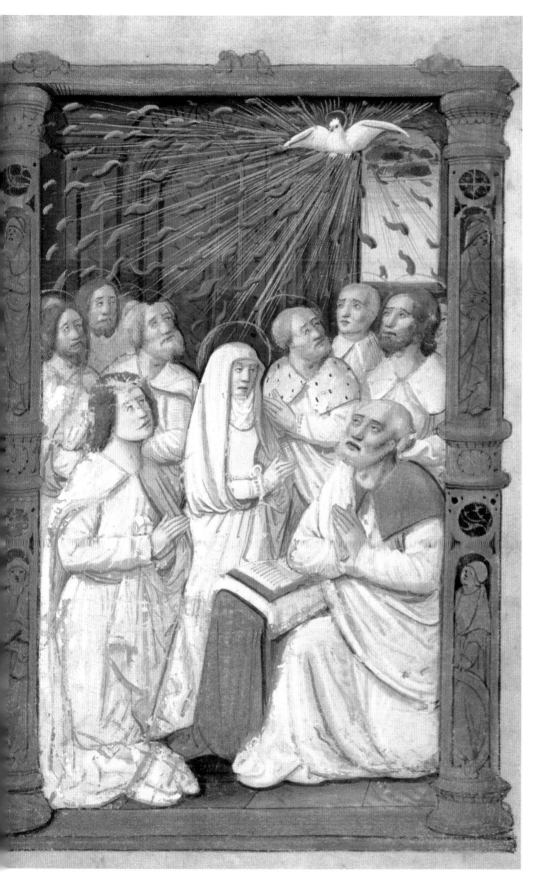

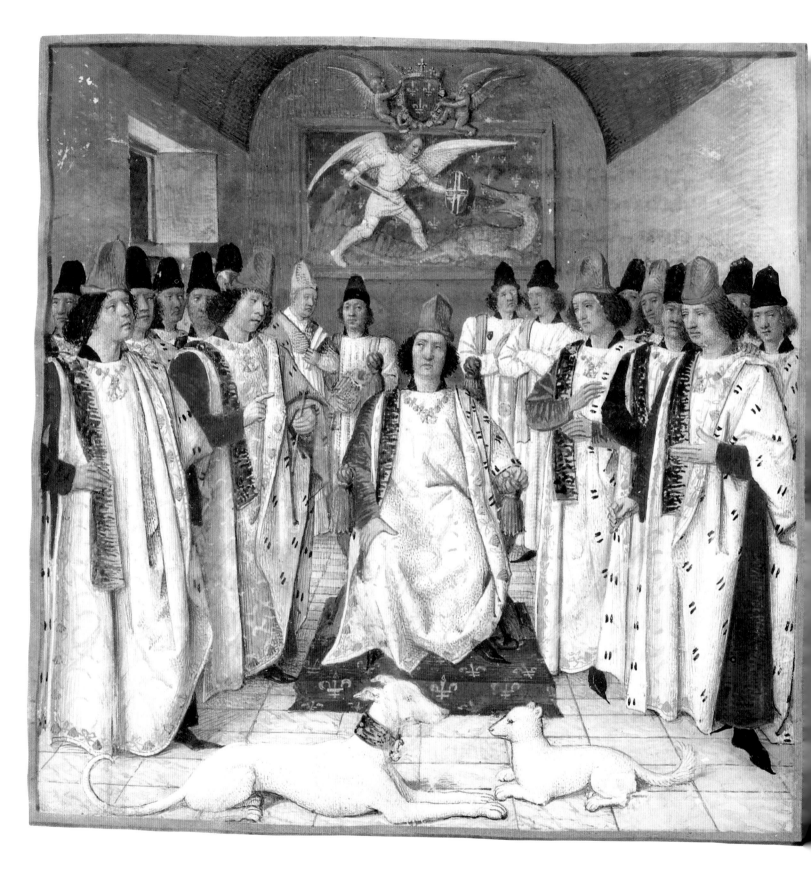

THE
COLOR
OF
KINGS

FIFTEENTH TO EIGHTEENTH CENTURIES

PREVIOUS PAGE SPREAD

Chapter of the Order of Saint Michael

Established by Louis XI in 1469, the Order of Saint Michael was composed of thirty-six knights. They wore white robes and white damask cloaks, embroidered in gold and lined with ermine. Their collars were made of scallop shells on double knotted gold chains, suspended from which was a medallion representing the Archangel Michael battling the dragon. The order held yearly meetings on the saint's day, September 29, in the great hall of Mont Saint-Michel Abbey. Painting by Jean Fouquet at the beginning of a manuscript of the statutes of the Order of Saint Michael intended for Louis XI, 1469–70. Paris, Bibliothèque Nationale de France, ms. français 19819, folio 1.

Long taciturn, even silent on colors, the texts become loquacious in the late Middle Ages and early modern period. This is true not only for encyclopedias and strictly scientific treatises (on optics in particular) but also for herbaria and pharmacopoeias, works on precious stones, medical books, alchemical treatises, and liturgical handbooks, not to mention collections of recipes used by painters and dyers. Whether it was a matter of flowers, stones, the rainbow, the mass, pigments, or urine, the discourse on colors proliferated. Especially since in addition to this literature were normative texts on dress and appearance: sumptuary laws and clothing decrees; *specula principum* and treatises on curial etiquette; books on manners, social customs, and bodily care; sermons and diatribes by moralists; descriptions and accounts by chroniclers.

And then there were literary texts, which sometimes abounded in color notations or, in certain cases, delighted in holding forth on the hierarchy and symbolism of colors. White often occupied the highest position and was always presented positively. It was not only the color of Christ but also, beginning in the sixteenth century, the color of kings, princes, the aristocracy, and then the wealthiest classes, which gradually were able to afford the luxury

of clothing that was truly white, no longer off-white, yellowed, ecru, or grayish like that of the Cistercian and Carthusian monks.

In the feudal period, only chivalric romances introduced a bit of color into a literary landscape where light played a much more important role than color did. With the dawn of the modern period, that was no longer the case. Poets, romancers, and chroniclers loved discussing colors, their beauty and their meanings. In doing so, they added an aesthetic and affective dimension to the growing discourse of the scientific, technical, and normative texts. Thus historians have at their disposal documentation for the fifteenth and sixteenth centuries that allows them to study preferences, oppositions, hierarchics, and correspondences. In the past, judgments on the beauty or ugliness of colors had been a matter especially of moral, religious, or social considerations. What was considered beautiful was almost always suitable, temperate, and customary. Of course the purely aesthetic pleasure of contemplation existed, but it only applied to the colors in nature, the only truly beautiful, licit, and harmonious ones since they were the work of the Creator. Henceforth that was no longer the case. Colors made by humans could also be attractive, and researchers are the ones most able to distinguish those that were pleasing to the eye or given positive symbolic value from those that were displeasing and considered unworthy or dangerous.

The Birth of a Symbolic System

Beginning in the fifteenth century, color symbolism gave rise to abundant literature. Colors were no longer envisaged only as material or light, they had also become abstractions, things in themselves, detached from their materiality and their supports. Considered in the absolute, removed from any context, such abstractions seem not to have existed in classical antiquity. A Roman could perfectly well say, "I like white horses," "I like red flowers," "I hate the blue clothes of the Germans," but would have had a hard time saying, "I like red," "I hate blue." Yet such phrases posed no problem in the late Middle Ages and the early modern period. They were even relatively common, because the terms for color were no longer just adjectives; they had also become nouns.

Sometime between the twelfth and fifteenth centuries, it seems, probably under the influence of heraldry, decisive changes resulted in what could be called "the birth of abstract color," and by extension, the birth of a true symbolic color system. The latter, in fact, operates truly and effectively only when color has become dematerialized and retains the same meaning or meanings regardless of the techniques used to produce it, the shades it takes, the support on which it occurs, and the medium that presents it. That represents a huge change.

For studying this symbolism, it is not the literary texts or scholarly works that provide the richest sources of documentation, but rather the encyclopedias, practical treatises, manner books, and more importantly, the treatises on heraldry. There were many of these in the fifteenth and sixteenth centuries, but the most useful for our purposes is one of the oldest of them, *Le Blason des couleurs*, attributed to a herald who was famous in his time, Jean Courtois, known as the Sicily Herald, the title of his position in the

Le Blason des couleurs en armes, livrées et devises

The first part of this work, which enjoyed considerable success in the sixteenth century, is a treatise on heraldry compiled about 1435 by Jean Courtois, the Sicily Herald. The more elaborate second part discusses the symbolism of colors and their role in dress codes. Compiled about 1480–90, its anonymous author was originally from Brussels or Lille. Title page of a copy printed for the bookseller Jean Janot of Paris, rue Neuve-Notre-Dame, 1521 or 1522.

Le blalon des

Couleurs en Armes/ Liurees et Deuises. ¶ Ensuyt le liure tresvtille et subtil pour scauoir et congnoistre du ne a chascune couleur la Vertu et proprieté/ Ensemble la maniere de Ra~sonner lesdictes couleurs en plusieurs choses pour apprendre a faire liurees, deuisee/ et leur blason/ Nouuellement Imprime A Paris. Dii.

¶ On les Vend a Paris en la rue Neufue noftre Dame a lenseigne sainct Nicolas.

service of King René of Anjou and then King Alphonso V of Aragon. Born about 1380 near Mons, in Hainaut, he died in 1437 or 1438. Toward the end of his life, he composed a treatise in French in which colors are by far the dominant theme. His work comes down to us through about twenty manuscripts and almost as many printed copies.[114] Actually, Jean Courtois is only the author of the first half of the book, titled *De la manière de blasonner les couleurs en armoiries*. Half a century later, an anonymous author, perhaps from Lille or Brussels, added a second part to it, more developed and no longer about heraldic colors and the composition of coats of arms, but rather on livery and the symbolism of colors in clothing. The work was then given a more complete title, *Le Blason des couleurs en armes, livrées et devises*. It enjoyed considerable success. It was first printed in Paris in 1495, then again in 1501, and then six more times until 1614. Meanwhile, it was translated or adapted into various languages (first Venetian, then Tuscan, German, Dutch, and Castilian).[115] It had great influence in various domains, notably literary and artistic ones. Some authors and illustrators followed it to the letter and presented figures dressed according to the color codes proposed by this small work. Others, on the contrary, mocked its rote and reductive symbolism, which seemed entirely gratuitous to them. Thus Rabelais wrote, with regard to Gargantua's livery:

> Gargantua's colors were white and blue. I know very well that reading these words, you say white is said to signify faith, and blue constancy. . . . But who told you that white signifies faith and blue constancy? A book, you say, very little read, sold at the book stalls, entitled *The Blason of Colors*. Who made it? Whoever he was, he was wise not to set his name to it.[116]

The Sicily Herald's successor, in fact, did propose colors for each social condition and each age or circumstance of life. His choices were based on the "virtues, properties, and meanings" of the colors. According to him, white was very much the color of faith and fidelity, while blue was the color of loyalty and steadfastness. Combined, the two colors formed a particularly virtuous livery that was suitable for a man "courteous and wise . . . loyal in love

Blason des couleurs
noire couleur/ et quant froideur et moisteur
sont fors noire couleur y est. Et quant moi.
steur est petite et froideur grande/ adonc est
causee blanche couleur/et se moisteur est grã
de & froideur petite& la chaleur forte&la noir
te est grande: si la moisteur est forte & la cha
leur petite la noirte nest pas si grãde. Froid
et chault oeuurent moyenement en vne ma
tiere/adõc est de necessite engédree vne cou
leur moyenne entre blanc et noir/ mais elle
approchera plus au noir que au blanc/ se la
matiere estoit seiche/ Et se la matiere estoit
moiste et se froit et se chault esgaulp / la cou
leur moyenne retrairoit plus au blãc que au
noir/& se la matiere est moyenne entre sec et
moiste la couleur sera moyenne entre noir &
blanc. Et se le chault est pl° fort que le froit
la couleur sera plus noire que blanche. Et
se le froit est plus fort elle sera plus blanche
que noire. Et si le froit et chault entrent es-
gallement la couleur aussi sera moyenne en
tre le blanc et le noir. Il appert donc par ce q
est dit que es couleurs ya deux extremitez/
cest blanc et noir/et ya cinq couleurs moyen
nes entre ces deux/& ny en peult plus auoir

ABOVE

The Symbolism of Colors

Most fifteenth- and sixteenth-century works that discuss colors and their meanings begin with white. That is the case in the second part of *Le Blason des couleurs en armes, livrées et devises*: "The color white is the first of the colors. It is through white that our pleasure in contemplating them and our knowledge of their use in heraldry begin." Chapter on white in a copy of *Le Blason des couleurs en armes, livrées et devises* printed for the bookseller Jean Janot of Paris, rue Neuve-Notre-Dame, 1521 or 1522.

OPPOSITE PAGE

Gargantua's Livery

In chapter nine of *Gargantua*, Rabelais describes the livery chosen for the young boy and uses this opportunity to mock the symbolism of colors and the authors who write on such subjects. "Gargantua's colors were white and blue . . . by which his father would give us to understand that his son to him was a heavenly joy. . . . But who told you that white signifies faith, and blue constancy?" Title page of a copy of the fourth edition, published in Lyon in 1535 by François Juste.

and in friendship."[117] That Rabelais chose these two colors to dress the young, intemperate Gargantua is clearly a provocation full of irony, especially since, according to *Le Blason des couleurs*, white and blue worn together by a young man or woman signify "virtuous youth." Which is very, very far from Gargantua! In matters of dress, our author recommends certain combinations and advises against others. Let us take white, for example, which is "delectable to the sight" and which "signifies honesty, wisdom, and innocence." It is suitable for a person "of good disposition and good sentiments." It must not be too "strong in light" for it could "corrupt the sight." White should be light but "very tempered," in the image of the person wearing it. Worn by a young woman, it signifies gentleness and virginity, "like her chemise of linen white as snow." Worn by a young man, it signifies humility and uprightness. White is the color of children but also the color of "fiancées not yet newly married." Once a woman takes a spouse, she should only wear white as "belt, garter, and other small things." As for old women, they should not choose white, the color of youth, but rather tan, purple, gray, or black.

If one wished to combine white with another color, it was better to avoid brown, because "white with brown is a very common livery, and hardly beautiful." On the other hand, "gray and white is a beautiful livery" and "white and pink, more beautiful still." With blue, white signifies, in addition to the faith and constancy that Rabelais satirizes, "wisdom and courtesy." With red, it signifies "boldness and generosity," with yellow, the "dissolute pleasure of love," with green, "virtuous youth," with purple, "pride and disloyalty," with black, "simplicity and sadness," with gray, "hope of attaining perfection," and with pink, "grace and beauty."[118]

Those are a few of the meanings that our author attributes to white and to its relationships with other colors. His discourse relies on considerations both aesthetic and symbolic. Thus he is very much of his time. Most of the treatises on heraldry in the fifteenth and sixteenth centuries proceeded in the same fashion. For the historian, the difficulty is knowing how closely they are tied to actual

practices in clothing colors. It is hard to evaluate them with precision, even for priestly or princely society, but we find much evidence of their influence on poetry, theater (with Shakespeare especially), iconography, and symbolism in all its forms.

In heraldic treatises and encyclopedias, colors were not only associated with virtues and vices.[119] They were also associated with various domains and entities: metals, planets, precious stones, the four elements, the four humors and temperaments, the ages of life, and sometimes the days of the week, the seasons, and the signs of the zodiac. Thus with the aid of colors, all sorts of relationships could be established between those different entities, offering poets and artists an almost infinite repertoire of correspondences and combinations. What made this even easier was the fact that, in this area, shades did not matter and colors functioned as abstract categories, that is, as pure concepts.

White was the sign of numerous virtues: faith, purity, innocence, virginity, chastity, frankness, fidelity, wisdom. Our authors sometimes assigned it a single vice, only one: sloth, and that was quite rare.[120] Among the metals, white represented silver; among the planets, the moon; for precious stones, the diamond or pearl; for the elements, air (along with blue); for the humors, lymph; for human temperaments, phlegmatic; for the ages of life, early childhood and very old age; for days of the week, Monday; for seasons of the year, winter (along with black); for signs of the zodiac, Pisces and Virgo.

Most of these correspondences are easy to understand. Monday, for example, is linked to white because it is the day of the moon (*dies lunae*). On the other hand, why would the color white be associated with the sign of Pisces? That remains a mystery.

The Moon of the Crucifixion

The Gospels report that at the moment Christ died, the sky grew dark and blackness covered the earth. Iconography evokes this passage symbolically in the image of the Crucifixion by placing the sun and the moon on either side of the Cross, thus creating a symmetry that can be interpreted as an allusion to the two natures of Christ or, more simply, to the two Testaments. In paintings and stained glass, the two celestial bodies usually appear white and/or gilded. Rouen, formerly Church of Saint Vincent (now Church of Saint Joan of Arc), stained glass window of the Crucifixion (detail), c. 1520–25.

White, First among the Colors

Treatises on heraldry were hardly isolated texts. Not only did they exert great influence on literary creation but they also had many imitators, sometimes in areas far removed from heraldry, like poetry and painting. The first half of the sixteenth century was, in fact, a very productive period for works dedicated to beauty, harmony, and the meaning of colors. Many of these texts remained manuscripts and still rest in the silence of libraries. But those that were printed, notably in Venice, shared with *Le Blason des couleurs* wide literary success.

Let us leave France for Italy and cite four examples of authors and publications from sixteenth-century Venice that were reprinted numerous times: Antonio Telesio, *De coloribus libellus* (1528);[121] Fulvio Pellegrini Morato, *Del significato dei colori* (1535);[122] Paolo Pino, *Dialogo di pittura* (1548);[123] Lodovico Dolce, *Dialogo dei colori* (1557).[124] It is no coincidence that these works devoted specifically to color were published in Venice by authors who were born or worked in the city of doges. In the fourteenth to eighteenth centuries, Venice was the European capital of color. It was a commercial city where dyestuffs arrived from far away, before being redistributed throughout western Europe.[125] It was also a city of art, where there were many painters, some of them renowned: the Bellinis, Giorgione, Titian, Tintoretto, Veronese. In the debates that divided the partisans of drawing from those of color, the Venetians were always on the side of color. Moreover, Venice was a city where dyeing reigned. No other European city possessed so great a number of workshops, strictly specialized according to fabrics, colors, and dyestuffs. Wool and silk were not dyed in the same facilities, and dyers in blue were not licensed to dye in red or yellow; the profession was carefully partitioned and controlled.[126] Moreover, it was in Venice that the first dyeing manual was printed in 1540, the famous *Plictho* by Giovanni Ventura Rosetti, and reissued many times until the end of the eighteenth century.[127]

Venetian Fashions at the Dawn of Modern Times

This panel was part of a much larger work, now in fragments and dispersed. These are not two courtesans it depicts but rather two women of patrician society wearing costly jewels and fashionable gowns. In Venice, as in Milan and all of northern Italy, red and white were very much in vogue. Vittore Carpaccio, *Two Venetian Ladies*, c. 1490. Venice, Museo Correr.

Venice was, in fact, an active center for printing beginning in 1465. Great numbers of books in all areas of literature and learning were published there each year. Books on color numbered among them, whether on dyeing, painting, clothing, aesthetics, or symbolism. A Latin translation of the *Blason des couleurs* by the Sicily Herald was published there in 1525, another in the Venetian dialect in 1535, and both were reprinted several times before the end of the sixteenth century. There, as in France, this treatise exerted definite influence on discourse involving the colors.[128]

Of the four works previously cited, the most instructive one for our purposes is undoubtedly *Del significato dei colori* by Fulvio Pellegrini Morato (1483–1548), humanist friend of painters. Much of it was certainly borrowed from the recently translated *Blason des couleurs*, but Morato distances himself on various points from the normative discourse on heraldry and social dress codes. Notably, he explains that in matters of pictorial art the eye is more important than the mind, and the beauty of the colors takes precedence not only over the perfection of the line but even over the virtues and meanings attributed to those colors. The aesthetic trumps the symbolic: surely this marks a rupture with the value systems of the late

Venice, Capital of Color

Painters, dyers, and printers made sixteenth-century Venice into the European capital of color. Valuable pigments and dyestuffs arrived there from the East to be distributed throughout Europe. Religious and civil holidays were occasions for ceremonies, processions, parades, and entertainment events rich in colors. Gentile Bellini, *Miracle of the Cross on the Bridge of San Lorenzo*, c. 1500. Venice, Galleria dell'Accademia.

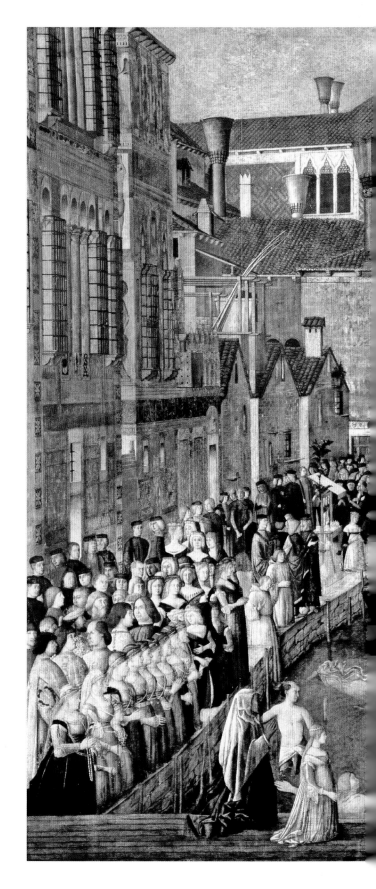

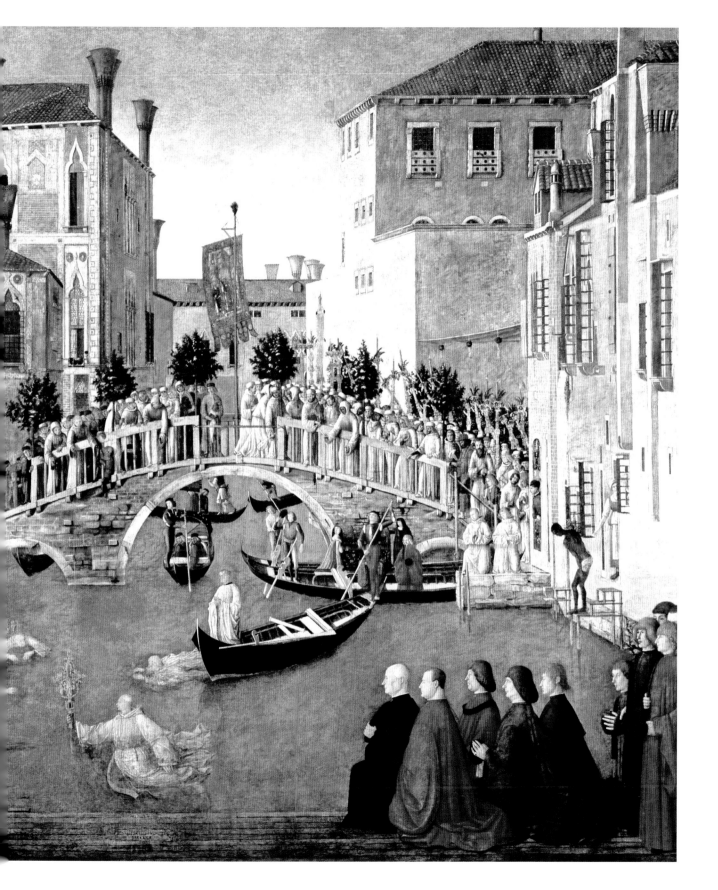

Middle Ages. Morato recommends to his painter friends many color associations meant solely to give pleasure to the eye and the senses and not to satisfy the mind or morality. According to him, the most beautiful combinations are white with black, blue with orange, gray with fawn (*leonato*), and especially light green with flesh color (*incarnato*).[129]

Also instructive is the small Latin treatise by Antonio Telesio (1482–1534), who taught rhetoric and belles lettres in Venice between 1527 and 1529. Telesio was also influenced by the *Blason des couleurs*, but he knew nothing about heraldry and adopts a more philological than symbolic discourse. An admirer of Virgil, Ovid, and Pliny, he highlights the richness of the Latin vocabulary, analyzing 114 color terms and emphasizing how difficult they are to translate. He also insists that it is impossible, no matter what the language, to name the color of the sky, the color of the sea, and the color of eyes (human as well as animal), and more generally, "everything situated between white, blue, and green." In a final chapter, he proposes various classifications for colors. On the moral plane, he distinguishes the sober colors (*colores austeri*) from the frivolous colors (*colores floridi*), as Pliny had done in his *Natural History*.[130] In the first group, he places white, black, gray, and brown; in the second, all the others. Such a moral distinction would certainly have pleased the great Protestant Reformers, all enemies of too lively or garish colors.[131] Three centuries later, it would attract the attention of Goethe, who cited and commented on it in the appendixes to his monumental *Farbenlehre* (1810).[132] On the aesthetic plane, Telesio contrasts the colors that please the eye (*colores suaves*) with those that are disagreeable to look at and seem dirty (*colores sordidi*). Among the first are pink—which he considers "the most beautiful of colors," white, sky blue (*celestinus*), and purple (*purpureus*), which—as often the case in Venice—was not purple at all, but a dark red. Among the second are russet, dull black (*ater*), most browns, and, unexpectedly, dark blue.

The dialogues of Paolo Pino (1534–1565) and Lodovico Dolce (1508–1568), two wholly Venetian authors, friends of painters, frequent visitors to Titian's studio, take little interest in morality, none in heraldry, more in symbolism, and much in aesthetics. Pino emphasizes the problems encountered by painters trying to reproduce colors of nature, not only of vegetation but also of sky, sea, and fire. He also develops the idea that very costly pigments do not necessarily make beautiful colors. The beauty is in the expertise and genius of the artist. In this domain, he vaunts the superiority of the Venetians over the Florentines, "mediocre at expressing colors."[133] Dolce, a prolific and versatile writer, who "wrote in all genres without excelling in any" (Goethe), lingered over defining what a color is—material, light, sensation, term—and explaining the notion of harmony. Harmony should depend on contrasts of coloration and saturation rather than the shades of neighboring colors, but those contrasts must be restrained. He cites the juxtaposition of white, pink, and green as a perfect harmony. Like both Telesio and Morato, he makes pink the most appealing of colors, whether it is a matter of flower petals or a young girl's complexion.[134]

At the dawn of the modern period, new sensibilities thus appeared in Venice that no longer made the beauty of colors subject to their symbolic dimension but only to the pleasure of the eye. These new sensibilities would gradually win over all of Europe. Nevertheless, another more traditional discourse existed among heralds, encyclopedists, and poets: which color was the most noble? No longer the most beautiful but the most noble, a concept rarely defined but that all readers understood: it was both moral and social. Here opinions were divided, at least until the end of the Middle Ages. A few rare authors considered it to be yellow because in heraldic terms, yellow meant *or* (gold), an esteemed metal and simultaneously a color, light, and material. Others, more numerous, preferred blue, the color whose spectacular rise began in the twelfth century and continued well into the modern period.[135] However, beginning in the fifteenth century, it was most often white that prevailed as most noble and was ranked first among the colors. As liturgical color of Christ and the Virgin, symbol of purity, innocence,

frankness, brilliance, and glory, white transcended blue and red in the hierarchy, not only in terms of honor and dignity but also in terms of perfection. All discourse on the nature and meaning of colors began with a chapter on white, and that would be true until the early seventeenth century. No author contested its status as a color in its own right. Not yet.

OPPOSITE

Color in Books

Venice was not only a city of art, it was also a city of printing. Throughout the sixteenth century, Venetian presses published treatises on painting, dyeing manuals, and works on the nature and symbolism of colors as well as coats of arms and heraldry. In Venice, color was ubiquitous, including in books. Lodovido Dolce, *Dialogo nel quale si ragiona della qualità, diversità e proprietà dei colori*, Venice, 1565, title page.

NEXT PAGE SPREAD

Titian's White

The young woman on the left, dressed in a flowing white gown, is a young bride who represents profane love, while on the right, Venus, nude, embodies sacred love. In the center, Cupid seems quietly to unite them. Viewed from a distance, the robe appears luminous; viewed up close, it is full of grayish, bluish, greenish, and even silvery highlights and folds. As Vasari stressed, "one must stand back to see the canvas in all its perfection." Titian, *Sacred and Profane Love*, 1514. Rome, Galleria Borghese.

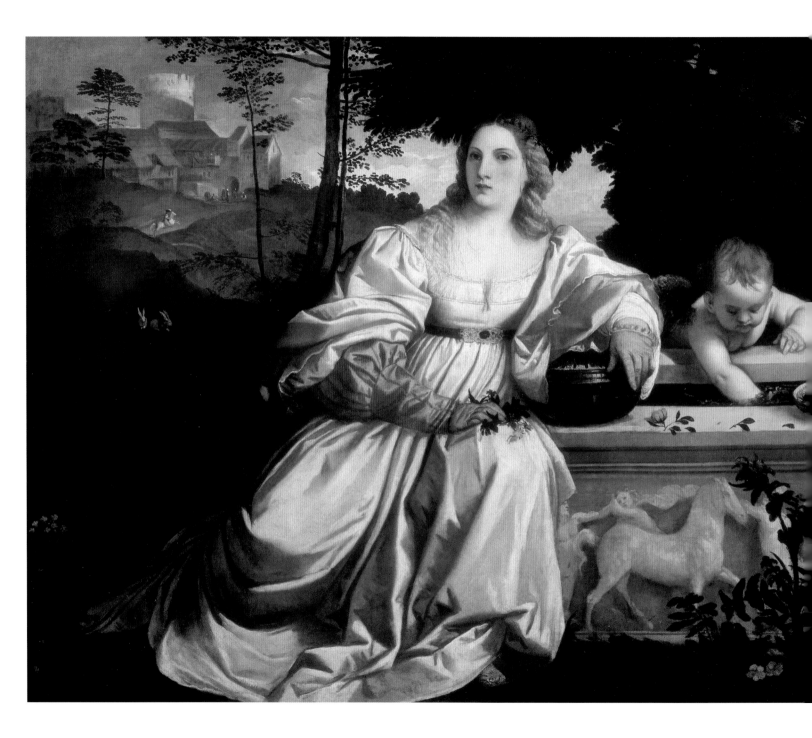

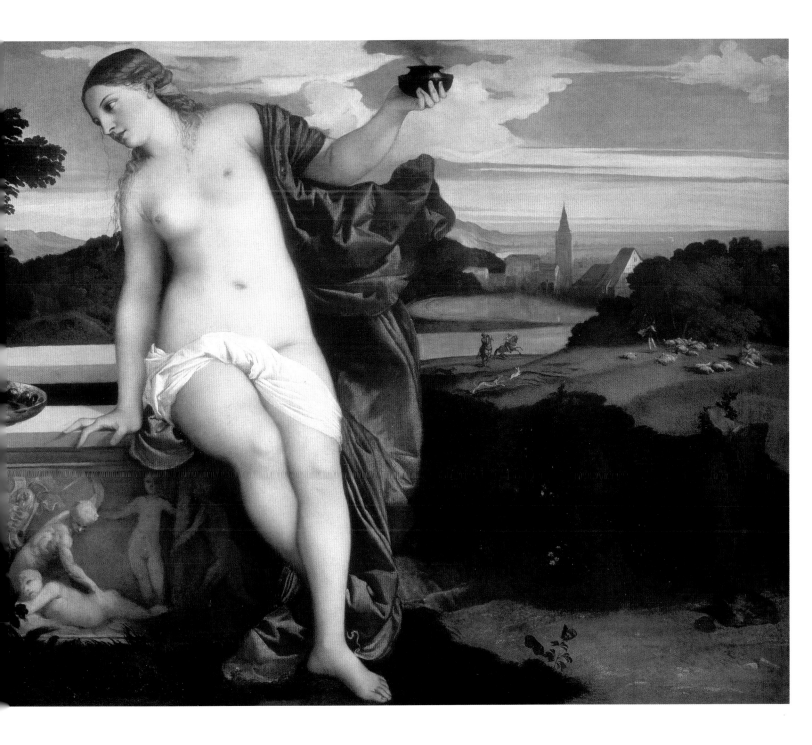

Birth and Death in White

Often the ages of life figure among the "categories" that treatises on heraldry, encyclopedias, and later, iconology manuals associate with colors. The number and division of those ages vary according to the authors, but the list most frequently proposed at the end of the Middle Ages and beginning of the modern period includes seven ages (whereas antiquity only distinguished three or four of them).[136] Thus, as with the vices, the virtues, the metals, the planets, and the days of the week, this list forms a septenary. Infancy is associated with white, childhood with blue, adolescence with pink, youth with green, middle age with red, old age with black, senility with white. There is no yellow or purple, as those colors had too little value. White, on the other hand, was cited twice: it symbolized the first years of existence as well as very old age, as if past old age—that is to say, living more than eighty years—one fell back into infancy. The nursing infant and senile old timer resembled each other, and white was their color.

In fact, babies were long dressed in white and only white. Iconography provides many examples showing newborns swaddled in all white, wrapped tightly from head to toe with cloth strips of that color. Some resemble little mummies, others oblong bread loaves covered in flour. This custom of swaddling all young babies predates the Middle Ages and extends well into the modern period. It was not until the mid-eighteenth century that some doctors began to question it. Previously, swaddling was thought to provide infants with warmth and protection at the same time as it made them easier to watch and transport, and reminded them of the enclosed, confined space they had inhabited in their mothers' bellies. Diapers were changed infrequently, meaning babies were washed less often and left swaddled in their urine and feces. Many doctors claimed that this protected them from injuries and epidemics.

The swaddling cloths of infants were wool or linen, as were the caps covering their heads to protect them from bumps or drafts. As anything in direct contact with the

The Seven Ages of Life
According to authors and artists, the ages of life are three, four, six, or seven in number, as here. Each age possesses its symbolic color. White is associated with infancy, blue with childhood, pink with adolescence, green with youth, red with middle age, black with old age, white with senility. White is thus evoked twice; it symbolizes both the first years and great old age, as if after becoming old one returns to infancy. Hans Baldung Grien, *The Ages of Life*, 1510. Vienna, Kunsthistorisches Museum.

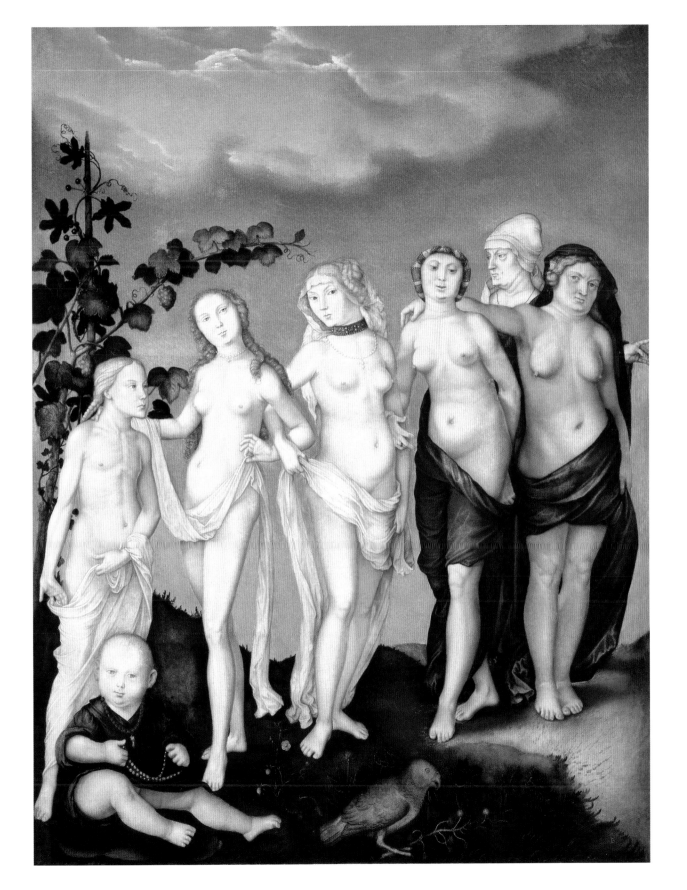

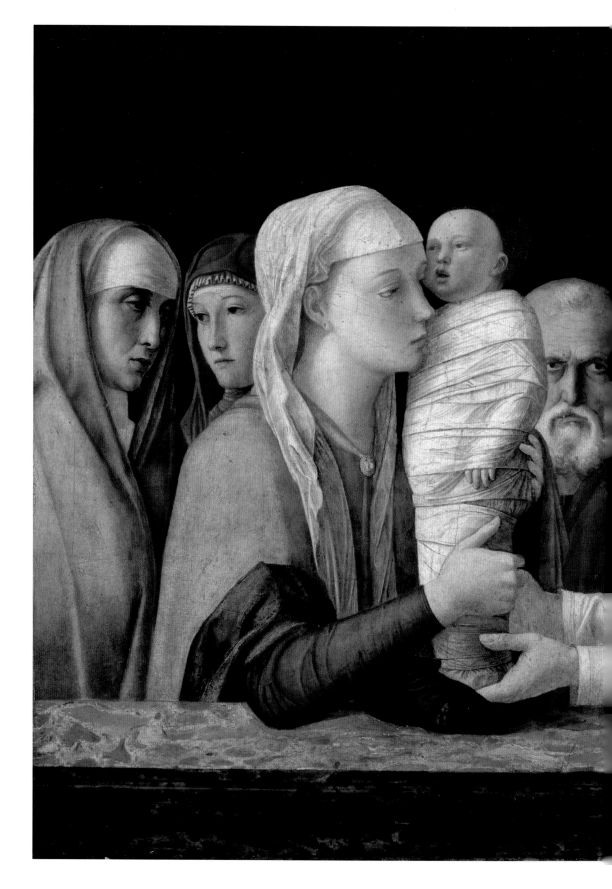

Infant White

The custom of swaddling
newborns predates the Middle
Ages and lasted until the
eighteenth century. Thus babies
were destined for white and only
white. Iconography provides many
examples showing them wrapped
from head to toe in swaddling in
the form of folded, overlapping
strips of white cloth. Andrea
Mantegna, *The Presentation
at the Temple*, c. 1460 (detail).
Berlin, Gemäldegalerie.

body, they were white, either naturally so or dyed that color. In images, only the infant Jesus is the exception: representations of the Nativity usually show him naked rather than swaddled, and illuminators and painters alike strive to give him slightly pink skin and a gilded halo with a cross. Moreover, his body is luminous and radiant, conveyed by the images in various ways but always involving gold and not some other color, not even white. In her *Revelations*, Saint Bridget of Sweden (1303–1373) explains that the radiance emanating from the newborn Jesus is much superior to that of lamps and candles and that it "sheds light into souls and brings light to the world."[137]

Jesus clearly constitutes a special case. In the iconography, most newborns are swaddled in white and placed in rooms where white fabrics dominate: sheets, bedding, cushions, drapes. Mothers themselves are shown wearing white chemises, the color of purity and maternity. White follows green, which they would have worn prior to it as a sign of hope, especially hope for a successful pregnancy. Pregnant women are often portrayed in green in miniatures and panel paintings. Many chroniclers inform us that in the years 1238–39, in order to conceive his first child, a son if possible, Saint Louis made an effort to sleep for several consecutive nights with his young wife, Marguerite de Provence, in the "green bedroom" of the Île de la Cité palace. We do not know what this "green bedroom" was exactly, but we can guess that it was painted with foliage and greenery, plant motifs then fashionable in secular decor.[138]

ABOVE

Suzanne of Bourbon as a Child
It is difficult to say precisely how old the young princess is in this painting. Born on May 10, 1491, she was the daughter of Duke Peter II of Bourbon and Anne of Beaujeu, daughter of King Louis XI of France. White, worn by children until they were six or seven, even later for girls, does not help at all with determining her age. But the child's entire outfit and her pose, as in prayer, suggest she is at least two or three years old. Jean Hay, known as "The Master of Moulins," *Suzanne of Bourbon*, c. 1493. Paris, Musée du Louvre, Département des peintures.

OPPOSITE PAGE

Christ's Shroud
Art from the Counter-Reformation often shows Christ's winding sheet, as here in the *Descent from the Cross* and seen again in *The Entombment*. Romanesque and then Gothic art was content with just the loincloth, but in the fifteenth century, it became larger and finally turned into a sort of sheet. In this famous painting by Rubens, the white of the cloth illuminates the canvas with an almost supernatural light. Beginning in the seventeenth century, many exegetes found an allegory of the Eucharist here, the shroud evoking the altar cloth, and the body of the Crucified One, the holy host. Peter Paul Rubens, *Descent from the Cross*, c. 1616–17. Lille, Palais des Beaux-Arts.

Infancy lasted until about the age of three, considered to be when speech and learning began, in the image of the Virgin, taken to the temple at that age to receive her initial education. Three was also the age of games and *esbattements* with brothers and sisters. But young children did not stop wearing white. Most images and artworks represent them dressed in white chemises or long tunics, sometimes decorated with a bit of embroidery, and identical for boys and girls. At the age of seven, however, distinctions between the sexes began to be emphasized; this was the age of reason and first responsibilities. Some children received an education and moral instruction, learned good manners and social customs; others already began working in the fields or shops. They all attended mass and abandoned the color white of early childhood for other shades, imitating those of adults: lively, saturated colors among young princes and lesser nobility; browns, grays, ecrus, and faded tones among the children of artisans and peasants. There is no need to exaggerate the sordid aspects of medieval dress among the commoners, however, as is too often done in films and graphic novels. Although all cloth was dyed, dyestuffs were unreliable because, lacking any effective mordants, they barely penetrated the textile fibers.

What was true of birth was also true of death: white was its color, or at least one of its colors. Death, in fact, was not always black. In the West at the end of the Middle Ages and beginning of the modern period, many colors were associated with it. Not until the second half of the seventeenth century, or even the eighteenth century, did black definitively take precedence over other shades in mourning practices and funeral rites among the wealthiest classes. There are many reasons for this apparent chromatic diversity, which historians find a bit disconcerting today. But the main one stems from the fact that in ancient societies—as is still true today in some non-Western societies—two deaths exist: one that is the opposite of life, and another that is the opposite of birth and that is considered just as, if not more, important.[139] If this idea of a dual death, with its very different aspects, is not taken into account, it is hard to understand almost anything about the history of death. In the Middle Ages, the Last Judgment, paradise, hell, and purgatory were at the heart of thoughts and beliefs on death and questions about eternal life. In iconography, on the day of the Last Judgment, the dead exit their tombs entirely naked, although some are still entangled in the white of their shrouds, forming a sort of habit they must cast off.[140] However, after the weighing of souls and the separation of the chosen from the damned, only the chosen receive garments, often brilliant white, the white of glory, before being led to paradise; the damned, on the other hand, remain naked and are forced toward the infernal abyss by entirely black demons or devils.

Thus it is very much as a birth into another life that death is associated with white. This white is never synonymous with colorlessness. It is fully a color, even, for many authors, the most luminous of all colors. And light is life, as many biblical passages repeat, passages glossed by theologians who compared white to the brilliant light of the sun and that of divine majesty. Therefore white, with which numerous medieval and modern documents associate funeral practices, should not be considered deathly or ghostly, that is, colorless, but rather extremely colorful, intense, saturated, brilliant, glorious, tied to the joys of resurrection and the triumph of the just. The New Testament abounds in allusions to this eschatological white that marks the passage from the state of sin to the state of justice. It announces a new life—eternal life—by proclaiming the victory of the Redeemer, who is himself also dressed entirely in white.

A passage from the Gospel of Luke particularly captures our attention here: the one in which Jesus appears before Herod who has him arrayed, perhaps to mock him, in a white tunic (*vestem albam*) that he keeps throughout the Passion (Luke 23:11). Jesus dies dressed in white! Here was an example and a color to be imitated, through means of the clothing in which the dead were dressed. It could be a simple chemise, a Cistercian or Carthusian robe, more costly white clothing, or else, more frequently, the shroud in which the deceased was wrapped and sewn before being laid in the coffin or the earth. Because there is white, and then there is white. Beside the white of the Resurrection

The Ascent of
the Blessed to
Heavenly Paradise

After the resurrection of
the dead and the weighing
of souls, the chosen are
separated from the damned
and transported by angels to
heaven and their heavenly
abode. Hieronymus Bosch
made this transport an ascent
through a tunnel and placed
an angel dressed in white at
its opening. As for the chosen,
they are naked, being "dressed
in light." Hieronymus Bosch,
*Visions of the Hereafter IV:
The Ascent of the Blessed*,
c. 1505–15. Venice, Galleria
dell'Accademia.

The White of
the Resurrection

White is both the liturgical
color and the iconographic
color of the Resurrection. In
images, angels, assistants,
and Christ himself are totally
or partially dressed in white;
for Easter Mass, all the
liturgical cloths, including the
priest's vestments, are this
color. Cecco del Caravaggio,
The Resurrection, c. 1619–20.
Chicago, The Art Institute of
Chicago.

and angelic glory, there is the white of humility and renunciation. The first is luminous and radiant, the second drab and wan.

To this second category belongs the shroud of revenants. Ghosts existed already in various forms in antiquity—many Greek and Latin authors mention them.[141] But in texts and images, they are dressed in white only beginning in the thirteenth century, and even then infrequently before the modern period. This is the white of the pall, linen, or winding sheet that covered them before they were buried. Thus, here again, the color maintains close ties with death, but not a glorious and beneficial death, rather, an incomplete, pallid, ghostly one. The white of revenants hardly illuminates, but it allows them to see in the darkness and to interfere in the world of the living.

This theme of the dead who come back to haunt the living is a universal one that gives rise to all sorts of beliefs, myths, and legends. In Europe, Christianity helped to distinguish these ghosts from all other apparitions encountered in many societies: specters, phantoms, shades, spirits, poltergeists, white ladies, and so on. A revenant is the soul of a dead person that takes on bodily appearance and returns from the otherworld to emerge among the living in order to torment and settle accounts with them, or alternatively to protect them and warn them of danger. Or—and this is the most frequent reason—to expiate for good their past sins on earth. Indeed revenants can find no peace in the tomb. Their passing from this world to the next does not go as it should: sometimes their eternal rest has been disturbed; sometimes they have not reached heaven and wander aimlessly because neither do they deserve hell; sometimes their ungrateful families have done nothing to ensure their salvation; sometimes they are victims of witches, enchanters, or necromancers, all wedded to the color black. More mundanely, they may have died a violent death or in a state of sin. They reappear at night, at Christmas, or during an important liturgical holiday, and very often on a Monday, the day of the moon and the dead. This occurs near their burial place or some in-between spot: a hedge, ford, moor, the edge of a woods, marsh, or strand, sometimes in the shadow of a cloister or

under a bridge. The theme of the haunted castle belongs especially to the Romantic period and more frequently features phantoms than revenants. Unlike revenants, phantoms are not easily identified dead people who return much as they were alive, but rather supernatural visions, apparitions, or manifestations.[142]

ci apres commence une
monlt meruelleuse et hu
uble exemplaire que len
dit des .uj. uis tes .uj. mois

S com la matiere noꝰ cōte.
Jl furent li ꝓ duc ou cōte.
Ͳꝰis noble hōme de grāt aꝟoy.
Ec de genꝛl com fil a Roy.

The Three Dead and the Three Living

Death is omnipresent in late medieval art. The theme of the three dead and the three living is among the most common, along with the danse macabre and memento mori. Three fleshless corpses in tattered shrouds appear to three rich young men, happy and very much alive, to remind them that life is short and to show them what will become of their bodies after death: decomposition, corruption, rot. Psalter of Bonne of Luxembourg, c. 1348–50. New York, The Cloisters Museum, Inv. 69. 86, folio 321 verso and 322.

The Color of Nobility

Considered the most noble color on the symbolic plane, white gradually became a sign of nobility, and even high nobility, in customs of dress in the late Middle Ages and early modern period. It was the women of the princely aristocracy who initiated the new style of white tones over the course of the fourteenth century, first discretely or sporadically, and then in a more persistent and recurrent way in the century that followed. Princes began to imitate them in France and England a few decades later, as curial etiquette required paying greater and greater attention to dress, decor, and accessories. In these areas, the Valois and Tudor courts mutually influenced each other and often took the opposite position from the Hapsburg courts. The Hapsburg courts, both in Spain and in the Holy Roman Empire, were devoted to black for religious, moral, and dynastic reasons. Never did the pious, austere monarchs Charles V and Philip II dress in white. In France, Francis I, Henry II, and his three sons all did, sometimes in provocative ways, while in England, Henry VIII, despite his growing stoutness, liked to dress not only in white but also in bright, lively colors, yellow being his favorite and symbolizing, in his eyes, splendor, generosity, and joy. His daughter Elizabeth, called "the virgin queen" not because of her chastity but because of her celibacy, also enjoyed wearing white, especially in the first half of her long reign (1558–1602): a brilliant white, accentuated with precious stones, embroidery, and many jewels. In Italy, on the other hand, despite very versatile fashions and great differences between principalities, white was not as popular as in France and England. Red, black, and dichromatic or trichromatic clothing, inherited from the Trecento, often retained the place of honor until the mid-sixteenth century, even later in the small courts of the northern peninsula.

The Ruff

Like lace, ruffs were worn by both women and men. This was a matter of a white collar, formed from folds and flutes, that hid the neck and emphasized the face. Appearing in the mid-sixteenth century, the ruff did not disappear until the early seventeenth century, after having sometimes achieved extravagant dimensions and forms. Frans Pourbus the Younger, Portrait of Isabelle-Claire-Eugénie of Austria, seventeenth century, Bruges, Groeningemuseum.

PREVIOUS PAGE SPREAD, LEFT

Lace

In the first half of the seventeenth century, both men and women wore ample lace. In the Netherlands and United Provinces, an elegant young man, as shown here, was expected to sport such cuffs and collars, their design and stitch changing each year. The lace patterns seen in this painting by Rembrandt thus allow us to date the work to 1634. Rembrandt, *Portrait of a Young Man*, 1634. Amsterdam, Jan Six collection.

PREVIOUS PAGE SPREAD, RIGHT

The Chemise

Beginning in the mid-sixteenth century, men's chemises expanded. In the first half of the following century, their collars, sleeves, and cuffs were very much on display. The chemise was no longer an undergarment, intimate and personal, but outer finery. The whiteness, fabric (linen, cotton, silk), embroidery, and accompanying ribbons identified the social class of the man who wore it. Sébastien Bourbon, *The Man with Black Ribbons*, c. 1657–58. Montpellier, Musée Fabre.

One reason why white clothing became—and long remained—a privilege for nobility in France was due to the extreme difficulty of dyeing materials in tones that were truly white, pure, uniform, and brilliant. The process was long, difficult, and costly, and the results often disappointing, except perhaps with linen. With wool, the difficulty that we noted with regard to the Roman toga lasted throughout the Middle Ages and the modern period. One often had to be content with tones whitened naturally in the fields with the oxygenated water of morning dew and sunlight. But that was slow, demanded much space, and was almost impossible in winter, at least throughout much of Europe. Moreover, the whites thus obtained did not remain white but turned back to grayish brown, yellowish, or ecru as time passed. That was why it was rare in medieval societies to be dressed in truly white white. The tinctorial use of some plants (saponins, essentially), or washes with ash, clay, or mineral (magnesium, chalk) bases produced whites with grayish, greenish, or bluish highlights, thus reducing some of their brightness.

Hence all those people, men or women, who should have dressed in white for moral, liturgical, or symbolic reasons, never did so entirely. That was the case notably with the queens of France and England who, beginning in the early fourteenth century, developed the custom of wearing white for mourning. For a long time, this ritual only existed in theory. It was almost impossible to obtain or stabilize a solid white, so the queens "broke it up" by combining it with black, gray, or purple. And that was also the case for priests and deacons on days when the color white was to be worn, according to the liturgical code of colors (feasts of Christ and the Virgin, feasts of the virgins and confessors, Epiphany, All Saints' Day). On those days, white was often combined with gold or gilt, for reasons that were not just symbolic but also and especially tinctorial. Let us mention again the Cistercians, those "white monks" whose robes in reality were rarely white, the color of their order. The same was true, moreover, for their Benedictine rivals, the "black monks," who also rarely dressed in true black, because obtaining a plain, solid, absolute black for wools was a delicate and costly operation. If Benedictine and Cistercian monks are shown in true blacks and whites in images, in their monasteries and priories, they were often dressed in gray or brown, or even more or less faded blue.

White, a Protestant Color

The Reformation gave many colors moral significance and distinguished the "honest" ones (white, black, gray) from those that were not (red, yellow, green) and that all good Christians should avoid. In the cathedrals of the United Provinces, converted to Calvinist churches, colors and images were totally absent, the walls painted white or whitewashed. Pieter Jansz Saenredam, *Interior of Church of Saint Catherine, Utrecht*, c. 1660. Banbury (Warwickshire, UK), Upton House, Inv. NT 446733.

In the modern period, progress in dyeing techniques and more diversity in the fabrics used for ceremonial clothing allowed for greater use of the color white, notably for silk, cotton, and certain kinds of wool. But the price of fabrics and dyes meant white was used exclusively by princes and the higher aristocracy. Lower or less wealthy nobles had to be content with lively, more or less stable colors, while commoners usually remained fated to gray, brown, and a few halftones until the eighteenth century. Throughout the ancien régime, wearing clothing of a saturated, luminous white remained a sign of high nobility.

The same was true for the chemise, an undergarment formerly considered intimate apparel, which men increasingly wore in public beginning in the sixteenth century. In the Middle Ages, the chemise (*camica*) was a simple tunic worn underneath, with long tails and no collar, undyed or white. To be seen in one's chemise was truly humiliating, worse than being seen naked. Hence various rituals of infamy developed by which men or women condemned for one thing or another were exposed, paraded, dragged, hung, or executed "*en chemise.*" This represented social nudity, the final debasement, whereas actual nudity simply symbolized the natural state, as the Creator made us. In itself, there was nothing obscene or transgressive about nudity, only the acts accompanying it could become so.

In the modern period, among the wealthiest classes, the male chemise changed status and lent itself to being seen, sometimes entirely, but especially at the neck and wrists, the sleeves, across the chest, and at the waist, all parts that were extended or amplified. This new chemise had to be the most beautiful white, if necessary by cheating a bit with the help of temporary highlights (chalk, talc, magnesium), in order to be a sure sign of nobility. Moreover, its linen, silk, or cotton cloth was covered with embroidery, ribbons, and various ornaments, and later with jabots and ruffs of all kinds. The collar became detachable—which meant the entire shirt was washed less often—and its immaculate whiteness indicated the social class of the individual wearing it. Our present-day "white collars" find their most distant roots here.

One white ornament in particular developed in the sixteenth century and came to be added to embroidery and ribbons, even to replace them: lace. Its origins remain a matter of debate but seem to date back to the late thirteenth or early fourteenth century, with both Flanders and Venetia claiming to be lace's birthplace. In any case, in the years 1550 to 1600, it was Venice that provided most of the lace produced in Europe, at least the luxury lace then used for men's clothing. Originally, in fact, lace was only worn by men and only involved the exterior facings of their dress. Women adopted it in the following century, and they were the ones responsible for its promotion throughout Europe and beyond the aristocracy. Visually, if not symbolically, this new white ornamental trimming, very visible on dark, plain clothing, seemed to take over from ermine, the expensive white fur with black flecks, used since the mid-sixteenth century not only to "fur" clothing, that is, to line it from the inside, but also to decorate it on the outside, at the collar, lapels, cuffs, and elsewhere. Of course, formal or ceremonial ermine retained its status in the world of the law, the magistracy, and the high clergy, but elsewhere, as extravagant finery, it was gradually replaced by lace. They were both predominantly white but left a more or less important place for black or dark tones, whether as flecks in the fur or openwork spaces in the lace.

Related to this new rage for lace was the fashion of ruffs, white collars formed by folds and flutes that hid the neck in order to highlight the face.[143] This strange ornament, worn by both men and women of nobility and the wealthy bourgeoisie, appeared toward the middle of the sixteenth century and did not disappear until the early seventeenth century. Originally, it was simply a matter of pleats in the collar of the male chemise that closed and rose increasingly higher, but the development of curial luxury, linked to that of more and more extravagant fashions, quickly made it an autonomous element of dress. First in France and England, the fashion of ruffs also spread throughout Europe and assumed various guises, according to gender, social rank, period, and region. Absent or rare in most Protestant countries (with the exception of England), the ruff sometimes took on inordinate proportions among

the Catholic ones, notably in Spain and Flanders in the years 1600 to 1620, to the point that King Philip IV had to legislate against such excesses before purely and simply banning their use. In this period, moreover, because of being mocked, ruffs fell into disuse in France and England and were replaced by a wide, turndown collar, embellished or bordered with lace and extending over the shoulders, back, and chest.

Whatever the form and dimensions of the ruff, it was always white in color, as was everything that touched the body, at least among the upper classes: undergarments or what replaced them, intimate apparel, nightshirts and nightcaps, sheets and bedding, handkerchiefs, sashes, and scarfs. The brighter white the fabric for these items of clothing, visible or not, the higher the rank of the one wearing it. Even the teeth themselves had to be perfectly white. If that was not the case, they had to be hidden or whitened using abrasive powders or detergents, or even disinfectants, always with limited and precarious effects. Like a good horse, a true nobleman was judged by his teeth.[144]

Chiaroscuro

In this famous painting, black and white dominate, but gray, beige, and brown tones accompany them. One part of the scene is in shadow and the source of light remains uncertain. But it illuminates the faces and almost all of the cadaver. This is the body of a man condemned to death whose name we know: Adriaen Adrianszoom. Three qualities of white are brought out in the painting: the brilliant white of the ruffs and collars; the dull white of the cloth that covers the dead man's genitals; the greenish white of the whole cadaver. Rembrandt, *The Anatomy Lesson of Doctor Tulp*, 1632. The Hague, Mauritshuis.

The White of the Monarchy

As the color of the aristocracy, white also became the color of kings and monarchies in the modern period, first in France, then in other European realms. This evolution was slow, slower than the color's progressive association with nobility. Let us linger a moment on the white of French kings.

Actually, the origins of royal white date back quite far, since the lily—white flower par excellence—was already a symbol of purity and an attribute of sovereignty in antiquity. We have seen how that double symbolic function earned it the role of Christological symbol in the Middle Ages, and then of Marian attribute, and finally of heraldic emblem for the Capetian monarchy, with King Louis VII placing the French realm under the protection of the Virgin. But in making its entry into coats of arms, the flower changed color, abandoning white for gold, since gold often played a superlative role in the Middle Ages, as a kind of "super white."

Lily aside, it was not until the early fourteenth century that the first material sign appeared associating the king of France with the color white, in this case a monochrome sash worn at the battle of Mons-en-Pévèle (1304) by some units of the army of King Philip IV (called Philip the Fair).[145]

That white sash reappeared many times on the battlefields during the Hundred Years' War: a wide band of cloth worn diagonally over armor or bliaut, from the shoulder to the top of the thigh. But as early as the mid-fourteenth century, another emblem was added to it or replaced it: an upright cross of the same color, sometimes called the "cross of Saint Michael," after the archangel who commanded the heavenly militia and was one of the patron saints of the realm.[146] In the following century, during the political and military crises that shook western Europe, the use of crosses of different forms and colors often allowed for

The White of Mourning

For the queens of France, the practice of wearing white for mourning appeared in the Valois court in the mid-fourteenth century and lasted until the end of the sixteenth century. The last queen to have followed this custom was the wife of King Henry III, Louise of Lorraine, who was widowed in 1589 and died in 1601. Meanwhile, the practice had been adopted in other European courts, but beginning in the years 1550–60, black began to replace white for mourning and finally achieved dominance. François Clouet, *Mary Stuart in Mourning*, c. 1562. Chantilly, Musée Condé.

Henry IV and the White Sash

Although Henry IV at the Battle of Ivry (March 14, 1590) probably never pronounced the words attributed to him by posterity, "Rally to my white panache . . ." he nevertheless did wear a white banner as a sash over his battle dress: first commanding the Huguenots in the wars against the League, and later commanding the royal armies during the wars against Spain and Savoy. Frans Pourbus the Younger, *Henry IV*, c. 1610–15. Versailles, Châteaux de Versailles et de Trianon.

distinguishing opposing forces: an upright white cross for the armies of the French king and the Armagnac contingent; an upright red cross (the cross of Saint George) for the English; a diagonal cross or "saltire" (cross of Saint Andrew), first white, then red and saw-toothed for the Burgundians; a white saltire for the Scottish; and later, an upright black cross for the Bretons. As for the crosses of the Flemish, in this troubled period, they showed much variety in form and color, in connection with memberships and reversals in alliances.[147] On the sea, signs were simpler but used less frequently: an entirely white flag for ships of the French king, white with a red cross for those of the English king, blue for those of the Scottish king, red with a white cross for those of the Danish king.

During the Italian Wars, white, which sometimes symbolized the figure of the French king, sometimes the whole of the realm, appeared more and more often, not only during military combat but especially in processions, parades, entrances, and ceremonies. A white cross and white clothing were joined by a large white standard sown with gold fleurs-de-lis or even displaying a shield *d'azur à trois fleurs de lis d'or*. France did not yet have an official flag—it was much too early—but this standard more or less took its place since it represented both king and state, and sometimes, more tentatively, the nation. Later, during the French Wars of Religion, the white sash made its reappearance, no longer to adorn the royal army but to distinguish the Huguenot troops. It opposed the red sash of the Spanish armies and some Catholic troops as well as the green sash of supporters of the houses of Guise and Lorraine. This white, the French Protestants claimed, symbolized the purity of their faith, while "papist" red was the color of pride, violence, and debauchery.[148]

It is unlikely that at the Battle of Ivry (March 14, 1590), Henry IV ever uttered the famous words that, following Agrippa d'Aubigné[149] and then Voltaire, historical tradition has attributed to him: "Rally to my white panache, you will always find it on the road to honor and victory."[150] What would the king of France be doing, after all, plunged into the fray, exposed to danger, and sporting a helmet adorned with a huge display of feathers so that everyone

The White Flag

At the end of the ancien régime, the king of France had a banner (*d'azur semé de fleurs de lis d'or*) and coat of arms (*d'azur à trois fleurs de lis d'or*), while the French realm had a flag. The latter was entirely white, sometimes strewn with a few gold fleurs-de-lis. This was the flag that the royal and Catholic armies carried into battle in the War in the Vendée (1793–96). Until 1815, it also reappeared frequently during royalist demonstrations and uprisings. Pierre-Narcisse Guérin, *Henri de La Rochejacquelin*, 1816. Cholet, Musée d'art et d'histoire.

could recognize him? That would be bizarre, degrading, and dangerous. On the other hand, it is possible that a standard-bearer stayed close to him, along with a few soldiers wearing white sashes, although he was observing the fighting from a distance, either on foot or on a white horse, the traditional mount of kings since very ancient times.

Later, Henry IV required royal troops to wear white sashes, sometimes combined with a cross of the same color.[151] The former Protestant emblem was thus transformed into a sign of the monarchy.[152] Similarly, over the course of decades, the white cross became the emblem of all infantry companies, appearing on both the colonel's and the orderly's flags. Moreover, a regulation from October 1690 required the presence of a white sash at the top of the flagstaff, below the point, not only on the flags of companies of foot soldiers but also on the standards of the cavalry. This organization of military practices put an end to mishaps resulting from confusion about emblems and colors, like the one that took place that same year at the battle of Fleurus (July 1), when French artillery fired on its own troops![153] At sea, similar rules developed. The royal navy displayed a white flag with the *d'azur à trois fleur de lis d'or* shield, while, beginning in 1765, the merchant marines replaced their blue flag with a monochrome white one.[154] At the dawn of the French Revolution, the white of the monarchy—which originally involved mainly military power—thus tended to become the white of France.

That did not last long, however. In 1789, in the days following the storming of the Bastille, the first tricolor blue, white, and red cockades appeared, and those three colors quickly became the ones signaling support for the new ideas, and subsequently for the Nation and the Revolution underway. In contrast, white became strongly monarchic and embodied the counterrevolution. The starting point may have been a banquet held at Versailles on October 1, 1789. On that day, the king's bodyguards were celebrating and reportedly trampled underfoot the tricolor cockades, very popular ever since the events of July. They replaced them with white cockades provided by various ladies of the court. The event caused a great outcry and was one reason for the October Days, October 5 and 6, 1789, when

a Paris mob marched on Versailles, lay siege to the castle, and forced the king and queen to return to Paris with them. Consequently, the counterrevolutionaries tried their best to replace the tricolor cockade—declared the "national" cockade by the Constituent Assembly on July 10, 1790—everywhere with the white cockade.

After the fall of the monarchy (August 10, 1792), this war of cockades paralleled an increasingly bloody war of flags. In western France, the "Catholic and royal" armies fought displaying white cockades and white flags. Sometimes appearing on the flags were fleurs-de-lis or even the image of the Sacred Heart of Jesus, to which Louis XVI, now imprisoned in the Temple, was particularly devoted.[155] In the various émigré armies, white cockades and white flags were adopted as well, and even, for the officers, white armbands.[156] White had fully become the color of the counterrevolution. It opposed both the blue of the soldiers of the Republic and the tricolored cockade and national flag.

The white flag made a return in France with the restoration of the Bourbon king in 1814–15. Substituting it for the tricolor flag did not happen without conflict or incident. Many officers, soldiers, civil servants, towns, and constituent bodies that recognized Louis XVIII would have liked to keep the tricolored flag, along with the white one. The Bourbons opposed the idea, which was undoubtedly a mistake. Moreover, they somewhat altered the white flag of the ancien régime, which had been entirely white. During the Restoration, and then among the Legitimists in the decades following the French Revolution of 1830, it was covered with gold fleurs-de-lis. This ran counter to earlier customs and somewhat weakened the symbolic power of the plain white cloth. Although it is true that since the eighteenth century, in the context of war, the plain white flag had also become a sign of surrender among all the armies in Europe.

After the days of July 1830 and Louis Philippe's ascent to the throne, the tricolor flag became once again—and definitively—the flag of France. The white flag again went into exile, reappearing only briefly on French soil in 1832, during the mad adventure of the Duchess of Berry in the south and west of France. A few decades later, in the years

1871 to 1873, the Count of Chambord's stubborn rejection of the tricolor flag prevented the monarchy's return in France. For this grandson of Charles X, the only legitimate flag was the white flag, under which he wanted "to bring order and freedom to France." According to him, Henry V (which was to be his name as king) could not "abandon the white flag of Henry IV."[157] Here, in fact, were two opposing conceptions of the future of France, symbolized by two flags that had long confronted each other. The white flag represented the monarchy of divine right; the tricolor flag represented popular sovereignty. In 1875, the Republic was confirmed (by a majority vote), the Count of Chambord remained in exile, and the white flag was used only by the monarchist Legitimists.

Meanwhile, the adjective "white" had taken on a political meaning and had become synonymous with "royalist." Although the expression "white terror" only appeared later, penned by historians toward the end of the nineteenth century to describe the bloody counterrevolutionary episodes of 1795, 1799, 1815, and 1871, the "whites" opposed the "blues" during the War in the Vendée (1793–96) to distinguish the two armies present, one supporting the Bourbons, the other the Republic. Alexandre Dumas made this the title of a successful historical novel, *Les Blancs et les Bleus*, serialized in 1867. Beyond France, the word "white" was also used in reference to monarchical regimes or their supporters. In Russia, for example, after the Bolshevik Revolution, the White Armies opposed the Red Army between 1917 and 1922, and until recently a "White Russian" was a Russian who lived in exile and advocated the return of the tzarist regime.[158]

From the White Flag to the Tricolor Flag

With this composition, the painter Léon Cogniet wanted to
celebrate the revolutionary days of July 27–29, 1830, and to show
how the white flag of the former monarchy was transformed into
the tricolor flag. Where the white flag is ripped, a bit of blue sky
appears, while on the right, the cloth is stained with the blood of
the martyrs of the revolution. Léon Cogniet, *Les Drapeaux*, 1830.
Orléans, Musée des Beaux-Arts.

Ink and Paper

For the moment, let us leave monarchical white to its fate and return to an earlier time. Between the late Middle Ages and the late seventeenth century, white entered a new phase of its history. Like black, with which it was closely associated henceforth—which had not always been the case previously—it acquired special status within the chromatic order, gradually leading to its loss of status as a true color. The sixteenth and seventeenth centuries witnessed the progressive establishment of a kind of black-and-white world, first located on the margins of the color universe, then outside that universe, and finally, in direct opposition to it.

These slow and extended changes—taking place over two centuries—began with the appearance of printing in the 1450s and achieved their outcome symbolically in 1665–66 when Isaac Newton carried out new experiments with glass prisms and broke down the white light of the sun into colored rays. In doing so, the English scientist revealed a new order of colors: the spectrum, which was not immediately adopted, of course, in all areas of knowledge—for Newton, it only involved physics—but which gradually took hold in all the sciences, before finding its way into the material culture and everyday life.[159] To the present

day, it remains the basic scientific order for classifying, measuring, studying, and monitoring colors. In this new chromatic order there was no longer a place for either white or black. Indeed the spectrum is a color continuum in which, conventionally, seven colors are distinguished, the colors of the rainbow: purple, indigo, blue, green, yellow, orange, red.

That said, the reasons that eventually led to expelling white and black from the color order were not only scientific. Religious and social moral codes of the late Middle Ages, which the Protestant Reformation inherited in part, probably provided the original incentive. With the Renaissance, some artists took up the charge and sought to "make color into black and white," notably through engraving. Later, they were replaced in turn by many men

Color in Black and White
The irony of technical advances: it is a black and white print that shows us the painter Jan Van Eyck's studio here and the invention attributed to him. The Latin caption expresses it nicely: *Oil paint, so useful to painters, it is the famous master Van Eyck who invented it.* This tradition was propagated by Vasari and accepted until the twentieth century. Jan van der Straet (drawing) and Théodore Galle (engraving), *Nova reperta 14: Oil paint*, c. 1600.

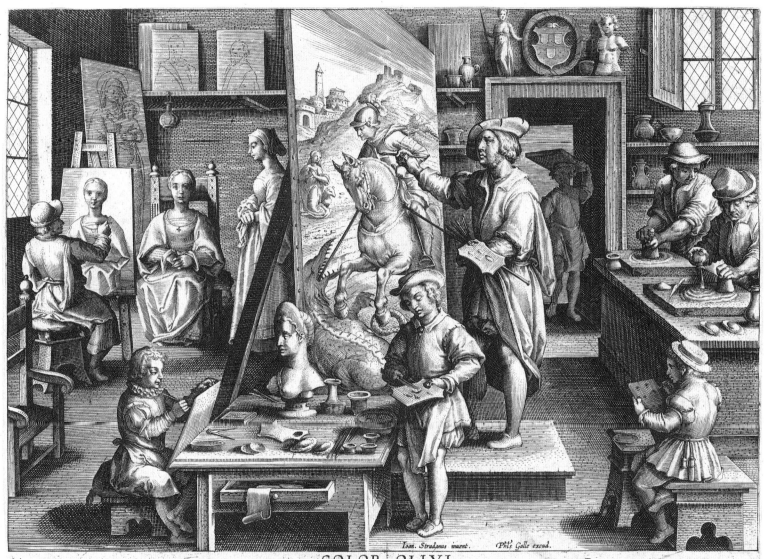

14.

COLOR OLIVI.

Colorem oliui commodum pictoribus, *Inuenit insignis magister Eyckius.*

Ioan. Stradanus inuent. Phs Galle excud.

Der Buchdrücker.

Printer's Workshop

There were many printing shops in the sixteenth century. These were somewhat mysterious places where the most noble knowledge existed side by side with the messiest materials, as did the immaculate white of the paper with the dense, heavy black of the ink. Jost Amman, *Book of Trades*, Nuremberg, 1568.

of science who, through their work on optics, prepared the way for Newton's discoveries. But the essential turning point dates further back, to the mid-fifteenth century, when printing made its appearance in Europe. More than the preoccupations of the moralists, more than the creations of artists, more than the research of scientists, it was the proliferation of the printed book and engraved image that constituted the principal vector for these changes and led to making white and black colors "apart." And even more than the book itself, it was undoubtedly the engraved and printed image—in black ink on white paper—that played the essential role in this process. All or almost all medieval images were polychrome; the vast majority of images in the modern period, circulating within and outside of books, were black and white. This marked a cultural revolution of great magnitude, not only in the realms of knowledge and technique but also in the realm of sensibility.

With printing, ink became a referent for black (in the same way as pitch and coal were), as paper became the white medium par excellence.[160] This was no longer the ink of handwritten manuscripts, pale, uneven, laboriously traced on parchment, and often fading from black to more brown or beige over the course of time. It was a heavy, thick, very dark ink that a mechanical press made penetrate the fibers of the paper and that perfectly resisted the various vicissitudes to which books were subjected. Any reader or simply curious person who opens a work printed in the fifteenth century is still struck, almost six centuries later, by the whiteness of the paper and the blackness of the ink. Without the development of this dense, solid ink, quick to dry and permanent, printing would certainly not have enjoyed the rapid success it did.[161] This particular ink made the world of printing a world that maintained close material, technical, symbolic, and even oneiric relations with the color black. From the beginning and for long after, the printing shop resembled an infernal grotto; not only did the smell of ink suffuse every nook and cranny, but the objects found there were permeated with it. Everything was black, dark, heavy, and more or less viscous.

Everything except the paper, which, on the contrary, before being printed, was an immaculate white and carefully handled to keep it that way ("accidents" and messes were nonetheless common). The book quickly created a universe imagined in particular colors; the black of the ink and the white of the paper merged harmoniously there. That was why later works printed with inks of different colors or on colored paper would never resemble real books. In a book worthy of its name, everything had to be "written in black and white"!

The white of the paper did indeed contrast with the black of the ink. Appearing in China in the first century CE, perhaps a bit earlier, paper was imported to the West by the Arabs. It was found in Spain by the end of the eleventh century and in Sicily at the beginning of the twelfth century. Two centuries later, it was generally used in Italy for certain notarial deeds and most private letters, after which it made its appearance in France, England, and Germany. By the mid-fifteenth century it was present throughout Europe and had already been competing with parchment for some decades for use in copying certain handwritten books. Numerous paper mills sprang up, especially in market towns. Gradually the West stopped importing paper and started exporting it. The primary material, rags, came from remnants of hemp or linen cloth, especially from cloth used for chemises, the only "undergarment" worn by both men and women, which had come into general use beginning in the thirteenth century. The textile industry produced these chemises in very large numbers; their contributions to the scrap heap kept the paper industry well supplied. Paper was an expensive product nevertheless and remained so until the eighteenth century. Papermakers were rich men, and often they were the ones who provided the first printers with the funds they needed, because, from the start, printing a book was first and foremost a business venture.[162]

The first paper used in Europe for archival documents, written missives, academic writing, and later for woodcut images, was not really white. It was closer to yellow, beige, or ecru and had a tendency to darken over time. With printing, which required vast amounts of paper, it became thinner, less grainy, more bonded, and especially lighter and more stable in color. Although we do not know how or why, paper rapidly lightened from beige to off-white, and then from off-white to true white. In medieval handwritten books, the ink was never completely black and the parchment never white. With the printed book, the reader henceforth beheld very black ink on very white paper. This marked a revolution that would lead to profound changes in the domain of color sensibility. Henceforth, artisans knew how to make a product for everyday use that was white as snow, flour, or salt. Paper remains that way today and, despite the digital revolution, does not seem close to disappearing or to losing its whiteness.

NEXT PAGE SPREAD

Paper, the Law, and Taxes

Even before printing appeared, handwritten documents—financial, legal, notarized—already proliferated in the major cities. Once printing was established, administrative "paperwork" spread throughout Europe. This famous painting, which exists in many versions, accurately captures the situation. Pieter Breughel the Younger, *The Village Lawyer* (or *The Tax Collector's Office*), 1621. Ghent, Museum of Fine Arts (MSK Gent), Inv. 1952 G.

THE
COLOR OF
MODERNITY

EIGHTEENTH TO TWENTY-FIRST CENTURIES

White at the Limits of Painting

The bibliography devoted to this painting is considerable. We now know that it was not the first monochrome in the history of modern painting, as has often been claimed. We also know that the political interpretation it has sometimes been given remains debatable. Better to note that such a canvas—nearly impossible to photograph or reproduce, especially with regard to rendering the various qualities of white—retains a share of its mysteries. Kasimir Malevitch, *White on White*, 1918. New York, Museum of Modern Art.

n Europe, many profound changes altered the course of history for the color white between the end of the seventeenth century and the present era. They involve a number of areas: fields of knowledge, social practices, language and the lexicon, emblems, and symbols. The first, and no doubt the most important, was the withdrawal of white from the universe of colors. When Isaac Newton discovered the spectrum in 1666, he revealed a new chromatic order within which there was no longer a place for either white or black. Of course at first this revolution only involved physics, but it rapidly expanded to include all the sciences, then technical skills, and finally material culture and everyday life. For almost three centuries, white and black ceased to be colors and eventually even came to be considered their opposites. Today, such ideas have largely been abandoned, even by many physicists, but a portion of the general public still adheres to them, viewing white as the absence of color and making the word "white" synonymous with colorless.

The second change was less theoretical and involved the color as material. Over the course of decades, the white tones developed by humans became increasingly clean, saturated, and luminous. They were no longer dirty, drab,

ecru, grayish, or yellowish as was the case in antiquity and the Middle Ages, but for the first time, truly white, sometimes brilliantly so. This was also a revolution. It affected cloth and clothing first, then objects produced by artisans and industries. Thus the place of white in the material culture was continually expanding and its symbolism growing richer. To the idea of purity, still and forever associated with this color, were added ideas of cleanliness, hygiene, elegance, health, and well-being. Relatively rare in the past, white became ubiquitous in everyday life, to the point of occupying almost too much space, becoming neutral, and letting other colors express ideas formerly associated with it, like peace, wisdom, and knowledge. Consider, for example, that ecology today does not entrust the mission of saving the planet to white, but rather to green.

That involves the future, however, let us return to the past. White's ever increasing presence on the technical and material planes was accompanied for two centuries by its growing influence on language and the lexicon, codes and sign systems, art and representations. In French, as in related languages, the figurative meanings for the adjective *white* multiplied, and in the world of signs, its role continued to expand, not so much independently as in combination with another color (dichromatic white/blue, white/red, white/green), thus becoming a mark of elegance, good taste, and modernity. That is perhaps the primary meaning of white in Europe today: "to make modern," or at least to express a sober, dignified modernity, free of all flourish, all fantasy, all vulgarity.[163]

White and Black: No Longer Colors

The seventeenth century was a great one for science. In many areas, knowledge was augmented or transformed and gave rise to new theories, definitions, and classifications. That was the case with the physical sciences, especially with optics, which had not seen much progress for many centuries. There was much speculation on light and therefore on colors and vision. At the very moment when painters were discovering empirically a new way of classifying colors by distinguishing what would later be called primary colors (blue, yellow, red) from complementary colors (green, purple, orange), scientists were proposing new theories and combinations that prepared the way for Newton and the discovery of the spectrum.[164] Of course, many authors continued to think, as Aristotle did, that color was light, light that lightened or darkened by passing through various objects or mediums. Its diminishment in quantity, intensity, and purity thus gave rise to different colors. That was why, when colors were located along an axis, they all fell between a white pole and a black pole, which were themselves fully part of the chromatic order. White and black were both colors in their own right. But along this axis, between the two poles, the other colors were not organized in the spectral order. A few variants existed, but the order most often proposed remained the one traditionally attributed to Aristotle: white, yellow, red, green, blue, black. No matter what the domain, these six colors were the basic ones. If one wanted to create a system of seven, a septenary, more effective on the symbolic level, a seventh color, purple, could be added, located between blue and black. That was how most diagrams, schemas, figures, and representation systems appeared as proposed by authors in the first half of the seventeenth century. White and black were part of

When Black Was Brown

Very often, nineteenth-century photographs were not so much "black and white" as a mix of more or less dark browns with other beige, cream, or off-white tones. The variety of these shades resulted from the type of photographic paper, the quality of the products used for developing and fixing, and the way the print aged. *The Sea and Victor Hugo's House (Hauteville House) in Guernsey*. Anonymous photograph, c. 1860.

THE HISTORY OF A COLOR

them, and their union or their fusion according to various proportions gave rise to the other colors.

Then came Isaac Newton (1642–1727), perhaps the greatest scientist of all time. Over the course of the academic year 1665–66, while the plague kept him away from Cambridge and forced him to return to his mother's home in Woolsthorpe in Lincolnshire for an extended vacation, he made two exceptional discoveries in a few months' time: first, the dispersion of white light and the spectrum; second, terrestrial attraction and universal gravitation. For Newton, the colors were "objective" phenomena; it was necessary to set aside questions involving vision, tied too closely to the eye (which seemed to him "deceptive"), and questions of perception, too subject to different cultural contexts, and to concentrate on the questions of physics alone. That is what he did by cutting glass and repeating old prism experiments again in his own way. He took as his starting point the hypotheses of his immediate predecessors, principally Descartes, for whom color was nothing other than light that in moving and encountering bodies was subject to various physical modifications.[165] Knowing the nature of that light—undulatory or corpuscular— was not important to Newton, although it was a question debated by all the physicists of his time.[166] For him the essential thing was observing its modifications, defining them, and if possible, measuring them. By multiplying the prism experiments he discovered that the white light of the sun did not diminish at all, nor darken, but that it formed an elongated, colored patch, inside of which it was dispersed into many rays of unequal lengths. These rays formed a chromatic sequence that was always the same: the spectrum. Not only could the white light of the sun be broken down in this way through experiments, but it could also be reconstituted beginning with the colored rays. By these means Newton proved that light did not weaken to give rise to colors, but was itself, innately, formed from a union of different colored lights. This was a very important discovery. Henceforth light and the colors it contained were identifiable, reproducible, controllable, and measurable.[167]

Newtonian Opticks

It was not until 1704 that Isaac Newton (1642–1727) published his great treatise on optics, comprising the synthesis of his many earlier works on light and color begun in the years 1665 to 1666 while he was still a Cambridge student. The first edition in English created less of a stir than the second one, published three years later in Latin. In the early eighteenth century, Latin remained the language of scholars. Isaac Newton, *Opticks: Or, a Treatise of the Reflexions, Refractions, Inflexions, and Colours of Light*, London, 1704.

These ideas, which constituted a decisive turning point, not only in the history of colors—especially that of white and black, absent from the new chromatic order—but also in the history of the sciences in general, had difficulty gaining acceptance nevertheless. That was largely because Newton kept them secret for many years, and then only revealed them partially, in several stages, beginning in 1672. It was not until his general survey of optics was published in English in 1704, summarizing all his earlier work, that the whole of his theories on light and colors became definitively known by the scientific world.[168] Newton explained how white light was a mix of lights of all colors, and that by crossing through a prism it was dispersed into colored rays, always the same, formed by minute particles of matter, possessing great speed, and variously attracted or repelled by bodies. Meanwhile other researchers, beginning with Christian Huygens (1629–1695), had made progress in the study of light and proposed that its nature was more undulatory than corpuscular.[169] Newton's work finally was favorably received, however, and to gain an even wider audience was immediately translated in Latin.[170] Authentic scientist that he was, Newton admitted to not being able to provide answers to all the queries he had posed and left to posterity thirty unresolved questions.

What marred the reception of his discoveries and led to a certain number of misunderstandings for many decades was the vocabulary he used; he employed the vocabulary of painters but gave the words different meanings. For example, for him "primary" colors had a particular meaning and were not limited to red, blue, and yellow, as they were for most painters in the second half of the seventeenth century. Thus arose confusions and misunderstandings that would last well into the eighteenth century and be echoed in Goethe's treatise *Theory of Colors*, nearly a century later. Similarly, on the number of colored rays dispersed by the white light crossing through the prism, Newton's position was a bit fluid and earned him various criticisms. His detractors were sometimes acting in bad faith, but he himself did not offer any very stable opinion.[171] First, in late 1665, he seemed to identify five colors in the spectrum: red, yellow, green, blue, and purple. Then, perhaps in the years 1671–72, he seemed to add two more colors, orange and indigo, to make a septenary and thus promote the reception of his ideas by not straying too far from traditional thinking, accustomed to chromatic ranges containing seven colors. Moreover, he himself proposed a comparison with the seven notes in the musical scale, which subsequently earned him reproach. Newton indeed recognized that dividing the spectrum into seven colors was artificial. The spectrum was, in fact, a colored continuum, which could easily be divided otherwise and in which could be seen a considerable number of colors. But it was too late: the spectrum—and with it, the rainbow—retained its seven colors.

Nevertheless, for the historian of color that was not the essential thing. Newton had developed a new chromatic order unrelated to earlier ones, forming a sequence unknown until that time, and which would remain the basic scientific classification up to the present: purple, indigo, blue, green, yellow, orange, red. The traditional order of the colors was overturned. Red was no longer at the center of the sequence but at the end, and green appeared between yellow and blue, thus confirming what painters and dyers had been doing for many decades—producing green by mixing blue and yellow. But, most importantly, in this new order of colors there was no longer a place either for white or for black. That constituted a revolution; white and black were no longer colors.[172] They would eventually assume their autonomy and create their own universe: black and white on one side, the colors themselves on the other.

That opposition was already at work in the printed book and engraved image. In the nineteenth century, it expanded into other technical areas. That was the case with photography. Even if, until the 1900s, photographic blacks were not completely black and photographic whites not truly white, even if grays and browns also found their way into this new process, there were nevertheless hundreds of millions of black-and-white images circulating in Europe and the world henceforth. True color photography long remained unsatisfactory in quality and limited in circulation. For over a century then, the world of photography was a

world of black and white, providing representations of current events and everyday life that were limited to these two colors, to the point that, over the course of decades, states of mind and sensibilities also developed the tendency to limit themselves to black and white, from which they had a hard time escaping. In the area of information and documentation in particular, despite considerable progress in color photography beginning in the 1950s, the idea persisted that black-and-white photography was precise, accurate, and faithful to the reality of beings and things, whereas color photography was unreliable, frivolous, and deceptive. In many European countries, for example, until very recently, official documents and identity papers had to be accompanied by black-and-white photographs and not color ones. In France, when I was an adolescent in the early 1960s, identity photographs in color, however easy to obtain in automatic booths on street corners, were strictly forbidden for passports and identification cards. They were not considered "true likenesses." Authorities were suspicious—and perhaps still are—of color, deemed fallacious, enticing, artificial.

Black-and-white photography exercised its monopoly over historians as well for many long decades. It is true that, in the area of documentary information, early photography took over from engraving, which, since the late fifteenth or early sixteenth century, had largely been responsible for the wide diffusion of images, within and outside of books, almost exclusively in black and white. Thus photography only prolonged and intensified practices more than three centuries old. For historians, color did not exist and would hardly find its way into their research for four or five generations to come. That explains why, in areas where specialized studies on questions of color might have been expected—the history of art, dress, everyday life—no such studies were undertaken prior to the late twentieth century. Even with regard to the history of painting, color was long neglected. From 1850 until about the years 1980 to 2000, there were many specialists in this field—some very famous—who published hefty, scholarly books on the works of painters or pictorial movements without ever discussing colors!

Photographing Mountains

Beginning in 1845–50, mountains attracted outdoor photographers. The photographs that were exhibited in the years that followed, notably during the 1855 Exposition Universelle in Paris, struck viewers because the images they offered were so different from those presented in romantic or fanciful engravings from the late eighteenth century and first half of the nineteenth century. Auguste-Rosalie Bisson, *The Ascent of Mont Blanc*, 1861. New York, Metropolitan Museum, Gilman Collection.

The White of Artists

et us remain in the world of painters to see what white pigments were used over the course of history before modern chemistry offered artists synthetic products to replace traditional materials, whether natural or produced by craftsmen.

On the painted walls of Paleolithic caves, white tones are less abundant than reds, blacks, and yellows, breaking down over millennia into numerous shades; whites may also be more recent. As for greens and blues, they are totally absent.[173] On the other hand, whites were used very early and abundantly for body painting, of which we know little more than that it probably preceded all other forms of painting. In comparison with practices that are clearly more recent, observable among certain African, American, or Oceanian peoples, we can assume that the white tones covering the face, torso, and limbs were chalk or kaolin (white clay) based.

In fact nature offers many materials for making white paint: various, easily crushed limes (chalks, calcites, shells), gypsum that becomes plaster after firing, as well as different clays, of which kaolin provides the best coverage. Transforming these materials into true pigments was relatively easy, which is why they were present in Egyptian painting and then later in Greek and especially Roman painting. Nevertheless, the white pigment most widely used in Europe, from ancient Roman times until the nineteenth century, was not lime, gypsum, or clay based; it was lead-based ceruse (basic lead carbonate). All painters appreciated its covering power, stability in light, low cost, adaptability, and the quality of tones it provided. It was not until the nineteenth century that it was phased out due to its dangers, which had nevertheless been known for a long time. It was gradually replaced by zinc oxide, nontoxic but providing much poorer coverage, and then in the twentieth century by titanium white, more satisfying to use but relatively expensive.

Vermeer's White

The pigments Vermeer used were classic in terms of his century's painting. For whites, he chose ceruse, that is, a common white lead paint. But, as was often true in the seventeenth century, that white lead contained a bit of antimony, which modern ceruse lacks. It was the absence of antimony that confirmed the alleged "Vermeers" painted by the famous Van Meegeren (1889–1947) were, in fact, forgeries, a finding that experts were very slow to acknowledge. Vermeer, *The Little Street*, c. 1658. Amsterdam, Rijksmuseum, Inv. SK. A. 2860.

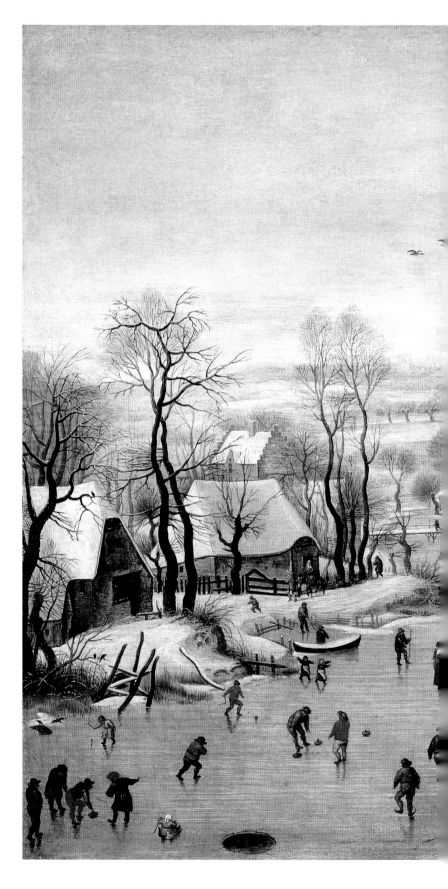

The Whites of Winter

Only relatively recently did European painters take an interest in snow and ice: winter scenes are rare in medieval and Renaissance painting. Avercamp (1585–1634) was the first painter to make winter central to his work. For him, winter was an opportunity to multiply the shades of white according to the state of the snow, the look of the frozen canals, the time of day, and the brightness or waning of the light. Hendrick Avercamp, *Winter Landscape*, c. 1608–10. Amsterdam, Rijksmuseum.

White on White: A Pierrot in the Snow

Originating in Italian commedia dell'arte, the Pierrot character is both naive and comic, always dressed in white with a powdered white face. In this painting by Gérôme, he appears as the victim of an early morning duel in the Boulogne wood, following a costume ball. The work was a huge success. Jean-Léon Gérôme, *The Duel after the Masquerade*, 1857. Chantilly, Musée Condé, Inv. PE 533.

As with all lead-based products, ceruse is a powerful toxin, for those making it as well as for those using it or even simply breathing it, which did not prevent it from being used early on as a pigment as well as a cosmetic. Roman matrons, for example, used it to whiten their complexions, covering themselves with thick makeup composed of white lead mixed with oils, wax, and various mineral powders. This permitted them to hide the irregularities in their skin (redness, spots, wrinkles). The women of medieval aristocracy used much less makeup than the great Roman matrons, but in the era of chivalry and courtesy, they sometimes applied a thin coat of ceruse over their faces to contrast with the red of their lips and cheeks. Such practices increased in the second half of the seventeenth century and reached their height in the eighteenth century. Men and women covered their faces with white lead that accentuated the red products they used on lips and cheeks, cinnabar based and just as dangerous. There were many, many accidents, but the desire to be beautiful was stronger than the fear of death.[174]

Medieval recipe collections, manuals, and treatises from the modern period offer many processes for making ceruse, the pigment so prized by painters. The simplest one consisted of employing the oxidizing action of an acid on thin strips of lead, tightly sealed in a receptacle containing organic materials that released carbon dioxide as they fermented. A simple cask, some vine shoots, some strips of lead, and vinegar or urine sufficed for making ceruse. Certain authors claimed that burying the filled cask in manure accelerated the process. Once collected, the ceruse was washed many times, crushed, dried, and stored in the form of powder. By heating ceruse, painters also made massicot (yellow) and minium (red), depending on the temperature. Like all lead-based pigments, ceruse could not be used next to sulfur-based ones (orpiment and vermilion, for example). Not all painters knew that, unfortunately, and their whites rapidly turned gray and then blackish. On the other hand, ceruse blended easily with chalk, which made it very stable. That was why in panel painting and then on canvas it was sometimes used in place of gesso (a coating made with plaster and animal glue) as a preparatory layer applied directly to the medium or more frequently as an undercoat for the actual pictorial surface.[175]

In the history of Western painting, white is the color most used, either by itself or in combination with another color. In the first case, ceruse is the dominant pigment, often employed alone; in the second, it is mixed with other pigments, notably those with a lime base because they stabilized the color and facilitated mixing practices. Eighteenth-century painters thus desaturated ceruse by combining it with chalk, but the tones they obtained were often too matte. For that reason, they added a few traces of more or less satiny blue or pink. For small surfaces they preferred whites with eggshell or calcined deer antler bases, thus animal and not mineral materials. Later, beginning in the years 1760 to 1780, neoclassical taste in painting as in architecture tended to intensify the use of white tones, and thus to increasingly diversify the range of materials for obtaining them.

Let us pause for a moment to consider neoclassical painting, which probably granted white the most important place ever on the painter's palette, that is, until the abstract movement of the twentieth century. It might seem that the discoveries of the sites at Herculaneum and then Pompeii (identified in 1763) would have made artists want to imitate Roman painting, with new examples of it coming to light each year. But that was not the case at all, at least at first. A few initial vestiges were uncovered in the late sixteenth century, but they were considered obscene and reburied. Scholars and travelers gradually became aware of Pompeiian painting thanks to excavations undertaken a century and a half later, which they went to study in situ. For a long time that painting was considered inferior to the sculpture and architecture and elicited little curiosity. Some works were deemed improper and destroyed. Others were taken down or moved and sustained damage in these transfers. As for the ones left in place, they were treated no better. Each time a high-ranking visitor came to see them, it was the custom to give them a thorough wetting to make them momentarily shine. Goethe, who visited Pompeii in 1787, was scandalized by this practice.

There was another reason for the lack of interest inspired by painting in comparison to sculpture and architecture: its reproduction through engravings, that is, in black-and-white images. By the 1770s, a few watercolor touches might be added, but distribution of such images remained limited. That was why Roman painting was long underrated and considered suspect or incomprehensible. Its colors seemed too violent, its lines uncertain, its subjects frivolous, vulgar, or esoteric, and very far removed from the more or less fantasized image then held of ancient art. Neoclassicism did not escape all this and, beginning in the 1760s, had developed new doctrines, determined new hierarchies, and gradually reestablished drawing's dominance over colors. Among those colors, it became almost religiously devoted to white.[176]

Here, a name must be introduced, that of German archaeologist Johann Joachim Winckelmann (1717–1768), sometimes considered the founder of art history as an autonomous discipline. That is an exaggeration no doubt, but there is no denying that his works exerted great influence over the evolution of knowledge and elite tastes. An adversary of baroque and rococo art, an enemy of color, Winckelmann saw in Greek art absolute beauty. In doing so, he contributed to the emergence of new sensibilities and advanced artistic theories that for many decades would influence not only sculpture and architecture but also painting.[177] Because he himself had little interest in painting, his disciples—Raphaël Mengs, Joseph-Marie Vien, Johann Heinrich Meyer, for example—extended the new conceptions of art to pictorial creations. Priority was given to the purity of the line, the clarity of the planes, the restraint of contours. Color was an accessory. Its main role was to highlight the drawing, especially since composition was inspired by ancient bas-reliefs, space was defined, and perspective was generally frontal. The role of shadows was important, on the other hand, as was the play of chiaroscuro, but they both depended on smooth workmanship and off tones: no impasto or uneven touches, no slightly diluted pigments, no bright colors or sharply contrasting color ranges. Whites, grays, browns, and blacks dominated, especially whites. Sometimes a saturated red broke the chromatic monotony, but it was immediately balanced by a gradation of dark, dull shades. The lack of interest most artists took in still lifes explains the absence of bold greens, vivid yellows, and luminous oranges. Such was the palette of neoclassical painting, or at least its dominant characteristics, although of course there were numerous exceptions.

For the following period, it is customary to oppose neoclassical and Romantic painting, but that opposition is tenuous. Beginning in the early nineteenth century, many painters were already Romantics judging by the subjects they chose and the way in which they freed themselves from academic rules, but not by their choice or play of colors. Conversely, some artists were Romantics judging by their colors, light, and subjects, but not by their lines or general workmanship.[178] This discrepancy would continue over many decades and involve a great number of works that are difficult to classify. As it happens, defining

NEXT PAGE SPREAD, LEFT

Claude Monet's Whites

Snow enticed the impressionist painters, Monet most of all. Thus he left us eighteen canvases representing the snowy streets of Argenteuil during the harsh winter of 1875. Each offers a symphony of white tones that are more or less bluish, grayish, greenish, yellowish, pinkish, and especially purplish. Claude Monet, *Snow Scene at Argenteuil*, 1875. London, The National Gallery, Inv. 6607.

NEXT PAGE SPREAD, RIGHT

Snow Is not Drawn

Here, painting snow frees the artist from contour lines and gives priority to color over drawing, letting the artist set aside not only pencil and pen, but even a brush in order to give the work form, simply with his fingers. Painting snow releases the painter from all technical constraints. Albert Marquet, *Pont Neuf in the Snow*, 1947. Paris, Musée National d'Art Moderne.

a Romantic painting is no easy task. There are different ways of being Romantic in painting (as in literature, moreover). The way color is treated is one among many, and it was not just because painters used little white in their canvases (as was the case, for example, with Delacroix) that they were Romantics.

Later, the impressionists showed greater interest in white. If they took liberties with the classic rules of composition for a painting, they remained quite traditional in terms of the work required for painting with oil: preparation of the canvas (most often white), sketched drawing (pencil or charcoal), rough wash outline, application of pastes (more or less thick, smooth, viscous), and subtle play of glazes to give depths, richness, gloss, or transparency. Their originality—at least for many of them—came from their working outdoors and their rapid execution: cursory underlying drawing, no contour lines, few straight lines, no large areas of single flat colors, totally fluid gestures, the movement of the hand very visible in touches and impasto. Rendering depth and volume hardly concerned them, and their painting seems relatively flat, or at least does not layer plane over plane. Even if some finishing touches were done in the studio, what interested them first and foremost was capturing movement in the moment, that is to say, what stirs, trembles, passes. Hence the importance of the sky, air, water, wind, smoke, and even the crowd. Dark tones were not absent but they were never pure: no true grays or blacks, but dark blends of reds, blues, and greens. On the other hand, there were whites, many whites: pure whites, off-whites, yellowish, bluish, grayish, pinkish, purplish whites. Sometimes to excess.

The White of Cotton

Like snow, cotton allows the painter to demonstrate skill in translating onto the canvas a whole range of white tones. Edgar Degas first discovered this fiber in New Orleans in the years 1872–73, during a trip he made to visit his grandson and maternal uncles. There he painted many canvases on which the white of cotton contrasts with the black of clothing. Edgar Degas, *Cotton Merchants in New Orleans*, 1873. Cambridge, Harvard Art Museums, Fogg Museum.

From Cleanliness to Health

Beginning in the late eighteenth century, white, which since time immemorial had been the symbol of purity, also became the symbol of cleanliness and then of health, not only in the imagination and images but also in the material culture and everyday life. That was conveyed first through whiter textiles, whether it was a matter of canvas, linen, wool, or one of the many other fabrics that touched or surrounded the body. For the first time in history, men, women, and children of both the wealthy and middle classes could wear truly white chemises and undergarments and could sleep in sheets that were no longer beige, ecru, or grayish.

Of course this evolution did not take place over just one or two generations, but it was made possible by two discoveries: first, the isolation of chlorine by Swedish chemist Carl Wilhelm Scheele in 1774, and then its identification as a chemical element by British chemist Humphry Davy in 1809. It was Davy moreover who gave chlorine its name, based on its pale green color (*chloros* in ancient Greek). Then came the perfecting of bleach by French scientist Claude-Louis Berthollet in the years 1775 to 1777. By relying on the decoloring properties of chlorine, he invented a process that was finally effective for whitening cloth.

Since it was manufactured in the village of Javel, southwest of Paris, that place-name was given to the new product. Throughout the nineteenth century, this liquid chlorine was improved but its name did not change. Chlorine bleach is still called Javel in France.

The development of bleach constituted major progress. Previously, as we have seen, cloth had to be whitened "in the field" relying on the morning dew, or else with ashes from various kinds of wood, or plants in the saponin family. The results left much to be desired because the whites thus

The White of Sleep

In Europe, white is the color of sleep. Not only have sheets and bedding been white since the Middle Ages, but also sleep is most powerfully induced when one dozes off in a chair, dressed in a white chemise or gown. In our time, whoever sleeps in multicolored sheets or pajamas sleeps badly. Carolus-Duran, *Sleeping Man*, 1861. Lille, Palais des Beaux-Arts.

obtained soon yellowed. There were also ways to whiten using sulfur, but done badly, they ruined wool and silk, even linen and hemp. Indeed the cloth had to be soaked for a day in a bath of diluted sulfuric acid; if there was too much water, the whitening process was not effective; if there was too much acid, the cloth was damaged. Bleach put an end to such inconveniences, and cotton and linen fabrics finally became truly white.[179] Bedding as well as chemises and undergarments changed appearance. Collars, cuffs, and handkerchiefs were no longer the only places where truly white cloth could be seen.

At the same time, the chemistry of soaps and detergents was progressing, which helped to lower costs and increase distribution. Soap, which had been made according to virtually the same recipes since antiquity—consisting of using wood ash and adding animal or vegetable fats to it, later potash or soda—benefited from the work of chemists on fatty substances and saponification, as well as from the lower price of oils.[180] It began to be manufactured industrially and used widely for washing laundry, removing grease marks from cloth, and cleansing the body. All those uses had long existed, of course, but became general practice in the nineteenth century. Later, ordinary soaps were enhanced with perfumes and colorants as well as various additives to make them less abrasive and more moisturizing.[181]

Detergents followed a similar evolution. They also had a wood ash base to which was added various grease-removing materials (chalk, clay, later soda). Laundry was generally washed in cold river water, sometimes in wooden vats or tubs. For a long time, it was an operation that was only done twice a year (spring and fall), since it was long, exhausting work. In addition to the washing itself, there was the sorting, soaking, draining, beating, rinsing, wringing, open-air drying, and mending of the clothing before it was put away. Among the wealthiest classes, laundry was sometimes washed in hot water, but that was rare until the eighteenth century. Rivers provided water for the wash houses, gathering places where women met to rinse as well as wash their laundry. These were also opportunities to exchange news, secrets, and gossip.[182]

The Bathroom

Rooms reserved for hygiene and bodily care appeared in the eighteenth century but did not become standard until the end of the following century. Furnishings were originally wood and stone, then metal, ceramic, and finally porcelain. Thus white became the required color for these places entirely dedicated to personal hygiene. Advertising poster illustrated by Alfred Choubrac, 1901.

LAVABOS DE STYLE H.M

Vente exclusive de cette Affiche AGENCE NATIONALE DE

Nudity Is Not White

Henri Gervex (1852–1929) is a great painter of white, the dominant color in many of his canvases. His painting *Rolla*, inspired by a poem by Musset, created a scandal in 1878. Not only is there a naked woman lying lasciviously on a bed asleep while a man in a chemise looks on, not only is her most intimate apparel displayed in the foreground, but amid the bluish white sheets, her body is "an enticing pink that makes her nudity all the more immoral" (the reason given by the Salon jury for rejecting the painting). Henri Gervex, *Rolla*, 1878. Bordeaux, Musée des Beaux-Arts.

In the nineteenth century, laundry soaps became standard, and mechanical washing machines made their appearance in the years 1880 to 1890. The first electric washing machines did not appear on the market for another half a century, first in the United States and then in Europe. In the meantime, numerous detergent products were developed and through posters, newspaper, radio, and then television, benefited from advertising as never seen before. All ads vaunted the merits of a detergent that washed laundry whiter than competing detergents. These various innovations upended the lives of women and contributed to the widespread use of white linens, fabric, clothing, and undergarments in everyday life.

At the same time, bodily hygiene was developing. Cleanliness became both a moral and social value, an image of civility, that is to say, of propriety and virtue.[183] Public baths appeared almost everywhere, replacing thermal baths and steam rooms and not becoming rare until the 1960s.[184] Beginning in the eighteenth century—a period of great development with regard to all intimate matters of the body—some houses and apartments featured rooms reserved for bathing. They became more numerous in the second half of the following century, first among the wealthy classes and then the middle classes in big cities who also wanted to have "bathrooms." The nature of the materials used for the furniture, objects, and receptacles found there changed: from wood and

Washstand

Before actual bathrooms became standard, many homes had washrooms or, more simply, a table and basin for washing oneself in a corner of the bedroom. This painting by Caillebotte shows us that in 1873, the furnishings and accessories for such practices were already white, as were women's undergarments. White was the color of hygiene, at least among the well-to-do classes. Gustave Caillebotte, *Woman at a Dressing Table*, 1873. Private collection.

Linen Cupboard

Linens, that is, all the textiles used domestically, were considered valuable property by all social classes. As early as the seventeenth century, they were mentioned in inventories and notarized documents. Whether hemp, linen, cotton, or some other fabric, they were always white. Félix Vallotton, *Woman Searching through a Cupboard*, 1901. Lausanne, Fondation Félix Vallotton.

Health Care in White

By the second half of the nineteenth century, white had become the required color for hygiene, cleansing, and health. Places, instruments, receptacles, and textiles used for bodily care, as well as the uniforms of health professionals, gradually assumed this color, the symbol of cleanliness. Edgar Degas, *The Pedicure*, 1873. Paris, Musée d'Orsay.

stone to metal, then to ceramic, and finally to porcelain and imitations of it. In this process, white became the color for all places linked to bodily hygiene, including those places of sequestered comfort that we now call "toilets."[185] Fabrics in direct contact with the body, either for washing, drying, or protecting it, would also progress from beige, ecru, or undyed to white, and only later, in the twentieth century, would they take on pastel shades or stripes, the now obligatory white sometimes being "broken up" by another color. Even so, white remained the dominant color, not only on walls, furniture, fabrics, and objects but also on products intended for bodily care, like soap and toothpaste.

There is nothing in physics or chemistry, much less in physiology, that accounts for this hygienic primacy of white over all other colors. It is a symbolic, ideological, and archetypal primacy that dates back to the dawn of social life and the first dyeing practices, when humans used color sparingly. White tended to be assimilated to what was clean, black to what was dirty, and red to what was colored.[186]

What happened with regard to bathrooms took place as well in kitchens, but more recently and in a less systematic way. Each in their turn, kitchen sinks, utensils and appliances, dishes, cupboards, shelves, dish towels, ceramic tiles, and later refrigerators all took on the color white, totally or partially, enlivened or not by other cheerful shades. Here again, it was the idea of cleanliness and hygiene that this color choice highlighted. The

Milk

With snow, milk shares the role of primary referent for the color white. Like snow, milk symbolizes purity and simplicity. But it is also a sign of abundance and good health. The bible abounds with similes and metaphors that highlight its virtues. Twentieth-century advertising does as well, but in comparison with the biblical texts, it offers little that is new despite the diversity of the brands and products that it vaunts. Advertising poster by Leonetto Cappiello for Gallia Milk, 1931.

The Hospital

In hospitals, as in all health facilities, white dominates and seems to guarantee cleanliness, reliability, and efficiency. But the ubiquitousness of white can sometimes increase rather than alleviate anxiety. Hence, since the 1960s, efforts have been made to introduce more colors into these places. Is that really a good idea? Henri de Toulouse-Lautrec, *Dr. Péan Operating at the International Hospital*, 1891. Private collection.

phenomenon began toward the end of the nineteenth century and reached its height in the 1950s and 1960s. Subsequently, white in the kitchen experienced a certain decline. The healthiness of that room was now a given; it was no longer necessary to signal it through a color. Stimulating, uplifting tones found a place there and accompanied the newfound pleasure of spending time in the kitchen.

Meanwhile, spaces themselves were becoming white, not just those for bathing or preparing foods, but all those where various forms of bodily care were practiced, beginning with health care. Here again, hygiene was making progress and white became its color. Hospitals, clinics, maternity wards, dispensaries, and medical offices adopted white between the mid-nineteenth and mid-twentieth centuries and still claim it. Today, light pastel tones in the range of blues or greens sometimes break up the monotony of white, but it would not occur to anyone to paint the walls of a hospital room or dental office bright red or dark brown. White evokes cleanliness, hygiene, and health just as in the past when it was associated with everything related to purity, whether material or symbolic. The clothing of health professionals (notably those of nurses, pediatric nurses, midwives, and nannies) also became white, with sky blue and pale green only recently offering competition. For a long time moreover, this clothing had to be boiled to clean it effectively, which prohibited any brightly colored dyes. Today such constraints have disappeared thanks to "colorfast" fabrics, but who would choose to see a dentist dressed all in black? And what mother would entrust her baby to a nurse dressed in the aggressive color of purple or the dirty color of mustard yellow? Even the very containers for medications had to be white. It is worth pausing here because these objects are emblematic of contemporary codes and practices in matters of color.

In European societies, it really seems that nothing has been as developed, refined, and subtly coded as pill boxes. Pharmaceutical laboratories invest huge sums in designing and manufacturing them. No other product—not even perfumes or cosmetics—is packaged, presented,

and labeled with so much care. On the packaging, color plays a subtle but carefully considered role. White clearly dominates and confers a hygienic, scientific, therapeutic, reassuring aspect. White simultaneously connotes reliability and knowledge, health and relief.[187] Often the typeface used for the product's name, the pharmaceutical company, and even the dosage is not black, which would contrast too sharply and too aggressively with the white background, but rather a more or less pale and legible gray. It may be on pharmaceutical packaging, or at least on some of it, that we now find the most subtle and elegant palette of grays. Discretely, here and there, a few notes of bright color against the white field highlight the company's logo or else, according to a tacit but effective code, signal the nature and function of the product contained within. In the range of blues we find painkillers, sedatives, and tranquilizers. In the range of yellows or oranges, on the contrary, we find tonics, vitamins, and anything that restores strength and vigor. Sometimes there is a rainbow—from which the blue might be omitted!—that plays the same role. In contemporary sensibility, orange has become synonymous with polychrome, the color of the sun with the colors of the rainbow, both sources or symbols of life.[188] Beiges and browns are reserved instead for medications to treat digestion or the digestive system. They are not given too obvious a presence on a white box however; brown, for example, must only evoke laxative effects in a subtle way. As for green tones, they correspond to a variety of practices and medications. In the past, green was only used in moderation (perhaps a remnant of the old idea that green brought misfortune?), even though it has been the color of apothecaries and pharmaceutical knowledge since the late Middle Ages. Today, the environmental trend tends to make it the color of gentle medicines, herbal treatments, and pharmaceutical products considered "natural and organic." Here as elsewhere, green now has the mission of saving the planet. As for black, it must be absolutely avoided, since a medication must never be associated, quite obviously, with a color that too often evokes death. That leaves red, a color that also

must be handled with caution. It can evoke a fruit flavor (strawberry, raspberry, red currant) as in candy stores, making it easier for children to swallow medications in liquid or tablet form. It can also signal an antibiotic or antiseptic effect, related to bleeding or wounds. But above all it represents the color of danger and prohibition, as the scary warning on the box proclaims: "Do not take more than the prescribed dose."

The Unicorn

A symbol of purity, the unicorn was chosen early on as an emblem for companies producing goods related to hygiene and health. The white of its coat was especially suited to products such as soap, detergents, and medicines. In the nineteenth century, this creature represented soap factories as well as pharmacies. Advertising poster for the Savonnerie Marseillaise de la Licorne. C. 1900.

Dressing in White

n the nineteenth and twentieth centuries, health care professionals were not the only ones who dressed in white, far from it. Many other categories of workers wore that color, such as builders, plasterers, house painters, millers, bakers, confectioners, dairy workers, cooks, and all those in direct contact with certain foods. Those foods were often white (flour, bread, milk, eggs) and, according to folklore, offered protection from witches and forces of evil, symbolized by black.[189] But that was not always the case; butchers who cut meat, for example, also wore white aprons. As in antiquity, white again has two opposing colors in the contemporary period: black on one side, red on the other.[190]

Since the late eighteenth century, there have also been many people who, because of personal taste, tradition, or simple fashion trends, enjoy dressing in white, totally or partially. Thus in the years 1790 to 1820, elegant young women belonging to the wealthy classes wore "ancient-style" white dresses, inspired by Greek kores and Roman statues. The waist was high, the sleeves short, the pleats natural, the fabric delicate, supple, and fluid. The "Merveilleuses" (Madame Tallien, Madame Hamelin, Joséphine de Beauharnais, and others) had launched this fashion in Paris during the Directory, but Juliette Récamier—said to be the most beautiful woman of her time by her contemporaries—was responsible for its lasting success; for most of her life (1777–1849), she wore only white dresses, at first simple tunics in the ancient style, then more ample dresses according to Romantic tastes, and finally as an older woman, sober, virtuous white clothing. In France and throughout Europe she was a true "star," sometimes compared to an ancient goddess, and countless women sought to imitate her famous white outfits.[191] Which led Goethe to write in 1810: "Women now appear almost universally in white and men in black," whereas "men in a state of nature, uncivilised nations, children, have a great fondness for colours in their utmost brightness, and . . . are also pleased with the motley."[192] In this period and for a century to come, in Paris, London, Berlin, and elsewhere, vivid colors were seen as eccentric or vulgar. Black was considered the most elegant color for men, and white for women. Furthermore, no woman of high society had to worry about soiling her dresses: that was why she had servants.

As the feminine color, white also became the color of wedding gowns over the course of the nineteenth century. Until then, a women donned her most beautiful dress for the occasion, no matter what the color. If necessary, she

Working in White

Health professionals are not the only ones devoted to white. Other occupations have required it as well, sometimes dating back many centuries, especially for workers who deal in one way or another with food products linked to flour, milk, and meat: millers, bakers, confectioners, dairy workers, cheese makers, cooks, butchers, and so on. Théodule Ribot, *Baker's Boy*. Marseille, Musée des Beaux-Arts.

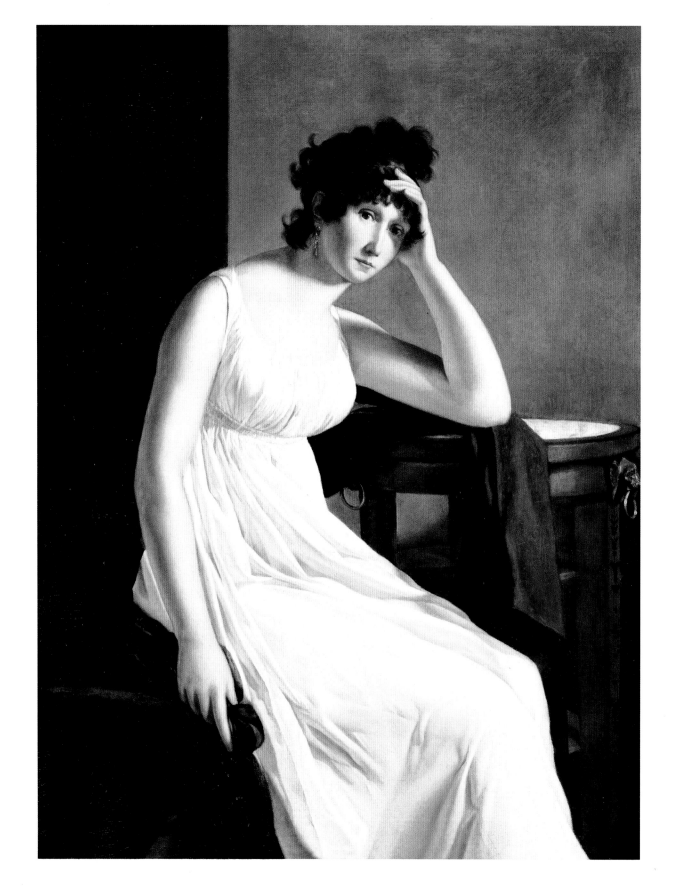

OPPOSITE PAGE

Dressing in the Ancient Style

From the time of the Directory to the beginning of the Restoration, elegant young women enjoyed dressing in the "ancient-style." They wore white dresses inspired by Greek kores and Roman statues: high waists, short or no sleeves, natural pleats, delicate, supple, flowing fabric. Constance Mayer, *Self-Portrait*, c. 1801. Boulogne-Billancourt, Bibliothèque Marmottan.

OPPOSITE

The Music of White

For painters, white is a color in its own right, rich in myriad properties and shades. In the nineteenth century, some painters took up the challenge of limiting themselves to the range of whites for entire figurative paintings that were not monochrome in the least. From these whites they derived "symphonic" effects, as Whistler does here. James Abbot Whistler, *Symphony in White 1: The White Girl*, 1862. Washington, DC, National Gallery of Art.

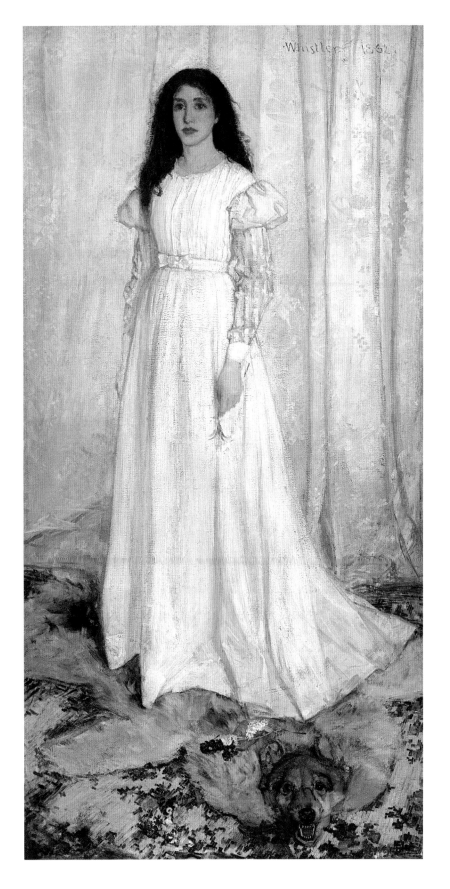

wore a new dress, most often red in the country and black in the city, at least among the bourgeoisie. Most aristocratic women were married in ball gowns. Subsequently, changes in society, the evolution of moral standards, the invention of the mechanical weaving loom, and then the appearance of the first sewing machines changed customs and codes. It became good form for a young woman to be married in white, at least in high society. A persistent legend holds that it was the marriage of Victoria, queen of Great Britain and Ireland, to Prince Albert of Saxe-Coburg on February 10, 1840, that started this fashion, but it seems to have begun earlier, first in the Catholic countries of France and Italy before crossing the English Channel. By the 1830s, women were marrying in white in Continental Europe. Victoria's innovation was to wear a veil during the wedding ceremony, as the traditional custom was only to cover oneself afterward.[193]

Whatever the origin, princely or not, the white wedding gown gradually spread throughout the whole of society, first among wealthy city dwellers and then to rural areas beginning at the turn of the century. For young women, to marry in white was a way of proclaiming the purity of their behavior, and the white gown a kind of reward, both moral and social, meant for those who entered into marriage as virgins. In certain cases, that reward was usurped and morality flouted, but the public image remained intact. Formerly, during the ancien régime, there was no need to stress the virginity of the young bride; it went without

The Wedding Dress

For a long time, young women did not have special clothing made for their weddings but simply wore their most beautiful dresses. In the country, that dress was often red, in the city, black. Beginning in the 1830s, white dresses became the fashion. Henceforth, a young bride had to prove her purity through the whiteness of her gown as she entered into marriage. Until that time, such symbolism was pointless: the bride's virginity was a given; anything else would have been unthinkable. Edmund Leighton, *The Wedding Register*, 1920. Bristol, Bristol City Museum and Art Gallery.

saying, anything else would have been strange and reason for annulment. By the 1830s however, after political revolutions, social changes, and loosening of morals, that was less certain. It was necessary to proclaim one's virginity, and the white wedding dress became the best way to do so.

Even if morals and codes were profoundly transformed, the custom of marrying in white did not disappear after World War II. The virginal white of the gown worn on the day of marriage was extended, by imitation, to other types of clothes worn by young women. Let us cite two very different examples: in Catholic circles, the albs worn for first communions; in high society, the dresses worn by "debutantes" for their first balls.[194]

In a completely different context and for very different reasons, white spread onto the playing fields beginning in the years 1850 to 1870. Actually, this color was very closely tied to the birth of modern sports, which occurred over those years. The first athletic event more or less resembling our own took place in Oxford in 1850; the first British Open for golf was held in 1860, the first British football competition (the Youdan Cup) in 1867, and the first international rugby match (Scotland-England) in 1871. Beginning in the 1880s, multiple associations and federations were formed in many sports at the same time as competitions and practices became more numerous.

The Elegance of White

Rarely have Parisian women been as elegant as they were in the Belle Époque. Painters from the years 1890 to 1910 left us much evidence of this. Like Henri Gervex, the great painter of women, they teach us that the fashion then was white, black, and pink, sometimes heightened with a touch of more vivid color, like red or green. Henri Gervex, *Five O'Clock at Maison Paquin*, 1906. Private collection.

Essentially, it was English and Scottish high schools that played the decisive role in establishing rules to ensure that games went well and in instituting dress codes to ensure that competitors could be distinguished from each other.[195] The earliest sports players were especially devoted to white. First, their uniforms, in direct contact with the skin, had to be white and not dyed, like chemises, undergarments, and nightclothes, for the same hygienic and moral reasons discussed in the last chapter. Second, since they got dirty or soiled during every competition, those uniforms had to be washed frequently, even boiled, which meant that vegetable dyes could not be used to give them bright, contrasting colors that could have served as emblems. As moral considerations fell away and synthetic colorants were gradually developed, those inconveniences slowly came to an end, allowing for the diversification and codification of colors on the sports fields in the last quarter of the nineteenth century, notably for team sports.

Let us take the example of soccer (or "football" as it is called in Europe and Great Britain). In the 1870s, a team playing in white still often opposed a team playing in black. But in the following decade, blue and red made an appearance, at least on jerseys, as white and black remained the obligatory colors for shorts. They were joined at the turn of the century by green, purple, and orange, while yellow and pink remained rare, and brown totally absent.[196] In the years 1900 to 1910, players were already displaying a wide variety of bright colors, but white remained the dominant one, notably because many teams took as their emblem a striped jersey: white and one other color.[197] As in coats of arms and on flags, those stripes could be horizontal, vertical, or diagonal; on the other hand, they were not wavy, toothed, scalloped, or zigzagged. Heraldry certainly influenced sports uniforms, but not to the point that all the subtle variations of its partition lines were adopted. In the 1950s, the dominance of white began to wane, but it was color television especially that hastened its demise and contributed greatly to transforming professional players into polychrome performers. At that point, the spectacle took over, supplanting the competitive event.

With certain individual sports, the tradition of white outfits lasted longer than with team sports. With fencing it is still obligatory today in local, national, and international competitions. In tennis, it has disappeared under pressure from the sportswear industry, but at Wimbledon, the oldest and most famous tournament of the Grand Slam, participants are still required to wear entirely white tennis outfits. In recent years the organizers have even proved to be particularly strict. In 2013, they forbade off-white, cream, and ecru, and in 2017 they required Venus Williams, five-time tournament champion, to change her bra because it was pink and one of the straps sometimes showed during rallies. A similar misadventure occurred in 2013 to another great champion, Roger Federer, asked to change his tennis shoes, which were clearly white but had orange soles.

In major tennis tournaments other than Wimbledon, white became less dominant beginning in the 1990s, not only under pressure from the sportswear industry and corporate sponsors but also from certain players who wanted to be free to dress according to their own tastes. It is interesting to note that this rejection of traditions was not the order of the day fifteen years earlier when in the late 1970s the white tennis ball became yellow, essentially for questions of visibility. More than the players, it was the umpires who complained of the difficulty of telling if a ball had or had not touched a line: both were white. Moreover, color television had made its appearance and had begun to broadcast the major tournaments. Now on a small screen the white ball was hard to see and easy to confuse here as well with the lines. For the comfort of television audiences, it was then decided to go from white to yellow, a very visible yellow because it was more or less fluorescent (*optic yellow*). Many top players, Borg, Connors, and McEnroe among them, displayed their hostility to this change and wanted to remain faithful to white balls. They did not win their fight (how to triumph over television and marketing?) but they did not entirely lose either; even today white balls are theoretically accepted in most national tournaments. In reality, however,

When Tennis Was Played in White

The first tennis tournaments originated in England and Scotland in the late 1870s, but they were soon taking place across Continental Europe and then in the United States and Australia. The rules of the game became standardized, and although each major tournament had its own codes, tennis whites were required throughout, both for men and women. Perspiration stains are not visible on white. Poster announcing the women's tennis tournament in Heiligendamm, a seaside resort on the Baltic coast, 1908.

yellow balls took over and quickly became the symbol of modern tennis.

Many explanations have been offered for the origins of white clothing for tennis, golf, cricket, rowing, and other outdoor sports. The least fantastic finds the source in practices of the English aristocracy in the second half of the nineteenth century. Supposedly they chose white for summer sports because perspiration stains from physical exertion were less visible on it than on other colors. White allowed them to retain their dignity and elegance under all circumstances. That was true not only for sports but also for other outdoor activities, especially those taken up by ladies. In "good" society, a woman was never to be seen perspiring. Worse than obscene, it would have been "working class."

White for Water Sports

As the color of summer sports for the English aristocracy, white came to dominate all outdoor sports over the course of the decades, not only in Europe but throughout the world. That was true until the years 1950 to 1960, when synthetic fabrics starting to compete with wool and cotton, and when "colorfast" sportswear could withstand repeated washings. Armin Bieber, *Rowing Club Bern*, vintage poster, c. 1925.

Lexicons and Symbols

More than any other documentary sources, language and lexicon allow historians to identify the meanings associated with each of the principal colors. That is equally true for the vocabularies of ancient languages, as we have seen in the first part of this book, as it is for the vocabularies of modern languages, particularly rich in figurative or derived meanings, imagistic or slang terms, expressions, wordplay, and slogans; all of these contain a great deal of information and provide various openings for deepening inquiry and moving from the semantic to the symbolic. In this regard, the term "white" proves to be particularly instructive. Very often it does not refer to the color white but to other notions.

The example of "white wine" is the first to note, considering its long history and widespread use. No one needs to point out that the liquid thus designated has absolutely nothing to do with white, and if proof were necessary, placing a glass of milk beside a glass of white wine would be sufficient. Not only are they not the same color, but they do not resemble each other in the least, not in appearance or taste, that is obvious. Now this expression, "white wine" was already commonly used in Old and Middle French;

it even exists in classical Latin (*vinum album*). Today it is used in most European languages, as is "red wine," which similarly designates a drink sometimes very far removed from the color red.[198] In lexical usage, there is often a great distance between the color named and the actual color of beings and things. When it is used for wine, the adjective "white" is synonymous with "light" or "clear." It refers not to the coloration of the liquid but to its lightness, limpidity, and luminosity. Its opposite would not be black so much as dark, dense, and opaque.

A related idea involves the color of the skin. No one has a truly white face unless they are made up and have applied a thick layer of ceruse, as did the matrons of imperial Rome or the pretentious eighteenth-century aristocracy.

Model in White
Richard Hamilton, *The Solomon T. Guggenheim (Black and White)*, fiberglass and cellulose, 1965–66. New York, Solomon T. Guggenheim Museum.

When White Is Not White

Sometimes there are wide gaps between the real color, the perceived color, and the named color. That is the case with the wine we call "white." It is never white; instead, it is yellow, golden, greenish, and so on. Used in this way, the adjective "white" means "light" and describes no precise color. Likewise, "red" wine is not red but dark. Often color terms are used more for classifying than describing. Max Buri, *After the Burial*, 1905. Berne, Kunstmuseum.

White Smoke

When white smoke rises from the Sistine Chapel, it means that a new pope has been elected by the cardinals convened there for a papal conclave. If the smoke is black, the vote has not been decisive and must be repeated. Sometimes the smoke is gray, which creates confusion. Then one must wait for the bells to ring to confirm the election. No bells, no election. Jeff J. Mitchell, photograph of the Sistine Chapel, March 13, 2013.

Nevertheless, we commonly refer to people as "white" or as having "white" skin. Here again, the adjective "white" means "pale" or "light." As a noun and in the plural form, "white" designates Western Caucasian populations as distinguished from African or Asian populations. Contrary to popular belief, this systematic use of color adjectives to distinguish ethnic groups according to skin color is not very old. The Romans were not aware of it; for them, the important thing was knowing if a given distant people was friendly or hostile to Rome. Nor was it familiar to the Middle Ages; what counted then was knowing whether the inhabitants of a distant country were Christian or not, and if not, whether they could be converted to Christianity. Their skin color was not important.[199] Skin color only began to play an important role in human classification systems starting in the sixteenth century when colonialism and capitalism experienced unprecedented growth. First simply chromatic, then racial, these taxonomies became racist (in the sense that we understand that word today) when, in the early nineteenth century, many authors claimed that a hierarchy existed between the races and that "Whites" were superior to other peoples.[200]

Many expressions also emphasize the link that exists between white and the idea of an absence or void, especially in English where "blank" often replaces the French *blanc*: "*une page blanche*" (a white/blank page);[201] "*laisser un nom en blanc*" (to leave the name blank); "*un chèque en blanc*" (a blank check); "*donner carte blanche*" (to give carte blanche). Similarly, "*passer une nuit blanche*" means to pass a sleepless night and "*un mariage blanc*" means an unconsummated marriage. "*Tirer à blanc*" is a little different and means to fire a gun with blanks or else a gun that is not loaded.[202] "*Faire chou blanc*" (literally, to make white cabbage) implies a failure, as in the English expressions "to come up short," or "to draw a blank." Other expressions derive from a more favorable, beneficial, superior white. White magic thus compares favorably to black magic and white bread to black bread. "To eat one's white bread first" means to begin with easier, more pleasant activities and leave the chores and difficult tasks for

later. "Marked with a white stone" describes a particularly lucky or memorable day or period. "To draw the white ball" is outdated but meant to benefit from an auspicious or profitable fate. Related is this remarkable association with the color white: "to be known like the white wolf" means to be well known since that animal is so rare and stands out conspicuously in a pack of gray wolves; likewise a "white blackbird" describes an object impossible to find or a person endowed with qualities too remarkable to actually exist. More common is the use of the word white in the sense of pure, innocent, and delicate: "to be white as snow" means to be without guilt, to be beyond reproach; "to handle with white gloves" means to treat someone with care. On the other hand, if a "white dove" is an innocent person, a "white goose" is a naive or even foolish young woman.

In French as in other European languages, there are a great number of expressions, adages, and proverbs that evoke white in derivative or imagistic ways. That is true of other colors as well, notably red and black, but these meanings are probably most numerous for white, more proof of the primacy of that color in symbolism and in the imagination. From this perspective, to deny it the status of a color in its own right would be absurd. Nevertheless, that is how many of our contemporaries still think of it, the adjective "white" remaining more or less synonymous with "colorless" for them.

Since the mid-nineteenth century and until recently, Western culture has had recourse to three ways of representing what, in one respect or another, was considered or described as colorless: white, gray, and black and white. The last of these, as we have seen, long constituted a world of its own, opposed to that of colors strictly speaking. First engraving, then photography, more recently cinema and television reinforced and extended that opposition through their new techniques. Today however it is less pervasive than it was two or three generations ago, and the day will come, in the not too distant future, that such an opposition will disappear from scientific theories as from their applications in everyday life. White employed alone, on

Known Like the White Wolf

In all European languages, the adjective "white" recurs frequently in lexicons, more often than "red" or "black," also popular in adages, maxims, proverbs, and sayings. "To be known like the white wolf" means "to be known by everyone." Since white wolves are rarer than gray or brown wolves, they get noticed, become well known, and prompt fear or fascination. Vincent Munier, *Arctic Wolf*, Ellesmere Island, Canada, 2013.

The Art of Black and White

As color photography began to gain popularity and become commonplace, many photographers embraced black and white. For them, it embodied "the very essence of photography" and its true nobility. Color photography had become too technical, according to them, thus limiting the artist's creativity. Mario Giacomelli, *Young Priests Dancing in the Snow*, photograph, 1961.

White and Design
Since the 1950s, white's importance in design has continued to grow. More than any other color, it seems to facilitate perfect accord between form and function, especially with regard to furniture and tableware. Patrick Jouin, *Service Wave*, 2000. Paris, Centre Pompidou—Musée d'art moderne—Centre de création industrielle.

the other hand, continues and will continue to embody a certain idea of colorlessness, as if the association of those two notions, originating with paper and the printed book, were impossible to call into question. However, there are numerous domains in which white has fully become a color with the same standing as red, blue, green, or yellow. But it makes no difference: for many people, if something is white, it is colorless. As for gray, perhaps it expresses neutrality more than colorlessness, "chromatic neutral," if that expression means anything. Here it is joined by all the colors that are neither lively nor bold, ones that do not dare claim a name or shade and that are part of a range of dull, ecru, or so-called natural tones. In the world of fashion, each year in spring, magazines resort to flashy slogans like "this summer, experience (or risk) the return of colors." As if colors had disappeared during the winter! For style and fashion design, for architecture and interior design, the true colors are the vivid colors, not black or white, much less gray and "natural" tones.

More than white and black, it is undoubtedly gray that now embodies the "degree zero of color," a vague notion it must sometimes share with monochrome. In many domains—clothing, decoration, advertising—a single shade, whatever it is, no longer suffices for "creating color." Many colors are needed for color to exist, to "function,"

to produce that play of association or opposition, of combinations, rhythms, and correspondences. In our time, the phenomenon of "color" only operates when there are two, three, or multiple colors. Color systems can then be reversed or transgressed, opposites can attract and merge, thus complicating the work of historians or sociologists and rendering their observations and analyses useless. It seems as if colors henceforth may speak only to colors! So let us leave them happily conversing among themselves, without us.

Audrey Hepburn in the film by William Wyler, *How to Steal a Million Dollars* (1966).

Farewell in White

This is Edward Hopper's last painting, completed a year before
his death. A stubborn legend holds that these two white clowns
leaving the stage represent the painter himself and his wife.
Nothing confirms this story. Edward Hopper, *Two Comedians*,
1966. Private collection.

NOTES

1. Here is the definition offered online by the *Trésor de la langue francaise* (nineteenth and twentieth centuries) (the official publication of the Institut National de la Langue Française) at the beginning of a long entry for the adjective *white*: "White: which, combining all the colors of the solar spectrum, has the color of snow, milk, and so on." Such a definition is hardly satisfactory, but can we find a better one? See, for the same nineteenth and twentieth centuries, the various lexical fields compiled by A. Mollard-Desfour, *Le Blanc: Dictionnaire de la couleurs* (Paris, 2008).

2. M. Pastoureau, *Rouge: Histoire d'une couleur* (Paris, 2016), 16–17. See also the English edition. M. Pastoureau, *Red: The History of a Color*, trans. Jody Gladding (Princeton, 2017).

3. A chemical mineral composed mainly of natural calcium carbonate, calcite is part of the composition of a great number of sedimentary rocks. Described and analyzed beginning in the seventeenth century, for a long time it was called "carbonated lime."

4. A white clay that is friable, resistant, and much less malleable than other clays, notably the ochers.

5. C. Couraud, "Pigments utilisés en préhistoire: Provenance, préparation, modes d'utilisation," *L'Anthropologie* 6, no. 1 (1988): 17–28; C. Couraud, "Les pigments des grottes d'Arcy-sur-Cure (Yonne)," *Gallia Préhistoire* 33 (1991): 17–52; F. Pomiès et al., "Préparation des pigments rouges préhistoriques par chauffage," *L'Anthropologie* 103, no. 4 (1998): 503–18; H. Salomon, *Les matières colorantes au début du Paléolithique supérior: Sources, transformations et fonctions* (thesis, Bordeaux, 2009). Online: HAL Archives ouvertes, January 7, 2020.

6. Allow me to cite here my remarks on the origins of abstract colors in M. Pastoureau, "Classer les couleurs au XIIᵉ siècle," *Comptes rendus: Académie des inscriptions et belles-lettres, fasc. 2* (April–June, 2016): 845–64.

7. B. Berlin and P. Kay, *Basic Color Terms: Their Universality and Evolution* (Berkeley and Los Angeles, 1969), 14–44.

8. Pastoureau, *Rouge. Histoire d'une couleur,* 14–17.

9. L. Gerschel, "Couleurs et teintures chez divers peuples indo-européens," *Annales ESC* 21, no. 3 (1966): 608–31.

10. M. Pastoureau, *Bleu: Histoire d'une couleur* (Paris, 2000), 49–84. See also the English edition: M. Pastoureau, *Blue: The History of a Color*, trans. Markus I. Cruse (Princeton, 2001).

11. M. Eliade, *Traité d'histoire des religions* (Paris, 1964), 139–64; J. R. Bram, "Moon," in *The Encyclopedia of Religion*, vol. 10 (London, 1987), 83–91; D. Colon, "The Near Eastern Moon God," in *Natural Phenomena: Their Meaning, Depiction, and Description in the Ancient Near East*, ed. D.J.W. Meijer (Amsterdam, 1992), 19–38.

12. G. Neckel, ed., *Edda: Die Lieder des Codex Regius* (Heidelberg, 1962); R. Boyer, ed., *L'Edda poétique* (Paris, 1992); U. Dronke, *The Poetic Edda: Mythological Poems*, vol. 2, 2nd ed. (Oxford, 1997), 349–62.

13. A. W. Sjöberg, *Der Mondgott Nanna-Suen in der sumerischen Ueberlieferung* (Uppsala, 1960).

14. On the moon in ancient myths and beliefs, many reference books exist but few are of high quality. Nevertheless, see T. Harley, *Moon Lore* (London, 1885); J.-L. Heudier, *Le Livre de la lune* (Paris, 1996); G. Heiken et al., *Lunar Source Book: A User's Guide to the Moon* (Cambridge, 1998); J. Cashford, *The Moon: Myths and Images* (London, 2003), D. Brunner, *Moon. A Brief History* (New Haven, 2010); R. Alexander, *Myths, Symbols, and Legends of Solar System Bodies* (Berlin, 2015); F. Kébé, *La lune est un roman: Histoire, mythes, légendes* (Geneva, 2019).

15. P. Duhem, *Le système du monde: Histoire des doctrines cosmologiques de Platon à Copernic,* vol. 1, *La Cosmologie hellénique* (Paris, 1913); G. Aujac, "Le ciel des fixes et ses représentations en Grèce ancienne," *Revue d'histoire des science* 29, no. 4 (1976): 289–307; J. Evans, *The History and Practice of Ancient Astronomy* (Oxford, 1998).

16. F. Cumont, "Le nom des planètes et l'astrolâtrie chez les Grecs," *L'Antiquité classique* 4, no. 1 (1935): 5–43.

17. E. Siecke, *Beiträge zur genaueren Erkentnis der Mondgottheit bei den Griechen*

(Berlin, 1885); W. H. Roscher, *Ueber Selene und Verwandtes* (Leipzig, 1890).

18. The bibliography devoted to Artemis is vast. Recent research confirms what ancient authors had already noted: Artemis is a subtle goddess, rebellious, dangerous, elusive, multifunctional, perhaps the most important in the Greek pantheon along with her brother Apollo, before Zeus and all other Olympic gods, the major figure among the ancient divinities and the one most widely represented.

19. A. Marx, "Job, les femmes, l'argent et la lune: À propos de Job 31," *Revue d'histoire et de philosophie religieuses* 92, no. 2 (2012): 225–40.

20. J.-B. Thiers, *Traité des superstitions*, 4 vols., 4th ed. (Paris, 1741), passim; E. Mozzani, *Le livre des superstitions: Myths, croyances et légends* (Paris, 1995), 1017–40.

21. See the comprehensive scholarly study by C. Brøns, *Gods and Garments* (Oxford, 2017). See also the collective work edited by C. Brøns and M.-L. Nosch, *Textiles and Cult in the Ancient Mediterranean* (Oxford, 2017).

22. Plato, *Symposium*, 211e; *Georgias*, 465b.

23. Plato, *Laws*, 956a.

24. See the fine study by Angelo Baj, "Faut-il se fier aux couleurs? Approches platoniciennes et aritotéliciennes des couleurs," in *L'antiquité en couleurs: Catégories, pratiques, représentations*, ed. M. Carastro (Grenoble, 2009), 131–52.

25. P. Jockey, *Le mythe de la Grèce blanche: Histoire d'un rêve occidental* (Paris, 2013).

26. A. Grand-Clément, "Couleur et esthétique classique au XIXe siècle: L'art grec antique pouvait-il être polychrome?" *Ithaca: Quaderns Catalans de Cultura Clàssica* 21 (2005): 139–60. See also the important thesis by the same author: *La fabrique des couleurs: Histoire du paysage sensible des Grecs anciens (VIIIe–début du Ve s. av. n. è.)* (Paris, 2011).

27. See a list and assessment of the most recent works in A. Grand-Clément, "Couleur et polychromie dans l'Antiquité," *Perspective* 1, online, December 31, 2018.

28. A. Grand-Clément, "Couleurs, rituels et normes religieuses en Grèce ancienne," *Archives de sciences sociales des religions* 174 (2016): 127–47.

29. Jockey, *Le mythe de la Grèce blanche*, 39–47.

30. See the thesis by H. Brécoulaki, *La Peinture funéraire de Macédoine: Emploi et fonctions de la couleur, IVe–IIe s. avant J.-C.*, 2 vols. (Athens, 2006). See also, among the numerous works now calling into question Pliny's idea of Greek painting being limited to four colors (Pliny, *Historia naturalis*, bk. 35, chap. 29): A. Rouveret, "Ce que Pline l'Ancien dit de la peinture grecque: Histoire de l'art ou éloge de Rome?" *Comptes rendus des séances de l'Académie des inscriptions et belles-lettres* 151, no. 2 (2007): 619–32; A. Rouveret, *Inventer la peinture grecque antique* (Lyon, 2011).

31. Amid a vast bibliography, see B. S. Ridgway, *Roman Copies of Greek Sculpture: The Problem of the Originals* (Ann Arbor, 1984); E. Bartman, *Ancient Sculptural Copies in Miniature* (Leiden, 1992); M. D. Fullerton, "Der Stil de Nachahmer: A Brief Historiography of Retrospection," in *Ancient Art and Its Historiography*, ed. A. A. Donohue and M. D. Fullerton (Cambridge, 2003), 92–117; M. Beard and J. Henderson, *Classical Art: From Greece to Rome* (Oxford, 2001). A summary of this question of Roman copies of Greek statuary can also be found in Jockey, *Le mythe de la Grèce blanche*, 67–86.

32. Pliny, *Historia naturalis*, bk. 35, chap. 20. According to tradition, the sculptor supposedly used his mistress Phryne, a famous courtesan, for his model, captured at the moment she was stepping naked from her bath. The original by Praxiteles no longer exists but many copies remain for us. In the most famous of them, Aphrodite covers her pubes with her right hand in a gesture sometimes interpreted as modesty, sometimes as lustfulness.

33. Nicias is thought to have invented a process of encaustic painting that rendered colors particularly vivid on marble. For Praxiteles, the bibliography is immense; a recent summary can be found in the catalog for the exhibition that took place at the Louvre in spring 2007: *Praxitèle*, ed. A. Pasquier and J.-L. Martinez (Paris, 2007).

34. Ovid, *Metamorphosis* 10, lines 243–97.

35. On the origins of dyeing, see F. Brunello, *The Art of Dyeing in the History of Mankind* (Vicenza, 1973), 5–36 and passim.

36. A. Varichon, *Couleurs: Pigments et teintures dans les mains des peuples*, 2nd ed. (Paris, 2000), 9–44 ("Le blanc").

37. M. Gleba and U. Mannering, eds., *Textiles and Textile Production in Europe from Prehistory to AD 400* (Oxford, 2012).

38. E. Kvavadze et al., "30,000-Year-Old Wild Flax Fibers," *Science* 325 (2009): 1359–71, and *Science* 328 (2010): 1634–38.

39. Pliny, *Historia naturalis*, bk. 29, chaps. 1–5.

40. Ovid, *Fasti* 10, line 619.

41. Brunello, *Art of Dyeing*, 38–46.

42. Brunello, *Art of Dyeing*, 87–116.

43. See A. Ernout and A. Meillet, *Dictionnaire étymologique de la langue latine*, 4th ed. (Paris, 1979), "Color."

44. On women's clothing and fashions, in addition to the works cited in note 45, see R. MacMullen, "Women in Public in the Roman Empire," *Historia* (Yale University), 29, no. 2 (1980): 208–18; J.-N. Robert, *Les Modes à Rome* (Paris, 1988); A. T. Croon, *Roman Clothing and Fashion* (Charleston, 2000); P. Moreau, ed., *Corps romains* (Grenoble, 2002).

45. On the Roman toga and its place in the clothing system: L. M. Wilson, *The Roman Toga* (Baltimore, 1924); J. L. Sebasta and L. Bonfante, eds., *The World of Roman Costume* (Madison, 1994); C. Vout, "The Myth of the Toga: Understanding the History of Roman Dress," in *Greece and Rome*, vol. 43 (Cambridge, 1996), 204–20; F. Chausoon and H. Inglebert, eds., *Costume et société dans l'Antiquité et le haut Moyen Âge* (Paris, 2003); F. Barette, "Le vêtement dans l'Antiquité tardive: Rupture ou continuité?" *Antiquité tardive* 12 (2004): 121–35. See also P. Cordier, *Nudités romaines: Un problème d'histoire et d'anthropologie* (Paris, 2005), passim.

46. For Hebrew and Aramaic, see F. Jacquesson, "Les mots de la couleur en hé-

breu ancien," in *Histoire et géographie de la couleur*, ed. P. Dolfus, F. Jacquesson, and M. Pastoureau (Paris, 2013), 76–130. For Greek: L. Gernet, "Dénomination et perception des couleurs chez les Grecs," in *Problèmes de la couleur*, ed. I. Meyerson (Paris, 1957), 313–24; E. Irwin, *Colour Terms in Greek Poetry* (Toronto, 1974); P. G. Maxwell-Stuart, *Studies in Greek Colour Terms*, vol. 1 (Leiden, 1981).

47. The fundamental work on the lexicon of colors in classical Latin remains the book by J. André, *Étude sur les termes de couleur dans la langue latine* (Paris, 1949).

48. André, *Étude sur les termes de couleur*, 25–38. The other terms that Latin offers for naming the various shades of black are less commonly used: *fuscus* designates what is dark but not totally black; *furvus* is closer to brown than to black; *piceus* and *coracinus* signify "black like pitch" and "black like the crow"; *pullus*, *ravus*, *canus*, and *cinereus* belong more to the range of grays than to the range of blacks.

49. André, *Étude sur les termes de couleur*, 43–63.

50. See the important study by W. J. Jones, *German Colour Terms: A Study in Their Historical Evolution from Earliest Times to the Present* (Amsterdam, 2013), 290–344.

51. Jones, *German Color Terms*, 329 and 371–72.

52. See relevant remarks by L. Gerschel, "Couleurs et teintures chez divers peuples indo-européens," and L. Gernet, "Dénomination et perception des couleurs chez les Grecs."

53. On these different terms, see André, *Étude sur les termes de couleur*, 39–42.

54. Suetonius, "Nero," *The Twelve Caesars* XXXV, 5. See G. Minaud, *Les vies de douze femmes d'empereurs romains: Devoirs, intrigues et voluptés* (Paris, 2012), 97–120.

55. A. Dubourdieu and E. Lemirre, "Le maquillage à Rome," in *Corps romains*, ed. P. Moreau (Grenoble, 2002), 89–114; E. Gavoille, "Les couleurs da la séduction féminine dans *L'Art d'aimer* d'Ovide: Désignations et représentations," *ILCEA: Revue de l'Institut des langues et cultures d'Europe, Amérique, Afrique, Asie et Australie* 37 (2019): 75–89.

56. F. Bader, *La Formation des composés nominaux du latin* (Besançon and Paris, 1962), 352–53 (§418).

57. J. André, *L'Alimentation et la Cuisine à Rome*, 2nd ed. (Paris, 1981), passim; D. Gourevitch, "Le pain des Romains à l'apogée de l'Empire," *Comptes rendus des séances de l'Académie des inscriptions et belles-lettres*, fasc. 1 (2005): 27–47.

58. G. Dumézil, *Rituels indo-européens à Rome* (Paris, 1954), 45–61. G. Dumézil takes the title of his chapter, "*Albati, russati, virides*," from the historian Jean le Lydien (sixth century), who used it to describe the tripartite division of the Roman people at the beginning of his history.

59. For the Middle Ages: G. Duby, *Les Trois Ordres ou l'Imaginaire du féodalisme* (Paris, 1978), passim; J. Grisward, *Archéologie de l'épopée médiévale* (Paris, 1981), 53–55 and 253–64.

60. M. Eliade, *Le symbole des ténèbres dans les religions archaïques: Polarité du symbole*, 2nd ed. (Brussels, 1958). See also the penetrating book by G. Bachelard, *La Flamme d'une chandelle*, 4th ed. (Paris, 1961).

61. The story of Apollo and Coronis exists in different versions. One of the earliest, retold by Apollodorus (*Bibliotheca* III, 10) is the one by Pindar (*Pythian Odes* III, 8–14). It differs slightly from the classical version by Ovid (*Metamorphosis* II, 531–707) in that the crow plays a less essential role.

62. On the story and myth of Theseus, see, amid a vast bibliography, the work by C. Calame, *Thésée et l'imaginaire athénien* (Lausanne, 1996). On the evolution of this story in the Middle Ages and the literary and symbolic legacy of white and black sails, A. Peyronie, "Le mythe de Thésée pendant le Moyen Âge latin," *Médiévales* 16, no. 32 (1997): 119–33.

63. H.J.R. Murray, *A History of Board Games Other Than Chess* (Oxford, 1952), 29–52.

64. A. Adam, *Antiquités romaines*, vol. 1 (Paris, 1818), 397–99; L. Ross Taylor, *Roman Voting Assemblies* (London, 1967), passim; H. Inglebert, ed., *Histoire de la civilisation romaine* (Paris, 2005), 113–54.

65. L. Gerschel, "Couleurs et teintures chez divers peuples indo-européens," *Annales ESC* 21, no. 3 (1966).

66. J. Siegwart, "Origine et symbolisme de l'habit blanc des dominicains," *Mémoire dominicaine* 29 (2012): 47–82.

67. On the colors in the Bible: H. Janssens, "Les couleurs dans la Bible hébraïque," in *Annuaire de l'Institut d'études orientales et slaves*, vol. 43 (Brussels, 1954–57), 145–71; R. Gradwohl, *Die Farben im Alten Testament: Eine Termilogie Studie* (Berlin, 1963); A. Brenner, *Colour Terms in the Old Testament* (London, 1983); F. Jacquesson, "Les mots de la couleur en hébreu ancien," in *Histoire et géographie de la couleur*, ed. P. Dollfus, F. Jacquesson, and M. Pastoureau, *Cahiers du Léopard d'or* 13 (Paris, 2013), 67–130.

68. F. Jacquesson, "Les mots de la couleur," 70.

69. Pastoureau, *Rouge: Histoire d'une couleur*, 50–51.

70. Exodus 23:19; Deuteronomy 32:13–14; Samuel 17:19; Proverbs 27:27, and so on. See A. Chouraqui, *La vie quotidienne des Hébreux au temps de la Bible: Rois et prophètes* (Paris, 1971), 123–27; O. Borowski, *Daily Life in Biblical Times* (Atlanta, 2003), 94–95.

71. E. Levine, "The Land of Milk and Honey," *Journal for the Study of the Old Testament* 87 (2000): 43–57; R. Hunziker-Rodewald, "'Ruisselant de lait et de miel': Une expression reconsidérée," *Revue d'histoire et de philosophie religieuses* 93, no. 1 (2013): 135–44.

72. On color and the Church Fathers: M. Pastoureau, *Noir: Histoire d'une couleur* (Paris, 2008), 39–42. See also the English edition: M. Pastoureau, *Black: The History of a Color*, trans. Jody Gladding (Princeton, 2009); Pastoureau, *Rouge: Histoire d'une couleur*, 58–63; F. Jacquesson, "La chasse aux couleurs à travers la Patrologie latine," *Academia Papers* online (December 8, 2008).

73. M. Pastoureau, "Classer les couleurs au XIIᵉ siècle: Liturgie et héraldique," *Comptes rendus: Académie des inscriptions et belles-lettres* fasc. 2 (April–June 2016): 845–64.

74. A few elements are nonetheless worth noting in older works: F. Bock, *Geschichte*

der liturgischen Gewänder im Mittelalter, 3 vols. (Berlin, 1859–69); J. W. Legg, *Notes on the History of the Liturgical Colours* (London, 1882) (addresses especially the modern period); J. Braun, *Die liturgische Gewandung in Occident und Orient* (Frieburg im Briesgau, 1907); G. Haupt, *Die Farbensymbolik in der sakralen Kunst des abendländischen Mittelalters* (Leipzig, 1941) (often cited, always disappointing). For the paleochristian period, some information can be found in the *Dictionnaire d'archéologie chrétienne et de liturgie*, vol. 3 (1914), cols. 2999–3001. On pontifical uses: Bernhardt Schimmelpfenning, *Die Zeremonienbücher der römischen Kurie in Mittelalter* (Tübingen, 1973), 286–88 and 350–51; M. Diekmans, *Le Cérémonial papal*, vol. 1 (Brussels and Rome), 223–26. Allow me to cite as well a short passage on liturgical colors in my study, "L'Église et la couleur des origines à la Réforme," *Bibliothèque de l'École des chartes* 147 (1989): 203–30; I discuss a few elements from it here.

75. M. Pastoureau, study cited in preceding note 74, "L'Église et la couleur des origines à la Réforme," 218–20.

76. A commentary and translation (abridged) of this text by Cardinal Lothar of Segni appears in M. Pastoureau, "Ordo colorum: Notes sur la naissance des couleurs liturgiques," *La Maison-Dieu: Revue de pastorale liturgique* 176, no. 4 (1988): 54–66.

77. On the conflict between Cluny and Cîteaux in the first half of the twelfth century, and particularly on the quarrel over the color of robes: M. D. Knowles, *Cistercians and Cluniacs: The Controversy between St. Bernard and Peter the Venerable* (Oxford, 1955); G. Constable, *The Letters of Peter the Venerable*, vol. 1 (Cambridge, MA, 1967), 55–58 and 285–90; G. Duby, *Saint Bernard: L'art cistercien* (Paris, 1976); A. H. Bredero, *Cluny et Cîteaux au douzième siècle: L'histoire d'une controverse monastique* (Amsterdam, 1986); M. Pastoureau, "Les cisterciens et la couleur au XIIᵉ siècle," *Cahiers d'archéologie et d'histoire du Berry* 136 (1998): 21–30.

78. H.J.R. Murray, *A History of Chess* (Oxford, 1913); J.-M. Mehl, *Des jeux et des hommes dans la société médiévale* (Paris,

2010); M. Pastoureau, *Le jeu d'échecs médiéval: Une histoire symbolique* (Paris, 2012).

79. The bibliography devoted to Chrétien de Troyes's *Conte du Graal* is vast. In French, for an introduction, see especially J. Frappier, *Chrétien de Troyes: L'homme et l'oeuvre* (Paris, 1957); J. Frappier, *Chrétien de Troyes et le mythe du Graal* (Paris, 1973); J. Frappier, *Autour de Graal* (Geneva, 1977); D. Poirion, *Chrétien de Troyes: Oeuvres complètes* (Paris, 1994); P. Walter, *Perceval: Le Pêcheur et le Graal* (Paris, 2004); E. Doudet, *Chrétien de Troyes* (Paris, 2009).

80. See preceding note.

81. On this episode of the three drops of blood on the snow (*Le Conte du Graal*, vol. 2, ed. F. Lecoy [Paris, 1970], lines 4109 and following), often commented on, see H. Rey-Flaud, "Le sang sur la neige: Analyse d'une image-écran de Chrétien de Troyes," *Littérature* 37 (1980): 15–24; D. Poirion, "Du sang sur la neige: Nature et fonction de l'image dans *Le Conte du Graal*," in *Polyphonie du Graal* (Orléans, 1998), 99–112; Pastoureau, *Rouge: Histoire d'une couleur*, 85.

82. Pliny, *Historia naturalis*, bk. 21, chaps. 10 and 11.

83. Walafrid Strabo, *Hortulus (De cultura hortorum)*, ed. K. Langosch, *Lyrische Anthologie des lateinischen Mittelalters* (Munich, 1968), 112–39.

84. Pliny, *Historia naturalis*, bk. 21, chap. 11, 1.

85. On the medieval lily: Dom. H. Leclerc, "Fleur de lis," in *Dictionnaire d'archéologie chrétienne et de liturgie*, vol. 5, cols. 1707–8; M. Pastoureau, *Une histoire symbolique du Moyen Âge* (Paris, 2004), 99–110; M.-L. Savoye, *De fleurs, d'or, de lait et de miel: Les images mariales dans les collections miraculaires romanes du XIIIᵉ siècle* (Paris, 2009), see especially 173–201.

86. The best expert on the Capetian fleur-de-lis is Hervé Pinoteau, whose earliest works, long scattered throughout largely inaccessible publications, have mostly been regathered into two collections of articles, *Vingt-cinq ans d'études dynastiques* (Paris, 1986) and *Nouvelles études dynastiques* (Paris, 2014). According to this author, with

regard to clothing and insignias, important changes in royal ceremonies took place between 1137 and 1154. The origin of the Capetian fleur-de-lis as a heraldic figure falls between those two dates. Formerly an advocate for dating it a bit later, I now share Hervé Pinoteau's opinion. The adoption of the heraldic fleur-de-lis must have happened in several stages, even before the definitive creation of the coat of arms, between the coronation of Louis VII (summer 1137) and his second marriage to Constance of Castille (early 1154).

87. J.-J. Chifflet, *Lilium francicum veritate historica, botanica et heraldica illustratum* (Antwerp, 1658); S. de Sainte-Marthe, *Traité historique des armes de France et de Navarre* (Paris, 1673). Chifflet maintained that bees constituted the oldest symbol of the French monarchy and denied the existence of the heraldic fleur-de-lis prior to the feudal period. Many authors responded to him through various small or large works, notably Père Jean Ferrand, *Epinicion pro liliis, sive pro aureis Franciae liliis . . .* (Lyon, 1663, 2nd ed. Lyon, 1671). See also four other works from the seventeenth century on the same subject: G.-A. de La Roque, *Les Blasons des armes de la royale maison de Bourbon* (Paris, 1626); Père G.-E. Roussell, *Le Lys sacré . . .* (Lyon, 1631); J. Tristan, *Traité du lis, symbole divin de l'espérance* (Paris, 1656); P. Rainssant, *Dissertation sur l'origine des fleurs de lis* (Paris, 1678).

88. Let us cite two examples: A. de Beaumont, *Recherches sur l'origine du blason et en particulier de la fleur de lis* (Paris, 1853); J. van Malderghem, "Les fleurs de lis de l'ancienne monarchie française: Leur origine, leur nature, leur symbolisme," *Annuaire de la Société d'archéologie de Bruxelles* 8 (1894): 29–38.

89. E. Rosbach, "De la fleur de lis comme emblème national," *Mémoires de l'Académie des sciences, inscriptions et belles-lettres de Toulouse* 6 (1884): 136–72; J. Wolliez, "Iconographie des plantes aroïdes figurées au Moyen Âge en Picardie et considérées comme origine de la fleur de lie en France," *Mémoires de la Société des antiquaires de Picardie* 9 (no date): 115–59. Such excesses

were especially pushed to their limit in the work of Sir Francis Oppenheimer, *Frankish Themes and Problems* (London, 1952), 171–235, and by the article by P. Le Cour, "Les fleurs de lis et le trident de Poséidon," *Atlantis* 69 (January 1973), 109–24. Equally suspect are the hypotheses of F. Châtillon, "Aux origines de la fleur de lis: De la bannière de Kiev à l'écu de France," *Revue du Moyen Âge latin* 11 (1955): 357–70.

90. We lack specific works on the flower history of the Virgin, but we have at our disposal high quality studies on this or that aspect or period. Let us cite for examples: G. Gros, "Au jardin des images mariales: Aspects du plantaires moralisé dans la poésie religieuse de XIVᵉ siècle," in *Vergers et jardins dans l'univers médiéval* (Aix-en-Provence, 1990), 139–53 (Senefiance 23); Savoye, *De fleurs, d'or, de lait et de miel*, 173–201 ("La rose et le lis" chapter).

91. On medieval bestiaries: F. McCullough, *Medieval Latin and French Bestiaries* (Chapel Hill, 1960); D. Hassig, *Medieval Bestiaries: Text, Image, Ideology* (Cambridge, 1995); G. Febel and G. Maag, *Bestiarien im Spannungsfeld: Zwischen Mittelalter und Moderne* (Tübingen, 1997); R. Baxter, *Bestiaries and Their Users in the Middle Ages* (Phoenix Mill, 1999); M.-T. Tesnière, *Bestiaire médiéval: Enluminures* (Paris, 2005); R. Cordonnier and C. Heck, *Bestiaire médiéval* (Paris, 2011); M. Pastoureau, *Bestiaires du Moyen Âge* (Paris, 2011).

92. Pastoureau, *Bestiaires du Moyen Âge*, 118–19.

93. Pastoureau, *Bestiaires du Moyen Âge*, 116–19.

94. On the medieval dove: R. Cordonnier, "Des oiseaux pour les moines blancs: Reflexions sur la réception de l'aviaire d'Hugues de Fouilloy chez les cisterciens," *Le vie en Champagne* 38 (2004): 3–12; R. Cordonnier, "La plume dans l'*avarium* d'Hugues de Fouilloy," in *La Corne et la Plume dans les textes médiévaux*, ed. F. Pomel (Rennes, 2010), 167–202.

95. A. R. Wagner, "The Swan Badge and the Swan Knight," *Archaelogia* 97 (1959): 127–38.

96. Aelian, *De Natura Animalium* V, 34.

97. P. Cassel, *Der Schwan in Sage und Leben: Eine Abhandlung* (Berlin, 1861); N. F. Ticehurst, *The Mute Swan in England: Its History and the Ancient Custom of Swan Keeping* (London, 1957); A. MacGregor, "Swan Rolls and Beak Markings: Husbandry, Exploitation, and Regulation of Cygnus Olor in England (circa 1100–1900)," *Anthropozoologica* 22 (1995): 39–68; L. Hablot, "Emblématique et mythologie médiévale: Le cygne, une devise princière," *Histoire de l'art* 49 (2001): 51–64.

98. M. Pastoureau and E. Taburet-Delahaye, *Les secrets de la licorne* (Paris, 2013).

99. R. Delort, *Le commerce des fourrures en Occident à la fin du Moyen Âge (v. 1300– v. 1450)*, 2 vols. (Rome, 1978).

100. Pastoureau, *Bestiaires du Moyen Âge*, 167.

101. C. Beaune, "Costume et pouvoir en France à la fin du Moyen Âge: Les devises royales vers 1400," *Revue des sciences humaines* 183 (1981): 125–46; J.-B. de Vaivre, "Les cerfs ailés et la tapisserie de Rouen," *Gazette des beaux-arts* (1982): 93–108.

102. On these two last badges, see the excellent book by Hugh Stanford London, *Royal Beasts* (London, 1956).

103. Unknown in antiquity, the first mention of the polar bear in the Christian West seems to occur in a saga in the form of a chronicle compiled about 1050–60; *Morkinskinna: The Earliest Icelandic Chronicle of the Norwegian Kings*, ed. and trans. T. M. Andersson and K. E. Gade (Copenhagen, 2000), 211–12. It is also mentioned a bit later by Archbishop Adam of Bremen in his curious treatise on the geography of Denmark and neighboring regions: *Situ Daniae et reliquarum quae sunt trans Daniam sunt regionum natura*, 2nd ed. (Leiden, 1629), 139 ("Northmannia ursos albos habet," "Norway possesses white bears"). See W. Paravicini, "Tiere aus dem Norden," *Deutsches Archiv für die Erforschung des Mittelaters* 59, no. 2 (2003): 559–91, especially 578–79; O. Vassilieva-Codognet, "Plus blans que flours de lis: Blanchart, l'ours blanc de *Renart le Nouvel*," *Reinardus* 27 (2015): 220–48.

104. J. Bailey, *The History and Antiquities of the Tower of London*, vol. 1 (London, 1821), 270; G. Loisel, vol. 1, 155; W. Paravicini, "Tiere aus dem Norden," 579–80, note 83. It is possible the Henry III of England received a second polar bear from the same Norwegian king in 1261 or 1262.

105. B. Milland-Bove, *La Demoiselle arthurienne: Écriture du personnage et art du récit dans les romans en prose du XIIIᵉ siècle* (Paris, 2006).

106. That is, in this order: light blue, blue-gray, blue-green, dark blue, very dark blue.

107. On the name Margaret, see the curious book by Edmond Stofflet, *Les Marguerite françaises* (Paris, 1888).

108. For the court of Valois, see what Aliénor de Poitiers says in his *Honneurs de la cour*, compiled 1484–85, published by La Curne de Sainte-Palaye, *Mémoires sur l'ancienne chevalerie, considérée comme un établissement politique et militaire*, vol. 2 (Paris, 1759), 169–267. See also J. Paviot, "Les honneurs de la cour d'Eléonore de Poitiers," in *Autour de Marguerite d'Écosse: Reines, princesses et dames du XVᵉ siècle*, ed. G. and P. Contamine (Paris, 1999), 163–79.

109. Although Blanche of Navarre was first betrothed to King Philip VI's oldest son, John the Good, then duke of Normandy, who had just lost his wife, Bonne of Luxembourg, the old king preferred to keep the lovely princess—the most beautiful in Europe, it was said—and marry her himself. Six months later, he was dead.

110. On this queen and her amazing fate: L. Delisle, "Testament de Blanche de Navarre, reine de France," *Mémoires de l'histoire de Paris et de l'Île-de-France* 12 (1885): 1–64; C. Bearne, *Lives and Times of the Early Valois Queens* (London, 1899); J.-M. Cazilhac, Jeanne d'Évreux, Blanche de Navarre: *Deux reines de France, deux douairières durant la guerre de Cents Ans* (Paris, 2011).

111. K.G.T. Webster, *Guinevere: A Study of Her Abductions* (Milton, 1951); L. J. Walters, ed., *Lancelot and Guinevere: A Casebook* (New York, 1996); U. Bethlehem, *Guinevere: A Medieval Puzzle; Images of Arthur's*

Queen in the Medieval Literature of Britain and France (Heidelberg, 2005); D. Rieger, *Guenièvre, reine de Logres, dame courtoise, femme adultère* (Paris, 2009).

112. Gothic art did not succeed in definitively limiting Mary to blue, even though blue remained her favored iconographic attribute until the beginning of the modern period. Certainly in works of art and painted images, her robe and mantle may be any color whatever, but blue remains—by far—the most common. With baroque art, however, a new trend developed: gold or gilded Virgins, henceforth the color attributed to divine light and constituting a kind of "beyond color" or "super color." Gradually, this marked the end of blue Virgins, who had to give way to gold Virgins. The trend triumphed in the eighteenth century and lasted into the first half of the nineteenth century. Then, following the adoption of the dogma of Immaculate Conception—according to which Mary, in the first moment of her conception, by a singular privilege granted by God, was preserved from the stain of original sin—a dogma definitively recognized by Pope Pius IX in 1854, the iconographic color most frequently used for the Virgin's clothes was no longer gold or blue, but white, the symbol of purity, virginity, and "immaculate conception."

113. Liturgists did not yet speak of the Visitation (July 2), which did not become an official feast day until the end of the fourteenth century.

114. For the editions of the text in French, see G. Saffroy, *Bibliographe généalogique, héraldique et nobiliare de la France*, vol. 1 (Paris, 1968), no. 1999–2020.

115. Saffroy, *Bibliographe généalogique*, vol. 1, no. 2012–13. A new edition of the *Blason des couleurs* would be welcome. We are forced to resort to the old edition by H. Cocheris, published in Paris by A. Aubrey in 1860. This mediocre edition was based on printed copies and not on manuscripts, and there are many variants between the two.

116. F. Rabelais, *Gargantua* (Paris, 1535), chap. 1.

117. H. Cocheris, ed., *Le Blason des couleurs en armes, livrées et devises*, 77–78.

118. Cocheris, *Le Blason des couleurs*, 77–126.

119. A list of heraldic treatises in Latin and French can be found in G. Saffroy's work, *Bibliographe généalogique, héraldique et nobiliare de la France*. Here are the major ones: Bartolo de Sassoferato, *De insignis et armis* (c. 1350–55); Johannes de Bado Aureo, *Tractatus de armis* (c. 1390–95); *Le Livre des armes* (anonymous, c. 1410); *Le Livre de Bannyster* (anonymous, c. 1430–40); Jean Courtois, Sicily Herald, and anonymous, *Le Blason des couleurs en armes, livrées et devises* (c. 1435 and c. 1485–90); Clément Prinsault, *Le Blason des armes* (short version c. 1445–50; long version c. 1480); Hungary Herald, *Traité de blason* (c. 1460–80); Jean Le Fèvre de Saint-Remy, *Avis de Toison d'or sur le fait d'armoiries* (1464); *Traité du Jouvencel* (anonymous, c. 1470–1500); *Traité de blason et du bestiaire héraldique* (anonymous: Bibliothèque Nationale de France, ms. fr. 14357, c. 1490); *Traité de l'Argentaye* (anonymous, c. 1482–92); Jean Le Féron, *Le Grand Blason d'armoiries* (1520); Jacques Le Boucq, *Le Noble Blason des armes* (c. 1540–50); Jean Le Féron, *Le Simbol armorial* (1555).

120. Fear is sometimes associated with the color white, but not as a vice or sin, only as an emotion or feeling.

121. Printed in Venice by Bernardino Vitalis in 1528, it was reprinted the following year, and then two more times before the death of the author in 1534. Lazare Baïf, ambassador to Venice, brought a copy of the work to France to share in his circles. Robert Estienne published it in Paris in 1549. A modern edition has recently been issued by M. Indergand and C. Viglino with Presses de l'École Estienne (Paris, 2010).

122. Modern edition by P. Barrochi, *Scritti d'arte del Cinquecento*, vol. 2 (Venice, 1971), 217–76.

123. P. Pino, *Dialogo di pittura* (Venice, 1548); modern edition by E. Camasasca (Milan, 1954).

124. L. Dolce, *Dialogo dei colori* (Venice, 1557). I used the second edition with a longer title and more extensive remarks: *Dialogo nel quale si ragiona della qualità, diversità e proprietà dei colori* (Venice, 1565).

125. The Venice-Nuremberg, Venice-Milan-Lyon, and Venice-Cologne-Brussels axes were essential with regard to the distribution of pigments, dyestuffs, and the expertise accompanying them. See M. B. Hall, ed., *Color and Technique in Renaissance Painting: Italy and the North* (London, 1987).

126. F. Brunello, *L'arte della tintura nella storia dell'umanita* (Vicenza, 1968); F. Brunello, *Arti e mestieri a Venezia nel medioevo e nel Rinascimento* (Vicenza, 1980); M. Pastoureau, "Les teinturiers médiévaux: Histoire social d'un métier réprouvé," in *Une histoire symbolique du Moyen Âge occidental* (Paris, 2004), 173–96.

127. Edition and study by S. M. Evans and H. C. Borghetty, *The "Plictho" of Giovan Ventura Rosetti* (Cambridge, MA, and London, 1969). For the collections of dyeing recipes and manuals compiled in Venice that survive as manuscripts, see also G. Rebora, *Un manuale di tintoria del Quattrocento* (Milan, 1970).

128. Saffroy, *Bibliographe généalogique*, vol. 1, no. 2012–13.

129. See J. Gage, *Couleur et culture: Usages et significations de la couleur de l'Antiquité à l'abstraction* (Paris, 2008), 119–20 (original English edition: *Colour and Culture: Practice and Meaning from Antiquity to Abstraction* ([London, 1993]).

130. Pliny, *Historia naturalis*, bk. 35, chap. 12 and bk. 36, chap. 45.

131. On the "chromoclasm" of the great Protestant Reformers, see M. Pastoureau, "La Réforme et la couleur," *Bulletin de la Société de l'histoire du Protestantisme français* 138 (July–September 1992): 323–42.

132. J. W. Goethe, *Farbenlehre: Historischer Teil*, vol. 4, ed. G. Ott (Stuttgart, 1986), 142–56.

133. Pino, *Dialogo di pittura*, 47–54 and 62–73.

134. On Lodovico Dolce's aesthetic ideas regarding painting, see M. Roskill, *Dolce's Aretino and Venitian Art Theory of the Cinquecento* (London, 1968).

135. Pastoureau, *Bleu: Histoire d'une couleur*, 49–84.

136. M. Zink and H. Dubois, *Les âges de la vie au Moyen Âge* (Paris, 1992).

137. *Bridget of Sweden, Revelaciones*, ed. B. Bergh (Uppsala, 1967), bk. 7, chap. 21.

138. On the green bedroom believed to favor pregnancy, see the fine study by T. Brero, "Le mystère de la chambre verte: Les influences françaises dans le cérémonial baptismal des cours de Savoie et de Bourgogne," in *La Cour du prince: Cour de France, cours d'Europe, XIIᵉ–XVᵉ siècle*, ed. M. Gaude-Ferragu, B. Laurioux, and J. Paviot (Paris, 2011), 195–208.

139. M. Godelier, *La pratique de l'anthropologie: Du décentrement à l'engagement*. Interview with M. Lussault (Lyon, 2016), 79–92 ("La mort et la vie après la mort").

140. P. Bureau, "De l'habit paradisiaque au vêtement eschatologique," *Médiévales* (1993): 93–124.

141. For example, Homer, *The Odyssey*, bk. 11, and Pliny the Younger, *Letters*, bk. 7, letter 27 (to Sura).

142. On phantoms and revenants, the bibliography is considerable but uneven. See especially C. Lecouteux, *Fantômes et revenants au Moyen Âge* (Paris, 1986); J.-C. Schmitt, *Les Revenants: Les vivants et les morts dans la société médiévale* (Paris, 1994); C. Callard, *Le temps des fantômes: Spectralités d'Ancien Régime, XVIᵉ–XVIIIᵉ siècles* (Paris, 2019).

143. The origin of the French word *fraise* (ruff) as used in relation to clothing is a subject of debate. A definite comparison to *une fraise de veau* (a calf's caul) is a very shaky explanation.

144. There were many customs during the ancien régime that associated the color white with nobility. Let us cite one curious example: the *taureau banal*, relic of an old feudal right that required peasants in many regions to have their cows bred not with just any bull but only by the one belonging to the local lord—and of course to pay a fee for this required service. This bull had to be white, and its coat was to be without spots, if possible.

145. Guillaume Guiard, *La branche des royaux lignages*, vol. 2, ed. J.-A. Buchon (Paris, 1828), lines 11052–68.

146. H. Pinoteau, *La symbolique royale française, Vᵉ–XVIIIᵉ siècle* (La Roche-Rigault, 2004), 739–78.

147. M. Pastoureau, *Les couleurs au Moyen Âge: Dictionnaire encyclopédique* (Paris, 2022).

148. D. Turrel. *Le Blanc de France: La construction des signes identitaires pendant les guerres de Religion (1562–1629)* (Geneva, 2005).

149. M. Reinhard, *La légende de Henri IV* (Paris, 1935); J.-P. Babelon, *Henri IV* (Paris, 1982), 482–86; P. Mironneau, "Aux sources de la légende d'Henri IV: Le cantique de la bataille d'Ivry de Guillaume Salluste du Bartas," *Albineana: Cahiers d'Aubigné* 9 (1998): 111–27.

150. Another tradition reports that at the Battle of Ivry, Henry IV, who had not yet been coronated but who was already the legitimate king of France for a good part of the realm, saw his cornet-bearer wounded and left on the battlefield. Holding up the white panache that this cornet-bearer displayed on his helmet, the king was supposed to have pronounced these words (no doubt also apocryphal): "If you miss the cornet, here is my rallying sign." See Turrel, *Le Blanc de France*.

151. Edicts of July 18, 1590, and June 1, 1594.

152. Turrel, *Le Blanc de France*, passim.

153. J. de Beaurain, *Histoire militaire de Flandre, depuis l'année 1690 jusqu'en 1694 inclusivement*, vol. 1 (Paris, 1755), 32–38.

154. *Édits, déclarations, réglemens et ordonnances du Roy sur le faict de la marine* (Paris, 1677), 15–17 and 37.

155. Amid a vast but sometimes disappointing bibliography, see J.-M. Crosepinte, *Les Drapeaux vendéens* (Niort, 1988).

156. R. Grouvel, *Les corps de troupe de l'émigration française (1789–1815)*, 2 vols. (Paris, 1961).

157. On the vicissitudes of the white flag, the works of Hervé Pinoteau are essential, especially *Le chaos français et ses signes: Étude sur la symbolique de l'État français depuis la Révolution de 1789* (La Roche-Rigault, 1998), 109–10, 246–47, 257, 372–75. See also J.-P. Garnier, *Le drapeau blanc* (Paris, 1971).

158. It is not unreasonable to think that in Washington, the White House, the official residence of the president of the United States since 1800, owes its name not only to the color of its walls but also to the small trace of kingly power exercised by the one who inhabits it.

159. On Newton's discoveries and their consequences, M. Blay, *Les figures de l'arc-en-ciel* (Paris, 1995), 60–77. See also, of course, the texts by Newton himself, especially *Opticks; Or, a Treatise of the Reflexions, Refractions, Inflexions and Colours of Light* (London, 1704) (a French translation by Pierre Coste was published in Amsterdam in 1720 and in Paris in 1722, reprinted in Paris in 1955).

160. Although in the modern period, as in antiquity and the Middle Ages, the black referent par excellence, considering all domains together, was not ink, pitch, or coal, but the crow.

161. Of course, ink was not the only factor that contributed to this success. The manufacturing of movable metallic type made of an alloy of lead, tin, and antimony; the availability of a mechanical press (perhaps inspired by the Rhenish wine presses); the widespread use of a paper medium permitting the uniform printing of recto–verso pages: these all represented decisive advances as well, as compared to handwritten manuscripts and xylographic reproduction processes. On the origins of printing, see again as always: L. Febvre and H.-J. Martin, *L'Apparition du livre*, 2nd ed. (Paris, 1971).

162. On paper and its role in the appearance of printing: A. Blanchet, *Essai sur l'histoire du papier* (Paris, 1900); A. Blum, *Les origines du papier, de l'imprimerie et de la gravure*, 2nd ed. (Paris, 1935); Febvre and Martin, *L'apparition du livre*.

163. In English, the adjective *white* sometimes has the meaning of suitable, polite, correct. A "white lie," for example, is a lie told out of politeness.

164. On relationships between the research of painters and of scientists in the seventeenth century, see especially A. E. Shapiro, "Artists' Colors and Newton's Colors," *Isis* 85 (1994): 600–30.

165. R. Descartes, *Discours de la méthode . . . Plus la diotrique* (Leiden, 1637).

166. See A. I. Sabra, *Theories of Light from Descartes to Newton*, 2nd ed. (Cambridge, 1981).

167. On Newton's discoveries and the development of the spectrum, M. Blay, *La conceptualisation newtonienne des phénomènes de la couleur* (Paris, 1983).

168. I. Newton, *Opticks; or, a Treatise of the Reflections, Refractions, Inflexions, and Colours of Light . . .* (London, 1704).

169. C. Huygens, *Traité de la lumière . . .* (Paris, 1690).

170. *Optice sive de reflectionibus, refractionibus et inflectionibus et coloribus lucis . . .* (London, 1707). Translated by Samuel Clarke, republished in Geneva in 1740.

171. That was the case with Father Louis-Bertrand Castel, who reproached Newton for having conceived his theories before doing the experiments and not the other way around: *L'optique des couleurs . . .* (Paris, 1740) and *Le Vrai Système de physique générale de M. Isaac Newton* (Paris, 1743).

172. And black perhaps even less so than white. White, in effect, was directly involved with the spectrum of colors since it contained them all within it. Not so for black, and for physics, it was henceforth located outside any chromatic system, outside the world of color.

173. Even in the first millennia of the Neolithic period, traces of greens and blues made by humans are extremely rare.

174. See the fine study by C. Lanoé, *La poudre et le fard: Une histoire des cosmétiques de la Renaissance aux Lumières* (Seyssel, 2008).

175. J. Petit, J. Roire, and H. Valot, *Encyclopédie de la peinture: Formuler, fabriquer, appliquer*, vol. 1 (Puteaux, 1999), 343–46; J. Rainhorn, *Blanc de plomb: Histoire d'un poison légal* (Paris, 2019).

176. Jockey, *Le mythe de la Grèce blanche*, 133–72.

177. J. W. von Goethe, *Winckelmann und sein Jahrhundert* (Tübingen, 1805); C. Justi, *Winckelmann und sien Zeitgenossen*, 3 vols., 2nd ed. (Leipzig, 1898); B. Vallentin, *Winckelmann* (Berlin, 1931); T. W. Gaehtgens, ed., *Johann Joachim Winckelmann (1717–1768)* (Hamburg, 1986); E. Pommier, *Winckelmann: Naissance de l'histoire de l'art* (Paris, 2003).

178. Typical in this regard is French troubadour painting of the years 1820 to 1850.

179. M. Sadoun-Goupil, *Le Chimiste Claude-Louis Berthollet (1748–1822):¸Sa vie, son oeuvre* (Paris, 1977).

180. M.-E. Chevreul, *Recherches chimiques sur les corps gras d'origine animale* (Paris, 1823).

181. The bibliography on the history of soaps and detergents is very scant. See R. Leblanc, *Le Savon, de la Préhistoire au XXIe siècle* (Montreuil-l'Argillé, 2001).

182. C. Lefébure, *La France des lavoirs* (Toulouse, 2003); M. Caminade, *Linge, lessive, lavoir: Une histoire de femmes* (Paris, 2005).

183. G. Vigarello, *Le Propre et le Sale: L'hygiène du corps depuis le Moyen Âge* (Paris, 1987).

184. Public baths with showers still exist today in most big cities in Europe.

185. Still today in bathrooms, white is considered the most hygienic color and the most suitable for washing. We can try the experiment of taking a bath in a white bathtub and then taking a bath in a pink, green, or blue bathtub. We will have the impression of getting cleaner in the first, even if it is old and worn and the others are new. White showers, bidets, and washbasins seem to have the same virtues. As for toilet bowls? Do toilet bowls exist that are not white or pastel? Bright red for example, or brown? And if so, are they truly capable of effectively fulfilling the functions that are rightfully expected of them?

186. L. Gerschel, "Couleurs et teintures chez divers peuples indo-européens," *Annales ESC* 21, no. 3 (1966).

187. Moreover, that is why many pills and tablets are white. Some are colored with titanium dioxide, an artificially made pigment that is now suspected of being carcinogenic!

188. M. Pastoureau, "Une brève histoire de l'orangé," in *Roux: L'obsession de la rousseur, de Jean-Jacques Henner à Sonia Rykiel*, exhibition catalog (Paris, Musée Henner, 2019), 11–35.

189. P. Sébillot, *Le folklore de France*, 8 vols. (Paris, 1904–6); R. Muchembled, *Magie et sorcellerie en Europe, du Moyen Âge à nos jours* (Paris, 1994); G. Bechtel, *La sorcière et l'Occident: La destruction de la sorcellerie en Europe, des origins aux grands bûchers* (Paris, 1997).

190. See above, 58–59.

191. E. Herriot, *Madame Récamier et ses amis*, 2 vols. (Paris, 1909); F. Wagener, *Madame Récamier* (Paris, 1990); S. Paccoud and L. Widerkehr, *Juliette Récamier, muse et mécène*, exhibition (Lyon, Musée des Beaux-Arts, 2009); C. Decours, *Juliette Récamier: L'art de la seduction* (Paris, 2013).

192. J. W. von Goethe, *Zur Farbenlehre* (Tübingen, 1810), *Theory of Colours*, trans. C. L. Eastlake (London, 1840), 327 and 329. Cited by E. Heller, *Wie Farben wirken*, 2nd ed. (Berlin, 2004), 138.

193. On the marriage of Victoria and Albert and the queen's attire: E. Longford, *Victoria R. I.* (London, 1964), 72–84; D. Marshall, *The Life and Times of Queen Victoria* (London, 1972), 60–66; S. Weintraub, *Albert, Uncrowned King* (London, 1997), 77–81; C. Hibbert, *Queen Victoria: A Personal History* (London, 2000), 94–123.

194. Although earlier examples exist, sometimes dating back to the eighteenth century, it was only in the years 1880–1900 that these two garments adopted the total whiteness that is still theirs today.

195. On the birth of modern sports, there is a vast bibliography. Few works address

the first athletic uniforms however, and fewer still the role of color. Nonetheless, see R. Holt, *Sport and Society in Modern France* (Oxford, 1981); M. Berjat et al., *Naissance du sport moderne* (Paris, 1987); R. Holt, *Sport and the British: A Modern History* (Oxford, 1990); A. Guttmann, *Women's Sports: A History* (New York, 1992); G. Vigarello, *Passion sport: Histoire d'une culture* (Paris, 2000); G. Vigarello, *Du jeu ancien au show sportif: Histoire d'un mythe* (Paris, 2002); P. Tétard, *Histoire du sport en France, du Second Empire au régime de Vichy* (Paris, 2007); M. Maurer, *Vom Mutterland des Sports zum Kontinent: Der Transfer des englischen Sports im 19. Jahrhundert* (Mainz, 2011).

196. We must wonder about the absence of brown on athletic fields, where even gray finds a place. Is this color too ugly? Too devalued? Brown is also absent from the world of flags and emblems. And in opinion polls, it appears as the least popular color, at least in Europe. The order of preference moreover has remained the same since the end of the nineteenth century: blue, green, red, black, white, yellow, orange, gray, pink, purple, brown.

197. On the history of the color of jerseys used in Italian soccer, from the beginning to the twenty-first century, see the excellent book by S. Salvi and A. Salvorelli, *Tutti i colori del Calcio* (Florence, 2008).

198. The French *vin blanc* becomes *Weisswein* in German, *white wine* in English, *vino bianco* in Italian, *vino blanco* in Castilian, *vinho branco* in Portuguese, and so on.

199. Nevertheless, skin color was sometimes described in the Middle Ages, notably by missionaries and travelers who related it to climate: the hotter the sun, the darker the skin. Thus there were biblical figures and even saints with black skin because they were originally from Africa: the Queen of Sheba, the black magus Balthazar, Priest John, and Saint Maurice, patron saint of knights and dyers.

200. On this subject, the bibliography is considerable and impossible to cite here. One of the first authors to systematize the classification of human populations according to skin color was the German doctor and anthropologist Johann Friedrich Blumenbach (1752–1840), author of various treatises on anatomy and natural history as well as a work on humankind and the diversity of the "races," published in 1795: *De generis humani varietate nativa*. Even while affirming the unity of the human species, Blumenbach distinguished five races (*varietates*) according to skin color: Ethiopian (black), Caucasian (white), Mongolian (yellow), Malayan (brown), and Amerindian (red). Nonetheless, he recognized that different skin colors formed a chromatic continuum and that there were numerous intermediate colorations difficult to classify. On the other hand, he set forth no racist theory, in the sense that we understand that word today. The idea of the superiority of one race over another or several others was foreign to him, and the explanation he advanced for understanding the differences in skin color and the diversity of physical types involved geography and climate. The more humans lived in hot, dry climates, the darker their skin: nothing very new here since such explanations already appeared among ancient and medieval authors; his originality lay in making skin color a characteristic subject to change. Blumenbach aptly recalled that in ancient Greek, the word designating color, khrôma, was related etymologically to the idea of skin. Additionally, he believed in monogenesis (all humans descending from a single ancestor) and stressed the existence of an absolutely impermeable boundary between the human species and animals, even those considered "superior." It is a common mistake to consider Blumenbach one of the first theorists of racism. As products of growing colonialism and capitalism, racist theories and racism predate him.

201. This is different from a "*livre blanc*," a "white paper" or "white papers," official documents published by a government or organization to lay out a political, diplomatic, or economic issue and propose measures for resolving it.

202. An "*arme blanche*," on the other hand, is a weapon with a metal blade and a handle, like a knife or sword.

BIBLIOGRAPHY

GENERAL WORKS

Berlin, Brent, and Paul Kay. *Basic Color Terms: Their Universality and Evolution.* Berkeley, CA, 1969.

Birren, Faber. *Color: A Survey in Words and Pictures.* New York, 1961.

Brusatin, Manlio. *Storia dei colori.* 2nd ed. Turin, 1983. Translated as *Histoire des couleurs*, Paris, 1986.

Conklin, Harold C. "Color Categorization." *American Anthropologist* 75, no. 4 (1973): 931–42.

Eco, Renate, ed. "Colore: Divietti, decreti, discute." Special number of *Rassegna* (Milan) 23 (September 1985).

Gage, John. *Colour and Culture: Practice and Meaning from Antiquity to Abstraction.* London, 1993.

Heller, Eva. *Wie Farben wirken: Farbpsychologie, Farbsymbolik, Kreative Farbgestaltung.* 2nd ed. Hamburg, 2004.

Indergand, Michel, and Philippe Fagot. *Bibliographie de la couleur.* 2 vols. Paris, 1984–88.

Meyerson, Ignace, ed. *Problèmes de la couleur.* Paris, 1957.

Pastoureau, Michel. *Bleu: Histoire d'une couleur.* Paris, 2000.

———. *Dictionnaire des couleurs de notre temps: Symbolique et société.* 4th ed. Paris, 2007.

———. *Jaune: Histoire d'une couleur.* Paris, 2020.

———. *Noir: Histoire d'une couleur.* Paris, 2008.

———. *Rouge: Histoire d'une couleur.* Paris, 2016.

———. *Vert: Histoire d'une couleur.* Paris, 2013.

Portmann, Adolf, and Rudolf Ritsema, eds. *The Realms of Colour: Die Welt der Farben.* Leiden, 1974. (*Eranos Yearbook*, 1972).

Pouchelle, Marie-Christine, ed. "Paradoxes de la couleur." Special number of *Ethnologie française* (Paris) 20, no. 4 (October–December 1990).

Rzepinska, Maria. *Historia coloru u dziejach malatstwa europejskiego.* 3rd ed. Warsaw, 1989.

Tornay, Serge, ed. *Voir et nommer les couleurs.* Nanterre, 1978.

Valeur, Bernard. *La Couleur dans tous ses états.* Paris, 2011.

Vogt, Hans Heinrich. *Farben und ihre Geschichte.* Stuttgart, 1973.

Zahan, Dominique. "L'homme et la couleur." In *Histoire des mœurs*, edited by Jean Poirier, vol. 1, *Les Coordonnées de l'homme et la culture matérielle*, 115–80. Paris, 1990.

Zuppiroli, Libero, ed. *Traité des couleurs.* Lausanne, 2001.

ANTIQUITY AND THE MIDDLE AGES

Beta, Simone, and Maria Michela Sassi, eds. *I colori nel mondo antiquo: Esperienze linguistiche e quadri simbolici.* Siena, 2003.

Bradley, Mark. *Colour and Meaning in Ancient Rome.* Cambridge, 2009.

Brinkmann, Vinzenz, and Raimund Wünsche, eds. *Bunte Götter: Die Farbigkeit antiker Skulptur.* Munich, 2003.

Brüggen, Elke. *Kleidung und Mode in der höfischen Epik.* Heidelberg, 1989.

Carastro, Marcello, ed. *L'Antiquité en couleurs: Catégories, pratiques, représentations*, 187–205. Grenoble, 2008.

Cecchetti, Bartolomeo. *La vita dei Veneziani nel 1300: Le veste.* Venice, 1886.

Centre Universitaire d'Études et de Recherches Médiévales d'Aix-en-Provence. *Les Couleurs au Moyen Âge. Senefiance*, vol. 24. Aix-en-Provence, France, 1988.

Ceppari Ridolfi, Maria A., and Patrizia Turrini. *Il mulino delle vanità: Lusso e cerimonie nella Siena medievale.* Siena, 1996.

Descamps-Lequime, Sophie, ed. *Couleur et peinture dans le monde grec antique.* Paris, 2004.

Dumézil, Georges. "Albati, russati, virides." In *Rituels indo-européens à Rome*, 45–61. Paris, 1954.

Frodl-Kraft, Eva. "Die Farbsprache der gotischen Malerei: Ein Entwurf." *Wiener*

Jahrbuch für Kunstgeschichte 30–31 (1977–78): 89–178.

Grand-Clément, Adeline. *La fabrique des couleurs: Histoire du paysage sensible des Grecs anciens.* Paris, 2011.

Haupt, Gottfried. *Die Farbensymbolik in der sakralen Kunst des abendländischen Mittelalters.* Leipzig, 1941.

Istituto Sorico Lucchese. *Il colore nel Medioevo: Arte, simbolo, técnica; Atti delle Giornate di studi.* 2 vols. Lucca, 1996–98.

Luzzatto, Lia, and Renata Pompas. *Il significato dei colori nelle civiltà antiche.* Milan, 1988.

Pastoureau, Michel. "L'Église et la couleur des origines à la Réforme." *Bibliothèque de l'École des chartes* 147 (1989): 203–30.

———. *Figures et couleurs: Études sur la symbolique et la sensibilité médiévales.* Paris, 1986.

———. "Voir les couleurs au XIIIᵉ siècle." In *View and Vision in the Middle Ages*, 2: 147–65. *Micrologus: Nature, Science, and Medieval Societies*, vol. 6. Florence, 1998.

Rouveret, Agnès. *Histoire et imaginaire de la peinture ancienne.* Paris, 1989.

Rouveret, Agnès, Sandrine Dubel, and Valérie Naas, eds. *Couleurs et matières dans l'Antiquité: Textes, techniques et pratiques.* Paris, 2006.

Sicile, héraut d'armes du XVᵉ siècle. *Le Blason des couleurs en armes, livrées et devises.* Edited by H. Cocheris. Paris, 1857.

Tiverios, Michales A., and Despoina Tsiafakis, eds. *The Role of Color in Ancient Greek Art and Architecture (700–31 B.C.).* Thessaloniki, 2002.

Villard, Laurence, ed. *Couleur et vision dans l'Antiquité classique.* Rouen, 2002.

MODERN AND CONTEMPORARY TIMES

Batchelor, David. *La Peur de la couleur.* Paris, 2001.

Birren, Faber. *Selling Color to People.* New York, 1956.

Brino, Giovanni, and Franco Rosso. *Colore e città: Il piano del colore di Torino, 1800–1850.* Milan, 1980.

Laufer, Otto. *Farbensymbolik im deutschen Volsbrauch.* Hamburg, 1948.

Lenclos, Jean-Philippe, and Dominique Lenclos. *Les Couleurs de la France: Maisons et paysage.* Paris, 1982.

———. *Les Couleurs de l'Europe: Géographie de la couleur.* Paris, 1995.

Noël, Benoît. *L'Histoire du cinéma couleur.* Croissy-sur-Seine, 1995.

Pastoureau, Michel. "La couleur en noir et blanc (XVᵉ–XVIIIᵉ siècle)." In *Le Livre et l'Historien: Études offertes en l'honneur du Professeur Henri-Jean Martin*, 197–213. Geneva, 1997.

———. "La Réforme et la couleur." *Bulletin de la Société de l'histoire du Protestantisme français* 138 (July–September 1992): 323–42.

———. *Les Couleurs de nos souvenirs.* Paris, 2010.

PROBLEMS OF PHILOLOGY AND TERMINOLOGY

André, Jacques. *Étude sur les termes de couleur dans la langue latine.* Paris, 1949.

Brault, Gerard J. *Early Blazon: Heraldic Terminology in the Twelfth and Thirteenth Centuries, with Special Reference to Arthurian Literature.* Oxford, 1972.

Crosland, Maurice P. *Historical Studies in the Language of Chemistry.* London, 1962.

Giacolone Ramat, Anna. "Colori germanici nel mondo romanzo." *Atti e memorie dell'Academia toscana di scienze e lettere La Colombaria* (Florence) 32 (1967): 105–211.

Gloth, Walther. *Das Spiel von den sieben Farben.* Königsberg, 1902.

Grossmann, Maria. *Colori e lessico: Studi sulla struttura semantica degli aggetivi di colore in catalano, castigliano, italiano, romano, latino ed ungherese.* Tübingen, 1988.

Irwin, Eleanor. *Colour Terms in Greek Poetry.* Toronto, 1974.

Jacobson-Widding, Anita. *Red-White-Black, as a Mode of Thought.* Stockholm, 1979.

Jacquesson, François. "Les mots de la couleur en hébreu ancien." In *Histoire et géographie de la couleur*, edited by P. Dollfus, F. Jacquesson, and M. Pastoureau, vol. 13, *Cahiers du Léopard d'or*, 67–130. Paris, 2013.

Jones, William Jervis. *German Colour Terms: A Study in Their Historical Evolution from Earliest Times to the Present.* Amsterdam, 2013.

Kristol, Andres M. *Color: Les Langues romanes devant le phénomène de la couleur.* Berne, 1978.

Maxwell-Stuart, P. G. *Studies in Greek Colour Terminology*, vol. 2: XAPOIIOE. Leiden, 1998.

Meunier, Annie. "Quelques remarques sur les adjectifs de couleur." *Annales de l'Université de Toulouse* 11, no. 5 (1975): 37–62.

Mollard-Desfour, Annie. *Le Dictionnaire des mots et expressions de couleur.* 6 vols. Paris, 2000–2012.

Ott, André. *Études sur les couleurs en vieux français.* Paris, 1899.

Schäfer, Barbara. *Die Semantik der Farbadjektive im Altfranzösischen.* Tübingen, 1987.

Sève, Robert, Michel Indergand, and Philippe Lanthony. *Dictionnaire des termes de la couleur.* Paris, 2007.

Wackernagel, Wilhelm. "Die Farben- und Blumensprache des Mittelalter." In *Abhandlungen zur deutschen Altertumskunde und Kunstgeschichte*, 143–240. Leipzig, 1872.

Wierzbicka, Anna. "The Meaning of Color Terms: Cromatology and Culture." *Cognitive Linguistics* 1, no. 1 (1990): 99–150.

THE HISTORY OF DYES AND DYERS

Brunello, Franco. *L'arte della tintura nella storia dell'umanita.* Vicenza, 1968.

———. *Arti e mestieri a Venezia nel medioevo e nel Rinascimento.* Vicenza, 1980.

Cardon, Dominique. *Mémoires de teinture: Voyage dans le temps chez un maître des couleurs.* Paris, 2013.

——. *Le Monde des teintures naturelles.* Paris, 1994.

Cardon, Dominique, and Gaëtan Du Châtenet. *Guide des teintures naturelles.* Neuchâtel and Paris, 1990.

Chevreul, Michel Eugène. *Leçons de chimie appliquées à la teinture.* Paris, 1829.

Edelstein, Sidney M., and Hector C. Borghetty. *The "Plictho" of Giovan Ventura Rosetti.* London and Cambridge, MA, 1969.

Gerschel, Lucien. "Couleurs et teintures chez divers peuples indo-européens." *Annales ESC* 21 (1966): 608–63.

Hellot, Jean. *L'Art de la teinture des laines et des étoffes de laine en grand et petit teint.* Paris, 1750.

Jaoul, Martine, ed. *Des teintes et des couleurs.* Exhibition catalog. Paris, 1988.

Lauterbach, Fritz. *Geschichte der in Deutschland bei der Färberei angewandten Farbstoffe, mit besonderer Berücksichtigung des mittelalterlichen Waidblaues.* Leipzig, 1905.

Legget, William F. *Ancient and Medieval Dyes.* New York, 1944.

Lespinasse, René de. *Histoire générale de Paris: Les métiers et corporations de la ville de Paris.* Vol. 3, *Tissus, étoffes. . . .* Paris, 1897.

Pastoureau, Michel. *Jésus chez le teinturier: Couleurs et teintures dans l'Occident médiéval.* Paris, 1998.

Ploss, Emil Ernst. *Ein Buch von alten Farben: Technologie der Textilfarben im Mittelalter.* 6th ed. Munich, 1989.

Rebora, Giovanni. *Un manuale di tintoria del Quattrocento.* Milan, 1970.

Varichon, Anne. *Couleurs: Pigments et teintures dans les mains des peuples.* 2nd ed. Paris, 2005.

THE HISTORY OF PIGMENTS

Ball, Philip. *Histoire vivante des couleurs: 5000 ans de peinture racontée par les pigments.* Paris, 2005.

Bomford, David, et al. *Art in the Making: Impressionism.* London, 1990.

——. *Art in the Making: Italian Painting before 1400.* London, 1989.

Brunello, Franco. *"De arte illuminandi" e altri trattati sulla técnica della miniatura medievale.* 2nd ed. Vicenza, 1992.

Feller, Robert L., and Ashok Roy. *Artists' Pigments: A Handbook of Their History and Characteristics.* 2 vols. Washington, DC, 1985–86.

Guineau, Bernard, ed. *Pigments et colorants de l'Antiquité et du Moyen Âge.* Paris, 1990.

Harley, Rosamond D. *Artists' Pigments (c. 1600–1835).* 2nd ed. London, 1982.

Hills, Paul. *The Venetian Colour.* New Haven, 1999.

Kittel, Hans, ed. *Pigmente.* Stuttgart, 1960.

Laurie, Arthur P. *The Pigments and Mediums of Old Masters.* London, 1914.

Loumyer, Georges. *Les traditions techniques de la peinture médiévale.* Brussels, 1920.

Merrifield, Mary P. *Original Treatises Dating from the XIIth to the XVIIIth Centuries on the Art of Painting.* 2 vols. London, 1849.

Montagna, Giovanni. *I pigmenti: Prontuario per l'arte e il restauro.* Florence, 1993.

Reclams Handbuch der künstlerischen Techniken. Vol. I, *Farbmittel, Buchmalerei, Tafel- und Leinwandmalerei.* Stuttgart, 1988.

Roosen-Runge, Heinz. *Farbgebung und Technik frühmittelalterlicher Buchmalerei.* 2 vols. Munich, 1967.

Smith, Cyril S., and John G. Hawthorne. *Mappae clavicula: A Little Key to the World of Medieval Techniques.* Transactions of the American Philosophical Society 64, no. 4. Philadelphia, 1974.

Technè: La science au service de l'art et des civilisations. Vol. 4, *La couleur et ses pigments.* 1996.

Thompson, Daniel V. *The Material of Medieval Painting.* London, 1936.

Boehn, Max von. *Die Mode: Menschen und Moden vom Untergang der alten Welt bis zum Beginn des zwanzigsten Jahrhunderts.* 8 vols. Munich, 1907–25.

Boucher, François. *Histoire du costume en Occident de l'Antiquité à nos jours.* Paris, 1965.

Bridbury, Anthony R. *Medieval English Clothmaking: An Economic Survey.* London, 1982.

Eisenbart, Liselotte C. *Kleiderordnungen der deutschen Städte zwischen, 1350–1700.* Göttingen, 1962.

Harte, N. B., and Kenneth G. Ponting, eds. *Cloth and Clothing in Medieval Europe: Essays in Memory of E. M. Carus-Wilson.* London, 1982.

Harvey, John. *Men in Black.* London, 1995. Translated as *Des hommes en noir: Du costume masculin à travers les âges.* Abbeville, 1998.

Hunt, Alan. *Governance of the Consuming Passions: A History of Sumptuary Laws.* London and New York, 1996.

Lurie, Alison. *The Language of Clothes.* London, 1982.

Madou, Mireille. *Le costume civil: Typologie des sources du Moyen Âge occidental,* vol. 47. Turnhout, 1986.

Mayo, Janet. *A History of Ecclesiastical Dress.* London, 1984.

Nixdorff, Heide, and Heidi Müller, eds. *Weisse Vesten, roten Roben: Von den Farbordnungen des Mittelalters zum individuellen Farbgeschmak.* Exhibition catalog. Berlin, 1983.

Page, Agnès. *Vêtir le prince: Tissus et couleurs à la cour de Savoie (1427–1447).* Lausanne, 1993.

Pellegrin, Nicole. *Les vêtements de la liberté: Abécédaires des pratiques vestimentaires françaises de 1780 à 1800.* Paris, 1989.

Piponnier, Françoise. *Costume et vie sociale: La cour d'Anjou, XIVe–XVe siècles.* Paris and The Hague, 1970.

Piponnier, Françoise, and Perrine Mane. *Se vêtir au Moyen Âge.* Paris, 1995.

Quicherat, Jules. *Histoire du costume en France depuis les temps les plus reculés jusqu'à la fin du XVIIIe siècle.* Paris, 1875.

THE HISTORY OF CLOTHING

Baldwin, Frances E. *Sumptuary Legislation and Personal Relation in England.* Baltimore, 1926.

Baur, Veronika. *Kleiderordnungen in Bayern von 14. bis 19. Jahrhundert.* Munich, 1975.

Roche, Daniel. *La Culture des apparences: Une histoire du vêtement (XVIIᵉ–XVIIIᵉ siècles)*. Paris, 1989.

Roche-Bernard, Geneviève, and Alain Ferdière. *Costumes et textiles en Gaule romaine*. Paris, 1993.

Vincent, John M. *Costume and Conduct in the Laws of Basel, Bern, and Zurich*. Baltimore, 1935.

THE PHILOSOPHY AND HISTORY OF SCIENCE

Albert, Jean-Pierre, et al., eds. *Coloris Corpus*. Paris, 2008.

Blay, Michel. *La conceptualisation newtonienne des phénomènes de la couleur*. Paris, 1983.

———. *Les figures de l'arc-en-ciel*. Paris, 1995.

Boyer, Carl B. *The Rainbow from Myth to Mathematics*. New York, 1959.

Goethe, Johann Wolfgang von. *Zur Farbenlehre*. 2 vols. Tübingen, 1810.

———. *Materialen zur Geschichte der Farbenlehre*. 2 vols. Munich, 1971.

Halbertsma, Klaas Tjalling Agnus. *A History of the Theory of Colour*. Amsterdam, 1949.

Hardin, Clyde L. *Color for Philosophers: Unweaving the Rainbow*. Cambridge, MA, 1988.

Lindberg, David C. *Theories of Vision from Al-Kindi to Kepler*. Chicago, 1976.

Magnus, Hugo. *Histoire de l'évolution du sens des couleurs*. Paris, 1878.

Newton, Isaac. *Opticks: Or, a Treatise of the Reflexions, Refractions, Inflexions, and Colours of Light*. London, 1704.

Pastore, Nicholas. *Selective History of Theories of Visual Perception, 1650–1950*. Oxford, 1971.

Sepper, Dennis L. *Goethe contra Newton: Polemics and the Project of a New Science of Color*. Cambridge, 1988.

Sherman, Paul D. *Colour Vision in the Nineteenth Century: The Young-Helmholtz-Maxwell Theory*. Cambridge, 1981.

Westphal, John. *Colour: A Philosophical Introduction*. 2nd ed. London, 1991.

Wittgenstein, Ludwig. *Bemerkungen über die Farben*. Frankfurt am Main, 1979.

THE HISTORY AND THEORIES OF ART

Aumont, Jacques. *Introduction à la couleur: Des discours aux images*. Paris, 1994.

Ballas, Guila. *La couleur dans la peinture moderne: Théorie et pratique*. Paris, 1997.

Barasch, Moshe. *Light and Color in the Italian Renaissance Theory of Art*. New York, 1978.

Dittmann, Lorenz. *Farbgestaltung und Farbtheorie in der abendländischen Malerei*. Stuttgart, 1987.

Fischer, Hervé. *Les couleurs de l'Occident, de la Préhistoire au XXIᵉ siècle*. Paris, 2019.

Gavel, Jonas. *Colour: A Study of Its Position in the Art Theory of the Quattro- and Cinquecento*. Stockholm, 1979.

Hall, Marcia B. *Color and Meaning: Practice and Theory in Renaissance Painting*. Cambridge, MA, 1992.

Imdahl, Max. *Farbe: Kunsttheoretische Reflexionen in Frankreich*. Munich, 1987.

Kandinsky, Vassily. *Über das Geistige in der Kunst*. Munich, 1912.

Le Rider, Jacques. *Les Couleurs et les mots*. Paris, 1997.

Lichtenstein, Jacqueline. *La Couleur éloquent: Rhétorique et peinture à l'âge classique*. Paris, 1989.

Roque, Georges. *Art et science de la couleur: Chevreul et les peintres de Delacroix à l'abstraction*. Nîmes, 1997.

Shapiro, Alan E. "Artists' Colors and Newton's Colors." *Isis* 85 (1994): 600–630.

Teyssèdre, Bernard. *Roger de Piles et les débats sur le coloris au siècle de Louis XIV*. Paris, 1957.

ABOUT THE COLOR WHITE

ANTIQUITY

Brenner, Athalya. *Colour Terms in the Old Testament*. London, 1983.

Brunner, Berndt. *Moon: A Brief History*. New Haven, 2010.

Calame, Claude. *Thésée et l'imaginaire athénien*. Lausanne, 1996.

Cashford, Jules. *The Moon: Myths and Images*. London, 2003.

Cordier, Pierre. *Nudités romaines: Un problème d'histoire et d'anthropologie*. Paris, 2005.

Dumézil, Georges. "Albati, russati, virides." In *Rituels indo-européens à Rome*, 45–61. Paris, 1954.

Gernet, Louis. "Dénomination et perception des couleurs chez les Grecs." In *Problèmes de la couleur*, edited by I. Meyerson, 313–24. Paris, 1957.

Gradwohl, R. *Die Farben im Alten Testament: Eine Termilogie Studie*. Berlin, 1963.

Grand-Clément, Adeline. "Couleur et esthétique classique au XIXᵉ siècle: L'art grec antique pouvait-il être polychrome?" *Ithaca: Quaderns Catalans de Cultura Clàssica* 21 (2005): 139–60.

———. "Couleurs, rituels et normes religieuses en Grèce ancienne." *Archives de sciences sociales des religions* 174 (2016): 127–47.

———. *La fabrique des couleurs: Histoire du paysage sensible des Grecs anciens (VIIIᵉ s.–début du Vᵉ s.)*. Paris, 2011.

Hunziker-Rodewald, Régine. "*Ruisselant de lait et de miel*: Une expression reconsidérée." *Revue d'histoire et de philosophie religieuses* 93, no. 1 (2013): 135–44.

Jacquesson, François. "Les mots de la couleur en hébreu ancien." In *Histoire et géographie de la couleur*, edited by P. Dollfus, F. Jacquesson, and M. Pastoureau, 67–130. Paris, 2013.

Janssens, H. "Les couleurs dans la Bible hébraïque." *Annuaire de l'Institut d'études orientales et slaves* 14 (Brussels, 1954–57): 145–71.

Jockey, Philippe. *Le mythe de la Grèce blanche: Histoire d'un rêve occidental*. Paris, 2013.

Levine, Etan. "The Land of Milk and Honey." *Journal for the Study of the Old Testament* 87 (2000): 43–57.

Moreau, Philippe, ed. *Corps romains*. Grenoble, 2002.

Pasquier, Alain, and Jean-Luc Martinez, eds. *Praxitèle*. Paris, 2007.

Ridgway, Brunilde S. *Roman Copies of Greek Sculpture: The Problem of the Originals*. Ann Arbor, 1984.

Roscher, Wilhelm Heinrich. *Ueber Selene und Verwandtes*. Leipzig, 1890.

Siecke, Ernst. *Beiträge zur genaueren Erkentnis der Mondgottheit bei den Griechen*. Berlin, 1885.

Wilson, Lilian May. *The Roman Toga*. Baltimore, 1924.

THE MIDDLE AGES

Bethlehem, Ulrike. *Guinevere: A Medieval Puzzle, Images of Arthur's Queen in the Medieval Literature of Britain and France*. Heidelberg, 2005.

Bock, Franz. *Geschichte der liturgischen Gewänder im Mittelalter*. 3 vols. Berlin, 1859–69.

Braun, Joseph. *Die liturgische Gewandung in Occident und Orient*. Freiburg im Breisgau, 1907.

Bredero, Adriaan H. *Cluny et Cîteaux au douzième siècle: L'histoire d'une controverse monastique*. Amsterdam, 1986.

Bureau, Pierre. "De l'habit paradisiaque au vêtement eschatologique." *Médiévales* (1993): 93–124.

Constable, Giles. *The Letters of Peter the Venerable*. 2 vols. Cambridge, MA, 1967.

Cordonnier, Remy. "Des oiseaux pour les moines blancs: Réflexions sur la réception de l'aviaire d'Hugues de Fouilloy chez les cisterciens." *La Vie en Champagne* 38 (2004): 3–12.

———. "La plume dans l'*aviarium* d'Hugues de Fouilloy." In *La Corne et la Plume dans les textes médiévaux*, edited by F. Pomel, 167–202. Rennes, 2010.

Delort, Robert. *Le commerce des fourrures en Occident à la fin du Moyen Âge (v. 1300–v. 1450)*. 2 vols. Rome, 1978.

Hablot, Laurent. "Emblématique et mythologie médiévale: Le cygne, une devise princière." *Histoire de l'art* 49 (2001): 51–64.

Knowles, David. *Cistercians and Cluniacs: The Controversy between St. Bernard and Peter the Venerable*. Oxford, 1955.

Lecouteux, Claude. *Fantômes et revenants au Moyen Âge*. Paris, 1986.

MacGregor, Arthur. "Swan Rolls and Beak Markings: Husbandry, Exploitation, and Regulation of Cygnus Olor in England (circa 1100–1900)." *Anthropozoologica* 22 (1995): 39–68.

Paravicini, Werner. "Tiere aus dem Norden." *Deutsches Archiv für die Erforschung des Mittelalters* 59, no. 2 (2003): 559–91.

Pastoureau, Michel. "Les cisterciens et la couleur au XII^e siècle." *Cahiers d'archéologie et d'histoire du Berry* 136 (1998): 21–30.

———. "Classer les couleurs au XII^e siècle: Liturgie et héraldique." *Comptes rendus: Académie des inscriptions et belles-lettres*, fasc. 2 (April–June 2017): 845–64.

———. *Les couleurs au Moyen Âge: Dictionnaire encyclopédique*. Paris, 2022.

———. "L'Église et la couleur des origines à la Réforme." *Bibliothèque de l'École des chartes* 147 (1989): 203–30.

———. *Le jeu d'échecs médiéval: Une histoire symbolique*. Paris, 2012.

Pastoureau, Michel, and Élisabeth Taburet-Delahaye. *Les secrets de la licorne*. Paris, 2013.

Peyronie, A. "Le mythe de Thésée pendant le Moyen Âge latin." *Médiévales* 16, no. 32 (1997): 119–33.

Poirion, Daniel. "Du sang sur la neige: Nature et fonction de l'image dans *Le Conte du Graal*." In *Polyphonie du Graal*, edited by D. Hüe, 99–112. Orléans, 1998.

Rieger, Dietmar. *Guenièvre, reine de Logres, dame courtoise, femme adultère*. Paris, 2009.

Savoye, Marie-Laure. *De fleurs, d'or, de lait et de miel: Les images mariales dans les collections miraculaires romanes du XIII^e siècle*. Paris, 2009.

Schmitt, Jean-Claude. *Les Revenants: Les vivants et les morts dans la société médiévale*. Paris, 1994.

Siegwart, Joseph. "Origine et symbolisme de l'habit blanc des dominicains." *Mémoire dominicaine* 29 (2012): 47–82.

Ticehurst, Norman F. *The Mute Swan in England: Its History and the Ancient Custom of Swan Keeping*. London, 1957.

Vassilieva-Codognet, Olga. "'Plus blans que ours de lis'": Blanchart, l'ours blanc de *Renart le Nouvel*. *Reinardus* 27 (2015): 220–48.

Wagner, Anthony R. "The Swan Badge and the Swan Knight." *Archaeologia* 97 (1959): 127–38.

Zink, Michel, and Henri Dubois. *Les âges de la vie au Moyen Âge*. Paris, 1992.

MODERN TIMES

Blanchet, Adrien. *Essai sur l'histoire du papier*. Paris, 1900.

Blum, André. *Les origines du papier, de l'imprimerie et de la gravure*. 2nd ed. Paris, 1935.

Callard, Caroline. *Le temps des fantômes: Spectralités d'Ancien Régime, XVI^e–XVII^e siècles*. Paris, 2019.

Crosepinte, Jean-Marie. *Les Drapeaux vendéens*. Niort, 1988.

Dolce, Lodovico. *Dialogo della pittura intitolato l'Aretino*. Venice, 1557.

Gaehtgens, Thomas W., ed. *Johann Joachim Winckelmann (1717–1768)*. Hamburg, 1986.

Garnier, Jean-Paul. *Le drapeau blanc*. Paris, 1971.

Guttmann, Allen. *Women's Sports: A History*. New York, 1992.

Hall, Marcia B., ed. *Color and Technique in Renaissance Painting: Italy and the North*. London, 1987.

Haskell, Francis, and Nicholas Penny. *Pour l'amour de l'antique: La statuaire gréco-romaine et le goût européen, 1500–1900*. Paris, 1988. English language edition: New Haven, 1981.

Lanoé, Catherine. *La poudre et le fard: Une histoire des cosmétiques de la Renaissance aux Lumières*. Seyssel, 2008.

Lefrançois de La Lande, Joseph Jérôme. *Art de faire le papier*. Paris, 1761.

Lemay, Pierre. "Berthollet et l'emploi du chlore pour le blanchiment des toiles." *Revue d'histoire de la pharmacie* 78 (1932): 79–86.

Martinez, Jean-Luc, ed. *Les antiques du Louvre, de Henri IV à Napoléon I^er^*. Paris, 2004.

Mironneau, Paul. "Aux sources de la légende d'Henri IV: Le cantique de la bataille d'Ivry de Guillaume Salluste du Bartas." *Albineana: Cahiers d'Aubigné* 9 (1998): 111–27.

Pastoureau, Michel. "La Réforme et la couleur." *Bulletin de la Société de l'histoire du Protestantisme français* 138 (July–September 1992): 323–42.

Pinoteau, Hervé. *La symbolique royale française, V^e^–XVIII^e^ siècle*. La Roche-Rigault, 2004.

Pomian, Krzystof. *Collectionneurs, amateurs et curieux: Paris-Venise, XVI^e^–XVIII^e^ siècle*. Paris, 1987.

Pommier, Édouard. *Winckelmann: Naissance de l'histoire de l'art*. Paris, 2003.

Roskill, Mark W. *Dolce's Aretino and Venetian Art Theory of the Cinquecento*. London, 1968.

Seguin, Joseph. *La Dentelle: Histoire, description, fabrication, bibliographie*. Paris, 1875.

Turrel, Denise. *Le Blanc de France: La construction des signes identitaires pendant les guerres de Religion (1562–1629)*. Geneva, 2005.

Winkelmann, Johann Joachim. *Geschichte der Kunst des Alterthums*. Dresden, 1764.

THE CONTEMPORARY PERIOD

Berjat, Muriel, et al. *Naissance du sport moderne*. Paris, 1987.

Caminade, Michèle. *Linge, lessive, lavoir: Une histoire de femmes*. Paris, 2005.

Candille, Marcel. "Les soins en France au XIX^e^ siècle." *Bulletin de la Société française d'histoire des hôpitaux* 28 (1973): 33–77.

Chantreau, Sophie, and Alain Rey. *Dictionnaire des expressions et locutions*. 4th ed. Paris, 2015.

Heller, Eva. *Wie Farben wirken*. 2nd ed. Berlin, 2004.

Holt, Richard. *Sport and Society in Modern France*. Oxford, 1981.

———. *Sport and the British: A Modern History*. Oxford, 1990.

Leblanc, Roger. *Le Savon, de la Préhistoire au XXI^e^ siècle*. Montreuil-l'Argillé, 2001.

Lefébure, Christophe. *La France des lavoirs*. Toulouse, 2003.

Leuwers, Daniel. *Le Blanc en littérature*. Bucharest, 2006.

Maillet, Jean. *Cinq cents expressions décortiquées*. Paris, 2019.

Maurer, Michael. *Vom Mutterland des Sports zum Kontinent: Der Transfer des englischen Sports im 19. Jahrhundert*. Mainz, 2011.

Mérimée, Léonor. *De la peinture à l'huile, ou, Des procédés matériels employés dans ce genre de peinture de Jean Van-Eyck jusqu'à nos jours*. Paris, 1830.

Mollard-Desfour, Annie. *Le Blanc: Dictionnaire de la couleur; Mots et expressions d'aujourd'hui (XX^e^–XXI^e^ siècles)*. Paris, 2008.

Petit, Jean, Jacques Roire, and Henri Valot. *Encyclopédie de la peinture: Formuler, fabriquer, appliquer*, vol. 1. Puteaux, 1999.

Picar-Cajan, Pascale, ed. *L'illusion grecque: Ingres et l'antique*. Paris, 2006.

Rainhorn, Judith. *Blanc de plomb: Histoire d'un poison légal*. Paris, 2019.

Rosen, George. *A History of Public Health*. New York, 1958.

Sadoun-Goupil, Michelle. *Le Chimiste Claude-Louis Berthollet (1748–1822): Sa vie, son œuvre*. Paris, 1977.

Salvi, Sergio, and Alessandro Salvorelli. *Tutti i colori del Calcio*. Florence, 2008.

Tétard, Philippe. *Histoire du sport en France, du Second Empire au régime de Vichy*. Paris, 2007.

Tollet, Casimir. *Les Hôpitaux modernes au XIX^e^ siècle*. Paris, 1894.

Vigarello, Georges. *Du jeu ancien au show sportif: Histoire d'un mythe*. Paris, 2002.

———. *Passion sport: Histoire d'une culture*. Paris, 2000.

———. *Le Propre et le Sale: L'hygiène du corps depuis le Moyen Âge*. Paris, 1987.

Art Brut and White

The Art Brut movement did not have much use for white, but that was not the case in Jean Dubuffet's work, where that color played an essential role, especially beginning in the 1960s and his *"Hourloupe"* period. Not only does white highlight the other colors but it also orchestrates the chromatic music that accompanies all his creations, whether painted or sculpted. Jean Dubuffet, *Blondeur et fard*, 1955. Amiens, Musée de Picardie.

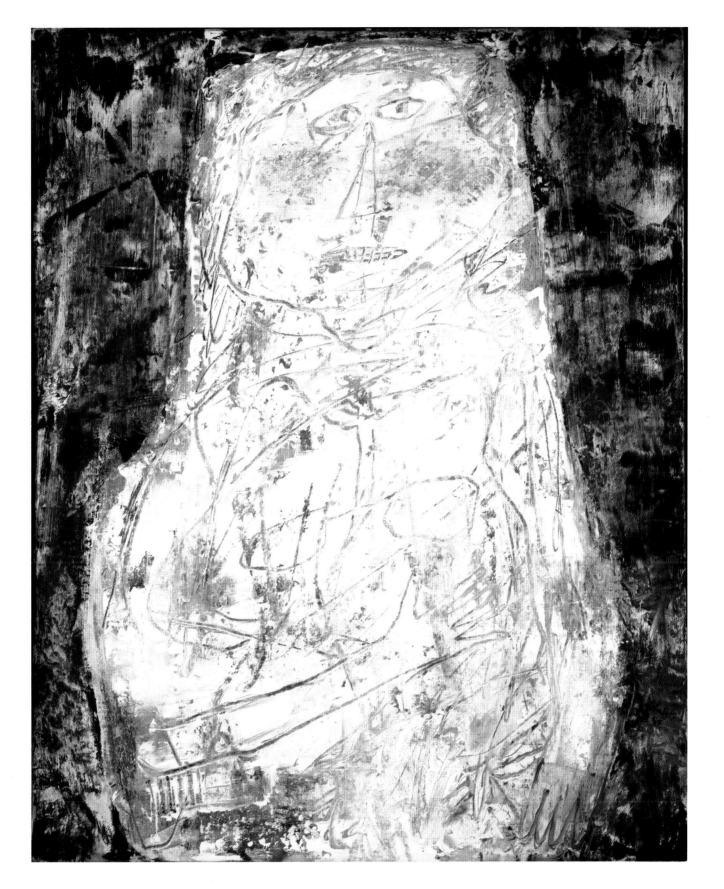

ACKNOWLEDGMENTS

Before taking the form of a book, this history of the color white in European societies constituted—as did those of blue, black, green, red, and yellow—the subject of my teaching and my seminars at the École Pratique des Hautes Études, the École des Hautes Études en Sciences Sociales, and the École des Chartes. I thank all my students and auditors for the fruitful exchanges we had for more than forty years.

I would also like to thank all those close to me—friends, relatives, colleagues, students—whose advice, comments, and suggestions I have benefited from, especially my faithful interlocutors in the domain of colors: Thalia Brero, Brigitte Buettner, Pierre Bureau, Perrine Canavaggio, Yvonne Cazal, Marie Clauteaux, Claude Coupry, Laurent Hablot, François Jacquesson, Philippe Junod, Christine Lapostolle, Christian de Mérindol, Claudia Rabel, and Anne Ritz-Guilbert.

Thanks as well to Éditions du Seuil, especially to the whole Beaux Livres team, Nathalie Beaux, Caroline Fuchs, Matilda Wolski, and Elisabetta Trevisan, as well as to iconographers Marie-Anne Méhay and Karine Benzaquin, to graphic designer François-Xavier Delarue, to proofreaders Renaud Bezombes and Silvain Chupin, to producer Carine Ruault, and to my publishing assistants, Marie-Claire Chalvet and Laetitia Correia. Everyone has worked to make the present volume a very beautiful one that, like its predecessors, will be available to a wide readership.

Nicolas de Staël, *The Road*,
1954. Private collection.

CREDITS